SCOTLAND

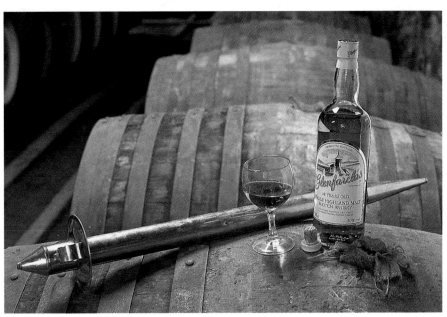

Scotland, my auld, respected mither!
Tho' whiles ye moistify leather,
Till whare ye sit on craps o',heather Ye tine your dam,
Freedom and whisky gang thegither, Tak aff your dram!

Robert Burns, 1790

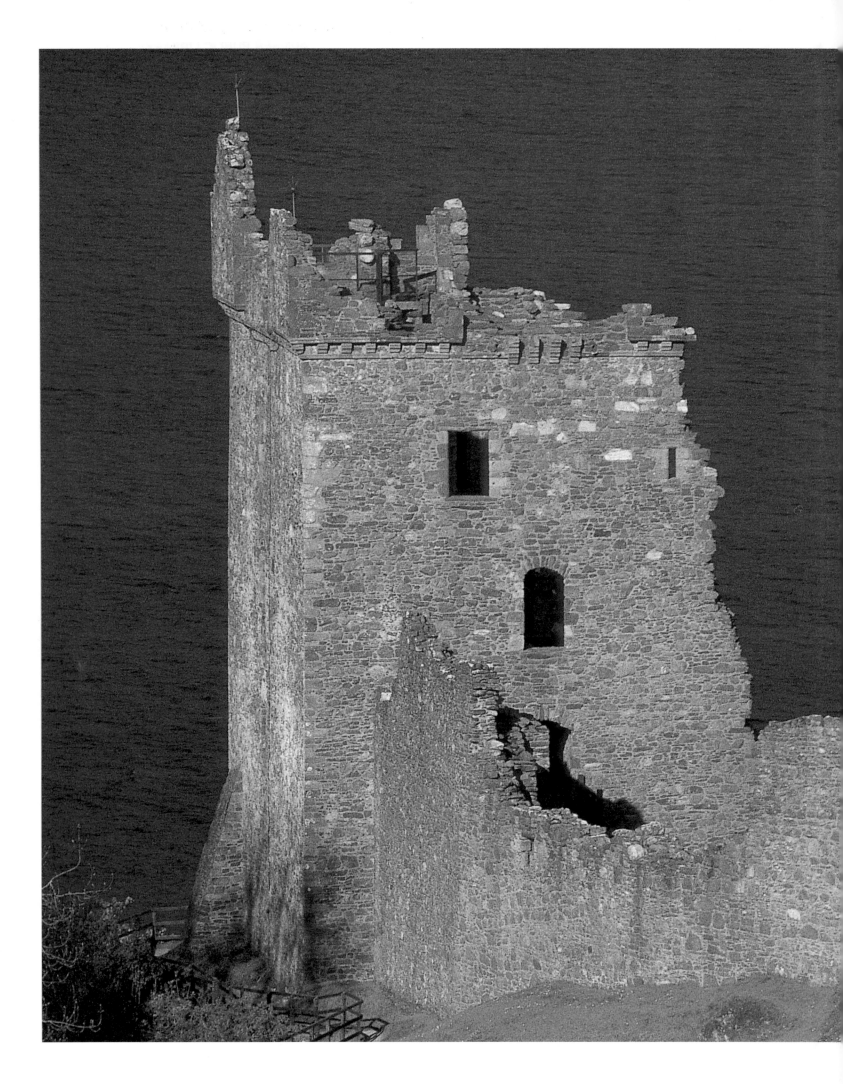

SCOTLAND

Photographs by Kai Ulrich Müller
Text by Roland Hill
Translated by Michael Mitchell

TAURIS PARKE BOOKS

LONDON • NEW YORK

CONTENTS

The Romantic North — 9
Roland Hill

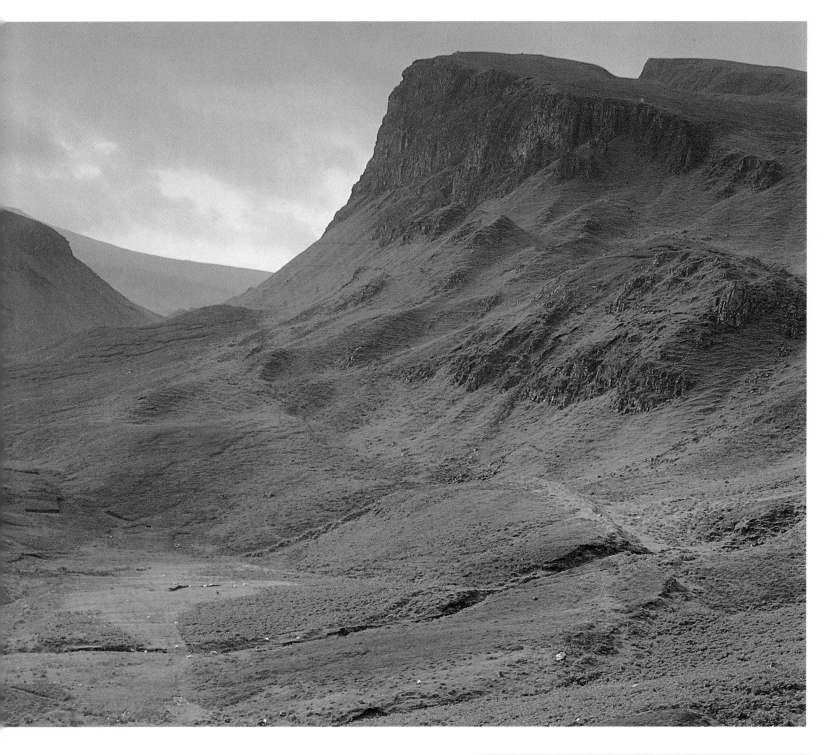

'... beaten upon and buffeted by all
the winds of heaven'

Page 1: Still life from the Glenfarclas Distillery, Ballindalloch
Pages 2–3: Castle Urquhart on Loch Ness
Above: Loch Leum na Luirquinn on Skye

T R A V E L ✦ G U I D E

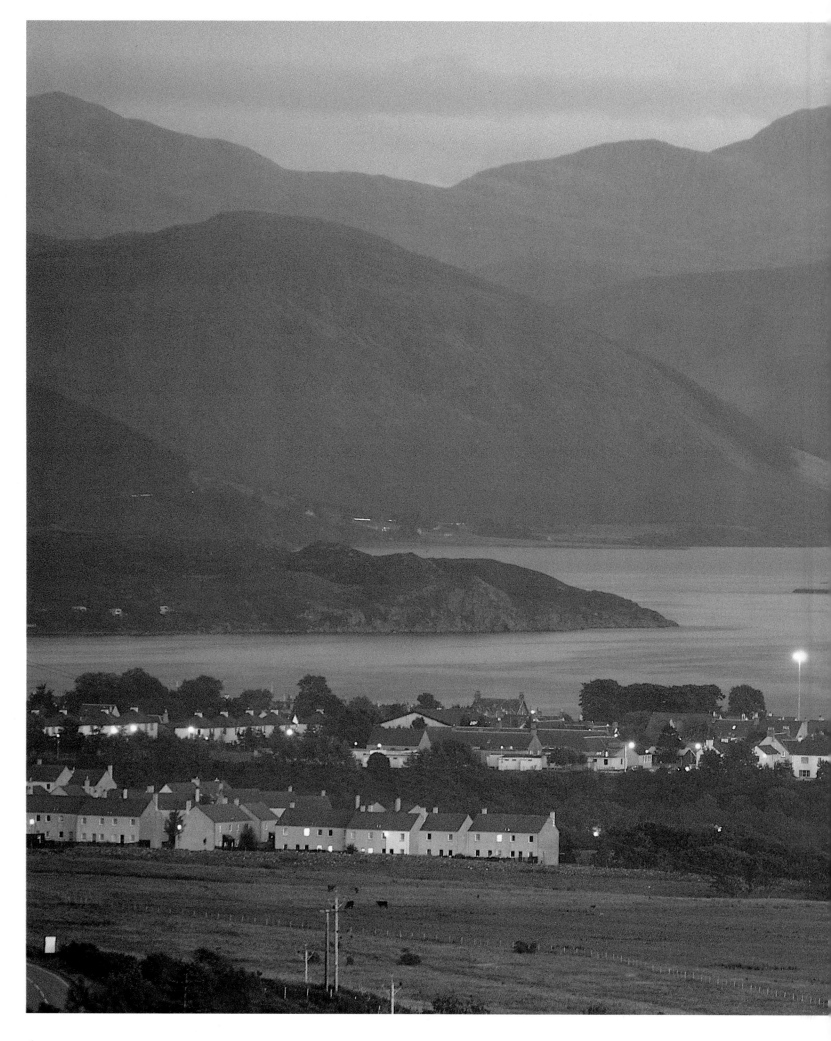

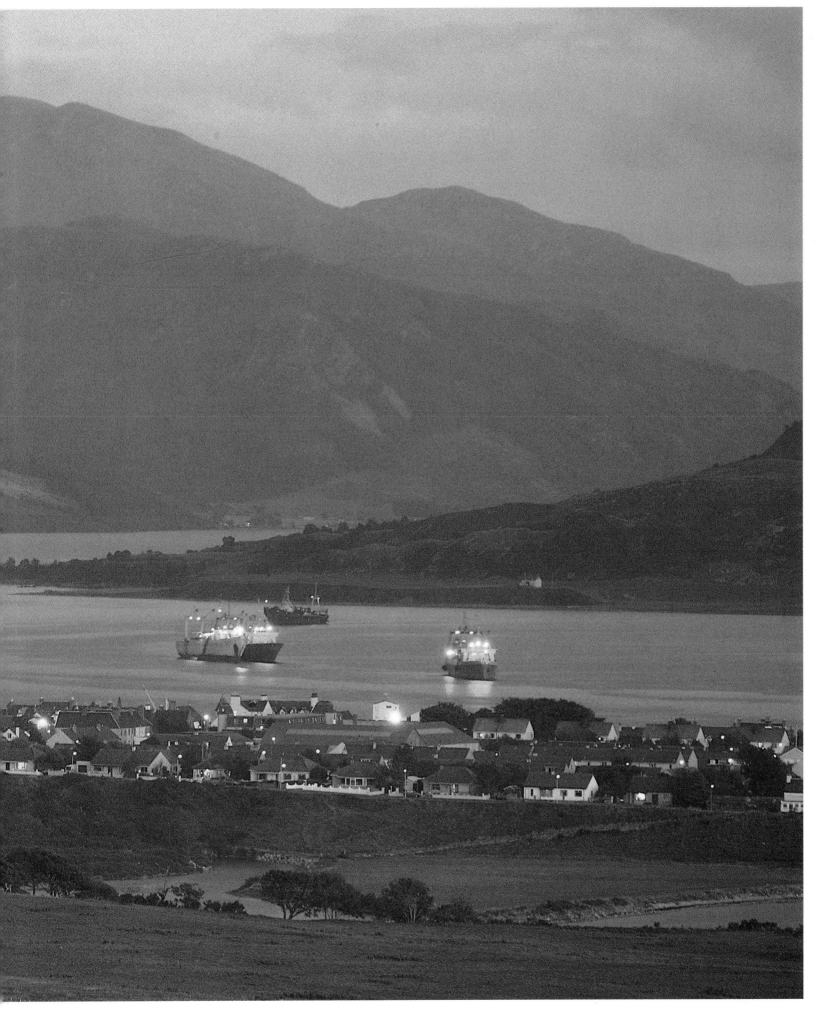

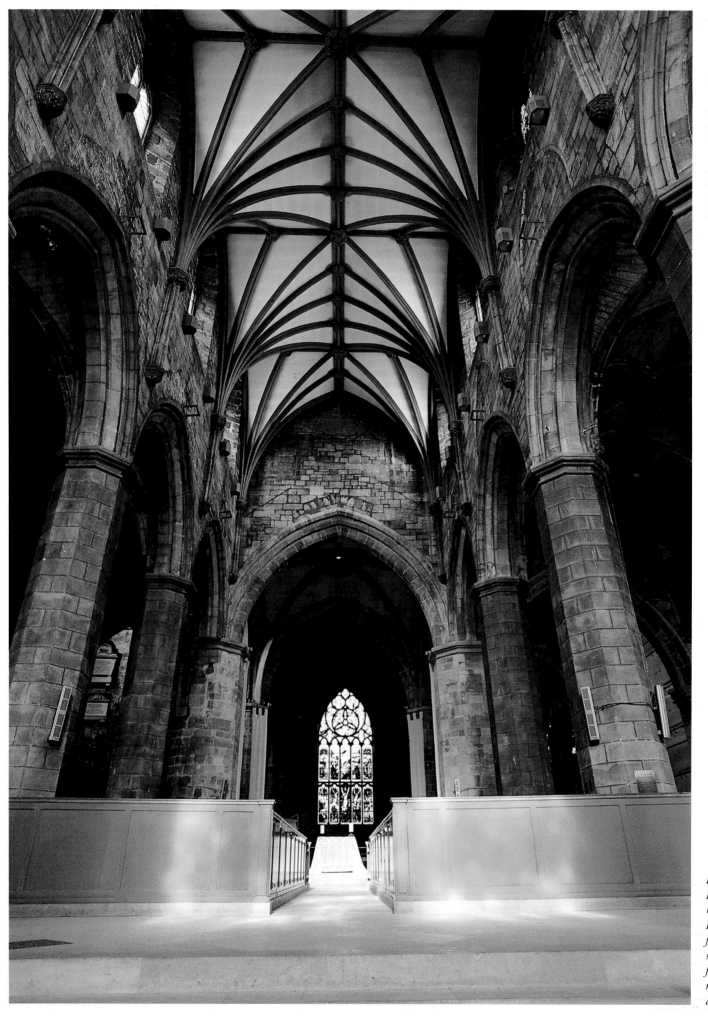

Massive pillars and delicate vaulting: the nave of St Giles Cathedral in the heart of Edinburgh. Various confessions set up their altars here and both John Knox's idol-breakers and 19th-century restorers tried to make it conform to their idea of what a church should be like.

Previous page: Evening haze over Ullapool on Loch Broom. The busy fishing port falls silent, the island ferries are lost in a maze of waterways among the hills.

The Romantic North

Roland Hill

Scotland is more than just a romantic region on the fringes of the British Isles. As well as its own five million inhabitants, there are millions of Scots living all over the world. Like the Irish, many were forced by poverty and the lack of opportunities at home to seek their fortune in faraway places. The London telephone directory, for example, has no less than 46 pages with names beginning with 'Mac'. Wherever there are harbours, bridges or houses to be built, water or oil pipelines to be laid, you will find Scottish engineers at work. Media editors in London, a bookkeeper in Paris, a dentist in Johannesburg, a bank manager in Vancouver, all probably Scots. They all have their dreams of highland shielings and clans, Edinburgh Castle in the mist, Loch Lomond in the drizzle, the picturesque Western Isles or their favourite pub in Glasgow.

Wherever they are, on festive occasions Scottish men insist on turning out in their kilts with the otter-skin sporran dangling in front and the skean dhu tucked into their right stocking. Kilts suit women just as well, as fashion designers have long been aware. In exile the Scots still celebrate their festivals, even dance the Scottish reel in the tropics, emitting their yodel-like whoops. They stick to their familiar whisky brands (under the motto, 'No whisky without water and no water without whisky'), cherish their accent and are active members of the expatriate Scots' Caledonian Clubs. They enjoy the company of other Scots – assuming, that is, they do not come from a clan with whom they have been in a state of feud for centuries. But hardly ever do they go back to Scotland, and that keeps their homesickness alive.

Disputed Origins

Who are these Scots, who can be as prickly as their thistles and gorse bushes, but also witty, warm-hearted and hospitable? Their origins are still disputed. A distinction is made between northern and southern, highland and lowland Scots, but east–west differences are no less marked. East-coast Scots are seen as cautious, practical, sober, taciturn, methodical and as hard as the granite of Aberdeen, the proverbial home of miserliness. West-coast people are more friendly, emotional; it is the land of bagpipes and tartans. Some west-coast Scots look almost like southern Europeans; they have dark hair, narrow heads and – at least according to shoe manufacturers – the smallest feet in the British Isles. The tough, stocky lads from Glasgow have achieved notoriety as football fans. Even with small amounts of alcohol in it, their blood can easily boil over, sending them to their knives and razor blades, which they handle with great skill.

Were the original inhabitants of Scotland the hunters, gatherers and fishers who settled on the west coast in the New Stone Age? Or the 'Beaker People' – so called from the beakers they buried along with their dead – who came later from Spain via the Rhineland and Holland? Or the Celts who resisted the Romans from their fortresses and round towers? These Picts, the 'Painted People' as the Romans called them because of their tattoos are still a mystery. Scotland nearly became 'Pictland', but after the 5th century the Picts were driven out by the Gaelic Scots advancing from the

west who, in turn, fled before the Scandinavians invading from the north and west from the 9th century on.

What is the main ingredient in this ethnic hotch-potch, to which were later added Angles and Normans, is difficult to say. One decisive factor, however, was the Christianisation of Scotland by Irish monks, who also carried their faith to mainland Europe. Until the 10th century, 'Scotia' remained the name for Ireland, only after that was it applied to Scotland, so that the 'Scottish' monasteries in Germany and Austria are actually misnamed today. Around 560 Columba, a disciple of St Patrick, sailed in an open boat with twelve companions across the sea to the island of Iona on the west coast of Scotland, where he settled in an old Druids' temple. From Iona his monks carried the faith to the north and south of Scotland, decades before St Augustine was sent as an apostle from Rome to found the Christian church in Anglo-Saxon England. Later, Iona became a place of pilgrimage and the burial place of the Highland kings, including Duncan and his murderer Macbeth.

Rome and the Caledonians

The Romans are a further historical factor. In the four centuries during which they ruled Britain, the most northerly of their provinces, they repeatedly clashed with the barbarians, or 'Caledonians' as they called them. And since the governor of Britain between 78 and 84 AD, Gnaeus Julius Agricola, had a son-in-law and brilliant biographer called Tacitus, his period is better documented than many others. The latter summed up the obstinacy with which the Scots resisted the Romans' attempts to subjugate the whole of Caledonia up to the distant northern coast, in the famous words, 'They create desolation and call it peace.' With Roman pride, he describes a decisive battle in the Highlands in which 'the enemy' lost 10,000 men, the Romans just 360. Following this, the Romans advanced to the Moray Firth, where they took ship and sailed round Britain, discovering that it was an island they were occupying. They were the first (apart from the Stone Age inhabitants) to sight the northern isles, the Orcades (Orkney) and Thule (Shetland), which antiquity considered the end of the world. 'Britannia perdomita' (The whole of Britain has been conquered), Tacitus noted, adding, 'et statim amissa' (and immediately given up). Defeats on the Danube forced the Romans to withdraw one of the four legions stationed in Britannia, and although they did not finally abandon Britain until the 5th century, they never really subjugated Scotland.

Hadrian's Wall, running for 100km between the Solway Firth and the mouth of the Tyne, remained the northern boundary of the Roman province, although on Scottish soil there are, between the Clyde and the Forth, the remains of the Antonine Wall, a 50km-long rampart which served as an advance defence against the barbarians. The Romans' relationship with the natives ranged from forced labour and deportation into slavery to trading and marriage. It was this period that laid the foundation for the later strained relationship between England and Scotland. Roman chroniclers sent back astonished accounts of the strange customs of these barbarians. Dio Cassius in the 3rd century, for example, records a conversation between the wife of a tribal chief and a Roman matron, who expressed her astonishment at the promiscuity of the Caledonian women, who clearly practised polyandry. To give themselves of their own free will to the best men was much better, the answer ran, than to be obliged to submit to the practices of debauched men in their orgies, as Roman women did.

After the withdrawal of the Romans, the history of Scotland, as that of the whole of the British Isles, sank into the darkness of the early Middle Ages. A Celtic kingdom arose in the north, which is known throughout the world from Shakespeare's *Macbeth*. The Normans, who conquered England in 1066, pushed north in order to contain the

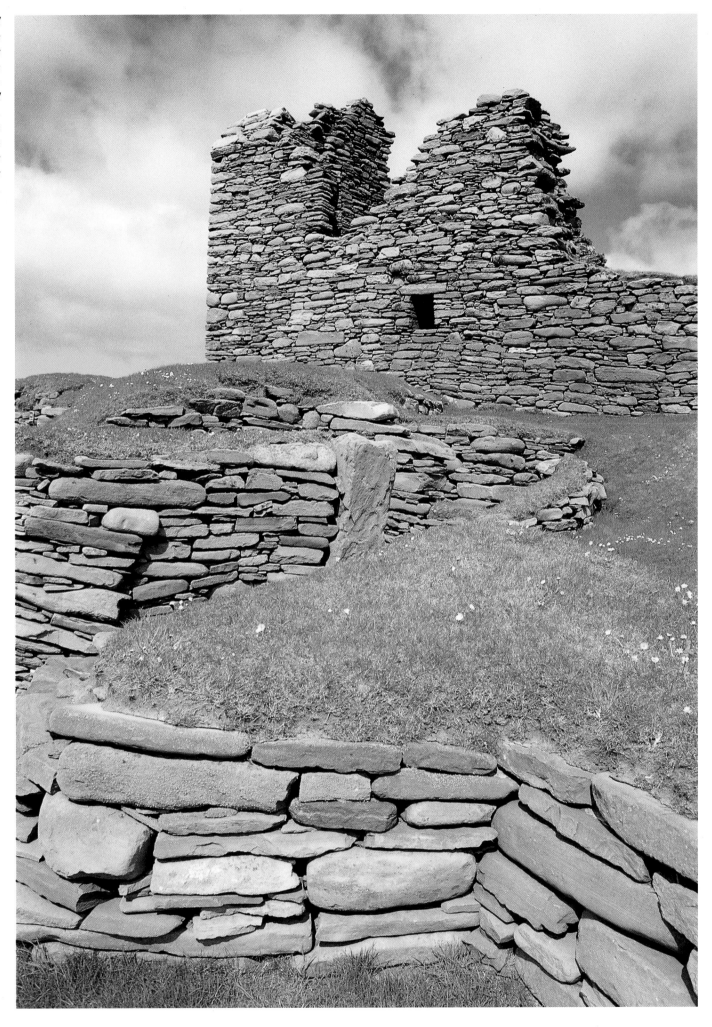

Jarlshof on Mainland in the Shetlands, one of the most important prehistoric settlements in Britain, was only discovered at the end of the 19th century. Various cultures from the New Stone Age to the late Middle Ages have left their traces here.

constant border raids, a speciality of the wild Scottish bands. During the feudal period Scottish princes became vassals of the Anglo-Norman overlords. Later this was to lead to many territorial claims and conflicts. Feudalism took deep root in Scotland, taking hold especially of the church, which remained loyal to Rome longer than in England. Today the Presbyterian Church of Scotland is the established church in Scotland and entirely distinct from the Church of England. The Queen, who is head of the Church of England, has no official status in the Church of Scotland, but is a member and attends that church, governed by elders and not by bishops, when visiting the country. The Roman Catholic Church too, which was only re-established during the 19th century, after having been abolished in the course of the Reformation, is administered by its own hierarchy, independent of England and Wales, and has its own primate.

Edward, 'Hammer of the Scots'

It was only in the 13th century that a firm boundary was drawn between England and Scotland. Having already subjugated Wales, Edward I of England exploited a disputed Scottish succession to conquer the land on the northern fringe of his kingdom. Since he carried out his plan in a very cruel manner, with a great deal of intrigue, occupying Scotland and imposing an English regime, it led to the first great uprising against the English, as a result of which William Wallace and Robert the Bruce managed to maintain Scotland's independence for a while. The hatred of England, which continued through the following centuries, drove the Scots into an alliance with England's traditional enemy, the French. Whenever war broke out between the French and the English, the Scots would take up arms and invade England. This 'Auld Alliance' meant that France had a significant influence on Scottish manners, art, science and law. Even though the French influence declined after the Reformation, Scotland remained in

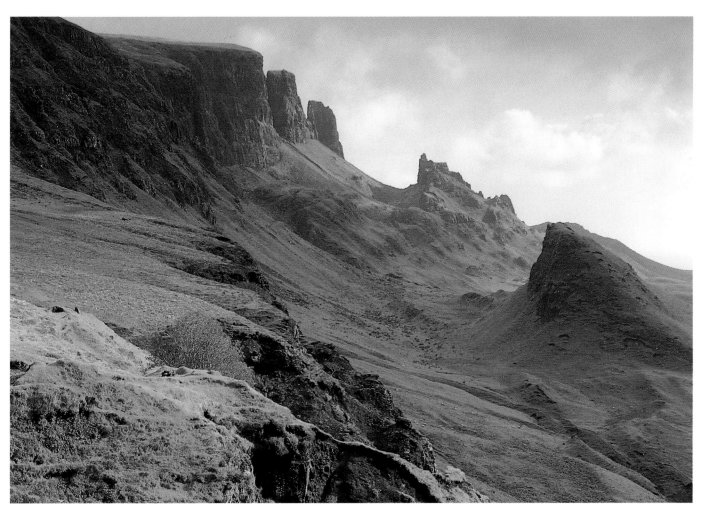

A contrast to the gentle hills of the Borders (p 12): the steep and barren landscape of the Quiraing with its bizarre rock formations dominates the Trotternish peninsula in the north of Skye.

some respects closer to continental Europe than England. Scots law, for example, is rooted more in French civil law than in English common law. The universities of St Andrews, Glasgow and Aberdeen were founded on the Paris model; even today the Scottish school system is distinct from the English. The Scottish cuisine also reveals a good deal of French influence: *hutaudeau* (a pullet) became howtowdie, stovies (stewed potatoes) comes from *étuvé* and a leg of lamb is called a gigot; even the Scottish national dish, haggis – a sheep's stomach stuffed with oatmeal and offal which, with a generous helping of sauce (ie whisky), tastes better than one would imagine – may well come from 'hachis'.

People in England take life less seriously, are more tolerant, perhaps more apathetic. Political and intellectual movements have always had more radical effects in Scotland. The great example is the Reformation symbolised by the figures of Mary Stuart, the representative of Catholic absolutism, and John Knox, the preacher of the new Calvinistic belief based on the Bible.

Mary, Queen of Scots

Mary, the daughter of James V and Mary, daughter of the French Duke of Guise, was only a week old when her father died. At the age of six she went to France, where she married the Dauphin, later Francis II. At seventeen she was Queen of both France and Scotland. However, in a deliberate affront to the heretic English queen, Elizabeth I, France and Spain jointly declared her Queen of England.

After the death of her sickly husband, the nineteen-year-old Mary returned as a widow to Scotland, where Catholicism had been ousted by the new Calvinist faith. She remained true to her Catholic belief, but it was the struggle with her opponents in the aristocracy and her foolish choice of lovers that brought about her downfall. A

13

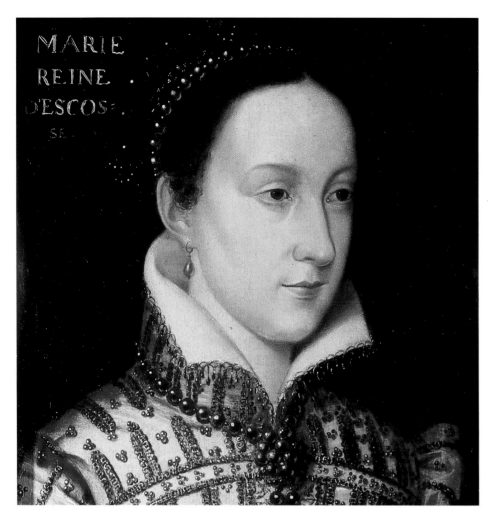

MARIE REINE D'ESCOS SE

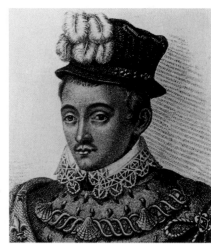

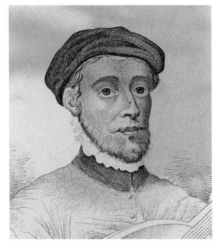

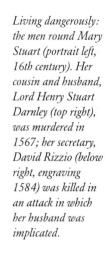

Living dangerously: the men round Mary Stuart (portrait left, 16th century). Her cousin and husband, Lord Henry Stuart Darnley (top right), was murdered in 1567; her secretary, David Rizzio (below right, engraving 1584) was killed in an attack in which her husband was implicated.

daemonic fate seemed to have a hand in everything she did. Spurned and abandoned by the people, she had to flee Edinburgh, being forced to abdicate and install a Protestant regent. Supporters of the queen gathered an army to defend her. She retracted her abdication and, when her troops were defeated, fled to England to place herself under the protection of her cousin Elizabeth. That faced Elizabeth with a dilemma: as the arguably illegitimate daughter of Henry VIII and Anne Boleyn, she feared her right of succession might be challenged and was bound to see in Mary, the symbol of Catholic hopes, a rival for her throne. The party that had remained true to the old religion in England saw Mary as the rightful queen. The Guises in France supported her and attempted to combine with Philip II of Spain against the English heretics. In this situation Elizabeth was guided by her political shrewdness. She could not put Mary back on her throne against the will of the Scottish people, nor could she be seen to support the Scottish rebels against Mary, which would create a dangerous example for England. She could not allow Mary her freedom in England, because that would have played into the hands of the Catholic conspirators, but neither could she send her back to France, as Mary could be just as great a danger to her from there. She therefore decided to keep Mary prisoner.

In all, the Queen of Scots was Elizabeth's prisoner in various English castles for nineteen years. Under the pretext of her participation in a Catholic plot against Elizabeth, she was tried in Fotheringhay Castle in October 1586. Elizabeth hesitated to sign the warrant of execution, which was eventually carried out on 8 February 1587. On her cloak the Queen of Scotland had embroidered the words, 'En ma fin est mon commencement' (In my end is my beginning). It was a kind of prophecy, for after the death of Elizabeth, Mary's son, James VI, came to the English throne and, as James I, united the crowns of England and Scotland in 1603 and the history of the Scottish royal line became part of the history of England.

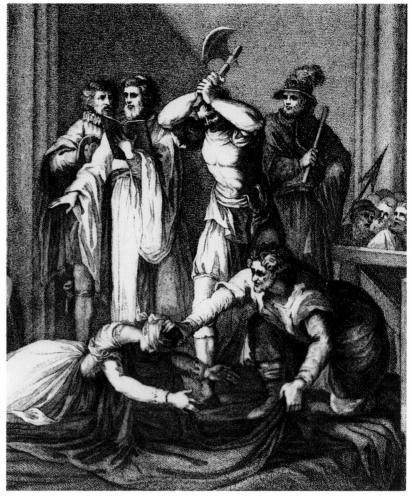

The Scottish Stuarts were thoroughly capable rulers, interesting, full-blooded characters who loved life, hunting and warfare, but were also cultured and appreciated art. They formed the transition from the absolute rulers to the later system of a politically weak monarchy. The same Protestant opponents, to whom Mary had had to give way in Scotland, were to prove to be the undoing of her descendants in England, not least because they were incapable of coming to terms with the new middle classes and landed gentry who had established a power-base in parliament. The rule of the Stuarts came to a temporary end with the execution of Charles I in 1649, the victory of Cromwell's Roundheads over the royalist Cavaliers bringing Britain the only period of republican rule in its history. After twelve years of that, the country recalled the son of the executed king from exile, and gave a sigh of relief when he returned to the throne. But Charles II and his brother James II found it difficult to renounce the principle of the divine right of kings. The house of Hanover, which eventually replaced the Stuarts in 1714 as kings of Great Britain and Ireland, was more prepared to govern the country with the assistance of the new aristocracy of land and money.

The legacy of John Knox

Calvinism had fallen on fertile ground in Scotland. Even before the Reformation, for example, it was customary to celebrate the sabbath with Old Testament strictness. Even the king went to mass on foot. Every kind of amusement was forbidden. Thus the Scottish reformers could build on local custom whereas in England the Anglican spirit of compromise triumphed. For the Scots, the Kirk, with its autonomous kirk sessions (council of elders) and General Assembly, a kind of democratic assembly of the faithful, came to signify what Westminster was for the English: the expression and embodiment of their sovereignty. How much the old religious tensions are still alive today can be

seen in the exclusion, in 1990, of Lord Mackay from the sacraments of the extremely strict Calvinist sect to which he, the Lord Chancellor of Great Britain, had belonged since childhood. He was excluded because he had attended, as the official representative of Great Britain, the funeral of a Catholic friend. He had no alternative but to leave the sect.

A characteristic feature of the religious situation in Scotland today is the growth of Catholicism to the point where it is practically the strongest confession. This is first and foremost due to the third and fourth generations of Irish immigrants living in Scotland. Today 40 percent of schoolchildren in Glasgow attend Catholic schools.

Nevertheless, the Scots have retained their puritanism. Religion clearly only satisfies them when it is really harsh and uncomfortable, demands plentiful sacrifices and does not beguile the eye and ear with 'the vain works of man such as art and music', indeed, clamps down on all the desires of the flesh. On the other hand, however, the Scots are well capable of letting themselves go, as their New Year celebrations show. Nowhere can the two sides of the Scottish character be seen so clearly as in the well-known novel, *Dr. Jekyll and Mr. Hyde,* by the Scot Robert Louis Stevenson, the author of the famous children's story, *Treasure Island*. Stevenson deals with the theme of the eternal battle between good and evil, angels and devils, through the psychological portrait of a split personality: Jekyll, the doctor, has developed a drug which completely changes his personality, turning him into Mr. Hyde, the embodiment of the evil inside him.

Even today the Scottish Sunday can be a dismal affair, especially for tourists who would like to explore Scottish hospitality. At least nowadays two thirds of the pubs are open, even if only for the usual limited periods. Sport, theatres and other entertainments, however, are still forbidden. The Scots' aversion to pork is probably also due to Protestant fundamentalism; the consumption of pork and bacon is twice as high in the rest of Britain as in Scotland. The puritan influence extends to all areas including, of course, fashion. White ladies' underwear is in much greater demand in Scotland than elsewhere; other colours are considered immodest. As market research confirms, white, being the colour of cleanliness and purity, generally has a positive effect on sales in Scotland. Scottish housewives are reputed to devote themselves more to cleaning and scrubbing than their English counterparts, and they are also said to be much more willing to accept the daily burden of housework, even cleaning their husbands' and sons' shoes for them.

Another remarkable aspect, and one that cannot be simply explained by the fact that people in the cold north might need to take more sugar, is the Scots' sweet tooth, as well as their liking for strong cigarettes and drinks such as whisky, rum and vodka, the consumption of which far exceeds that in England. They are real gluttons as far as cakes, biscuits, chocolate, jam, jellies, ice cream, puddings and sweet drinks are concerned. They spend twice as much as the English on sweets (and not only the children) and their teeth are in a correspondingly poor state.

That the Scots are aware of their 'sinful cravings' can be seen in their simultaneous readiness to 'mortify the flesh'. Sales of hard toothbrushes and rough towels are higher in Scotland than anywhere else in the United Kingdom. The Scots are less frivolous in their use of the National Health Service than the English, who run to the doctor at the slightest suggestion of an indisposition. And the Scottish lifestyle is more frugal than the English as well. They are keen on saving, a habit that goes well beyond simple penny-pinching and has nothing to do with the miserliness of traditional Scottish jokes. On the contrary, the Scots can be extremely hospitable, but they are 'canny', careful with their money, always on the lookout for bargains and, for example, more willing to take out life membership of clubs because it is cheaper. Scottish men keep their razor blades in use longer, Scottish women their bras. They don't like throwing things away. They buy things to last. As was revealed in a survey in 1991, the Scots decorate their own homes and make their own curtains much more than the English. The Scots prefer

16

continued on page 33

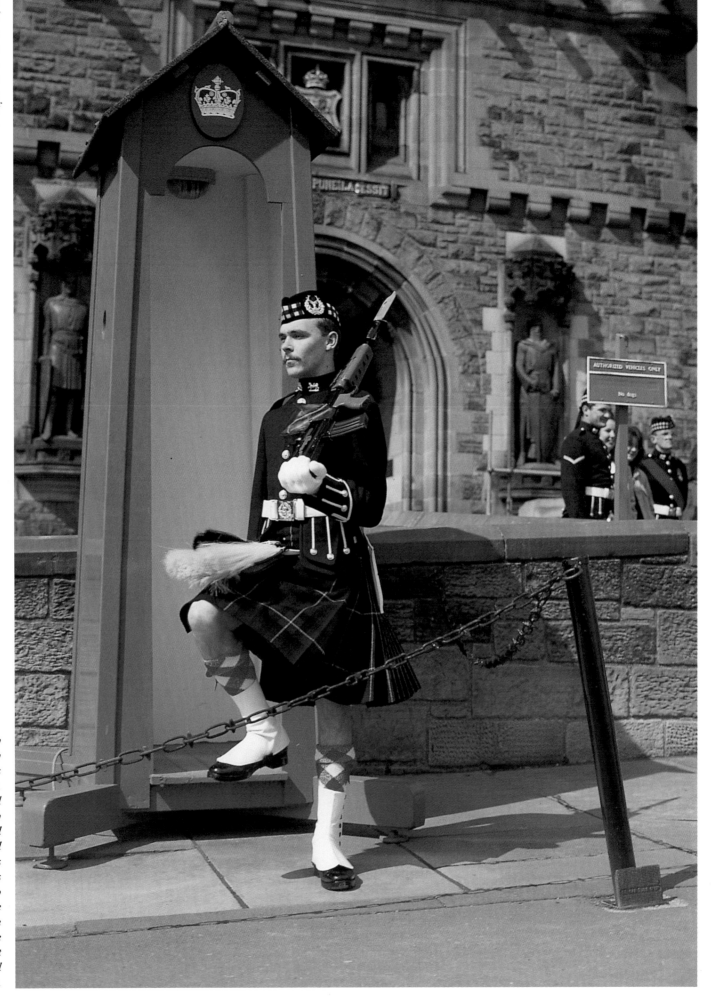

The sentry with tartan kilt and solemn expression is one of the attractions of Edinburgh Castle. It has over a million visitors every year; only the Tower of London has more.

Overleaf: The view from Edinburgh Castle across Princes St to the New Town. The district was laid out in the 18th century in the classical style of the period according to plans drawn up by James Craig, in order to relieve the severe shortage of space in the old town. The building on the right is the National Gallery.

17

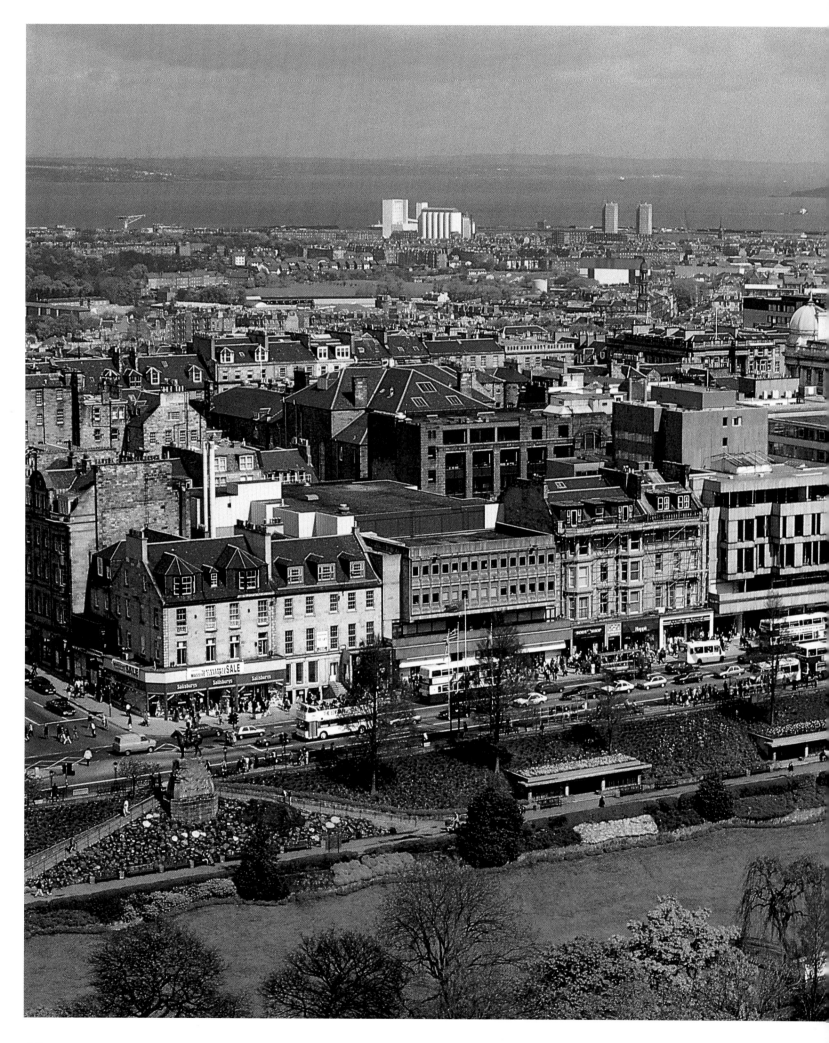

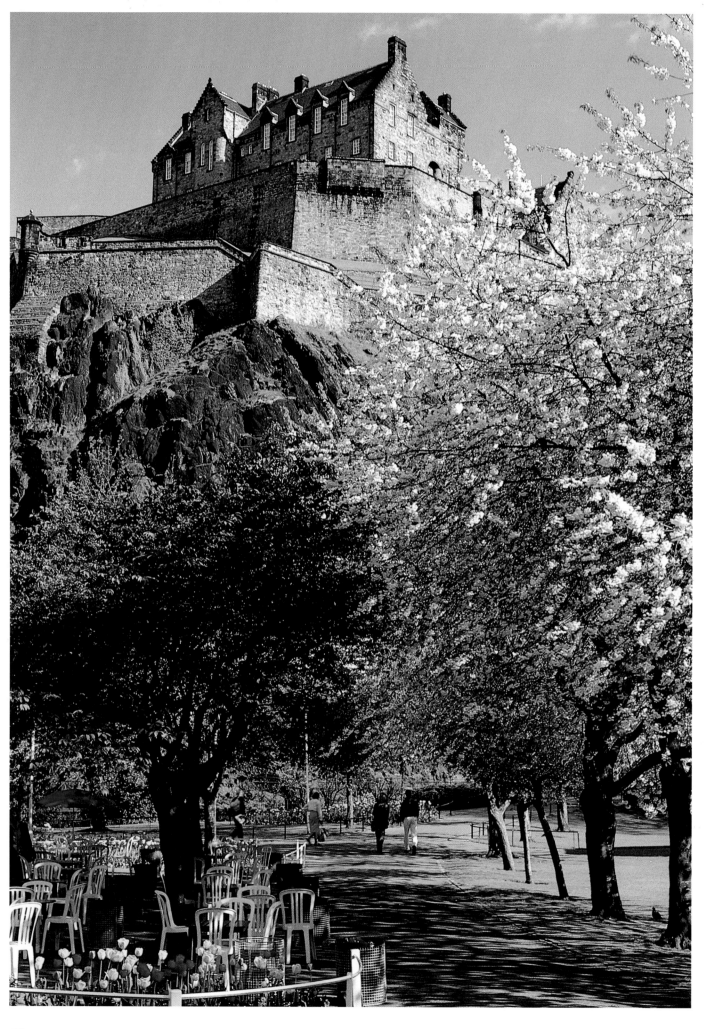

The park below Edinburgh Castle, perched on top of a 134m-high extinct volcano. The draining of the North Loch in the 19th century allowed the creation of Princes Street Gardens.

20

Since the 7th century the history of Edinburgh Castle has been marked by siege, destruction and reconstruction. Despite changes of ruler it has steadfastly remained the symbol of Scotland's unshakeable sense of nationhood.

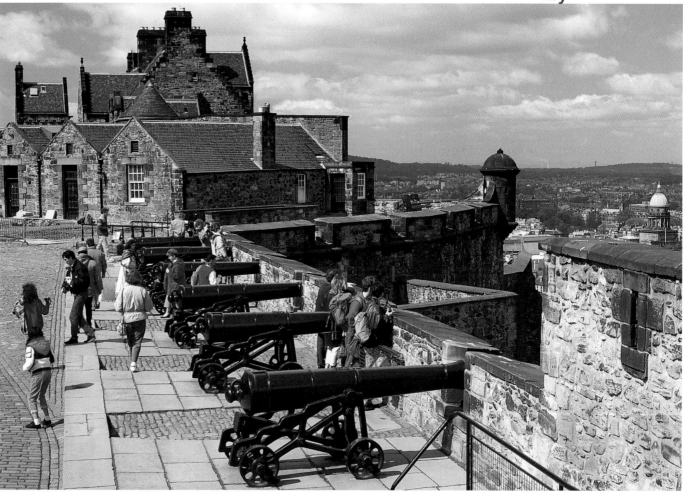

The North Barracks on Crown Square were transformed by the architect, Sir Robert Lorimer, into a Scottish National War Memorial (1924–27) with exhibits recalling Scottish battles and heroes.

Overleaf: The Palace of Holyroodhouse developed out of the guest house of Holyrood Abbey. It was given its present appearance in the 17th century, following plans by Sir William Bruce. It is considered the most important example of Palladian architecture in Scotland.

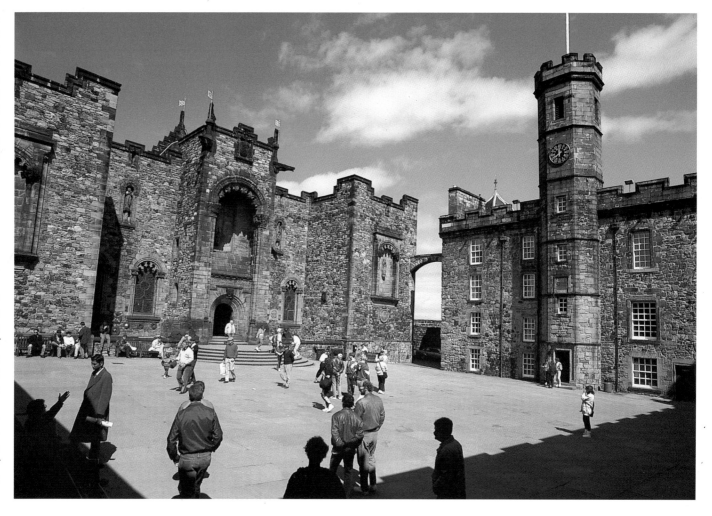

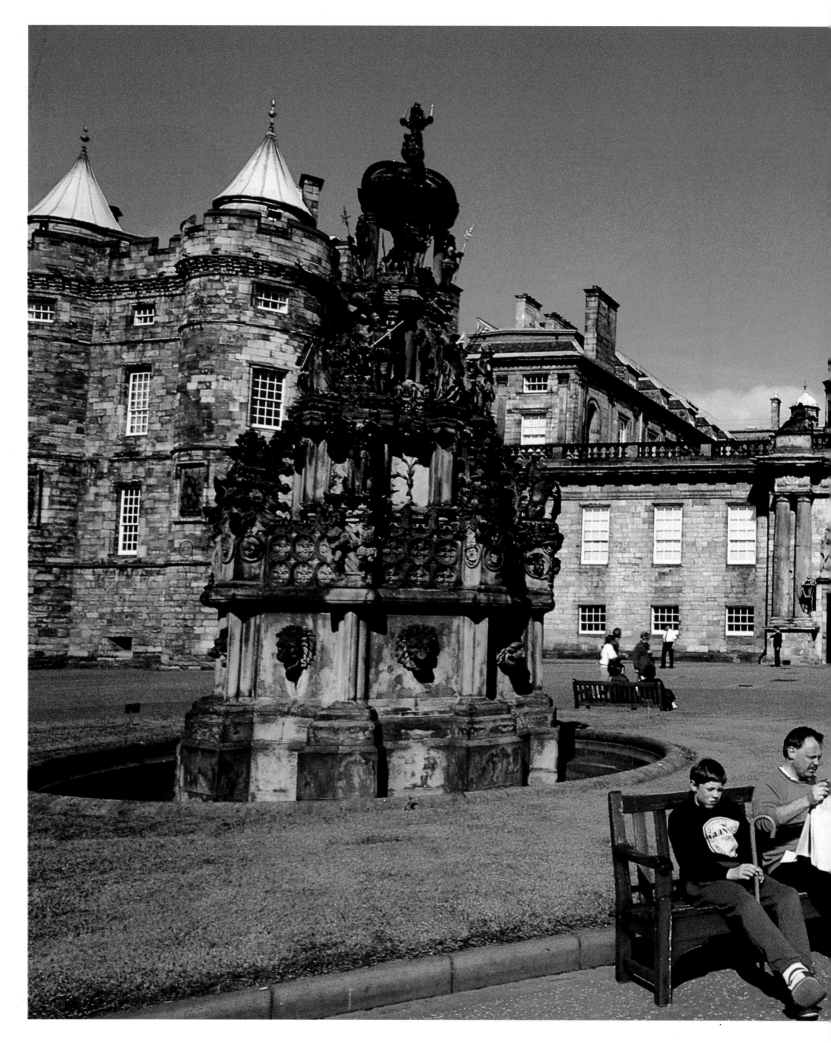

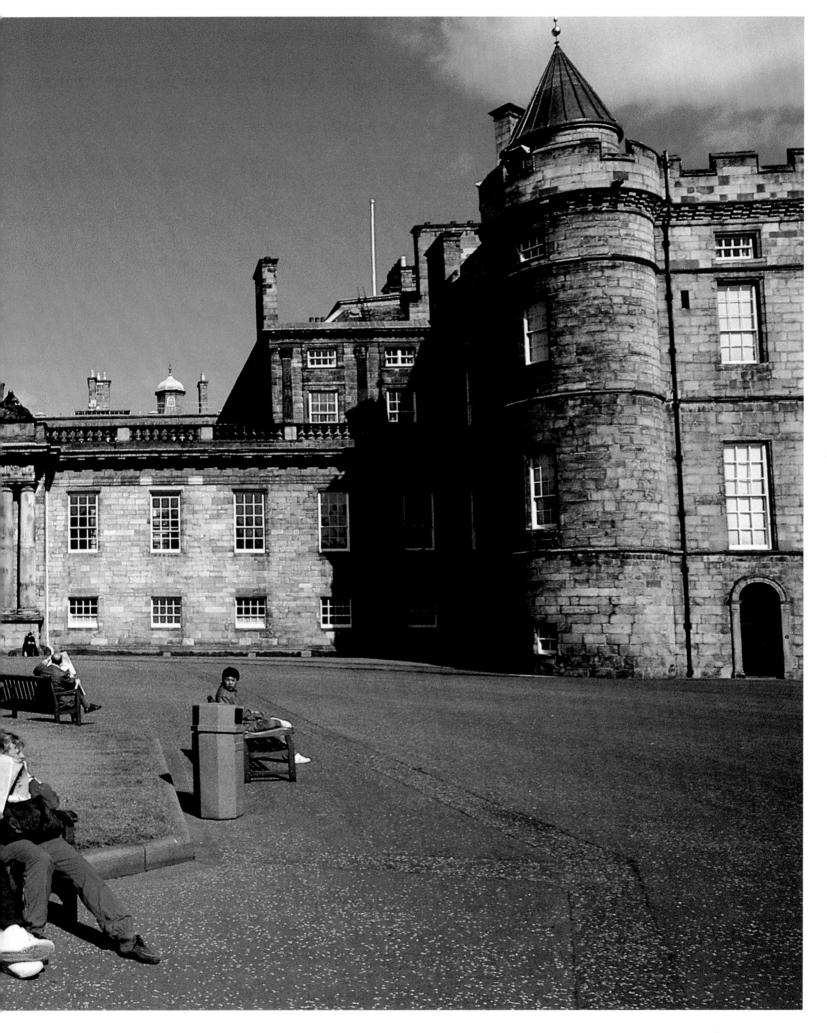

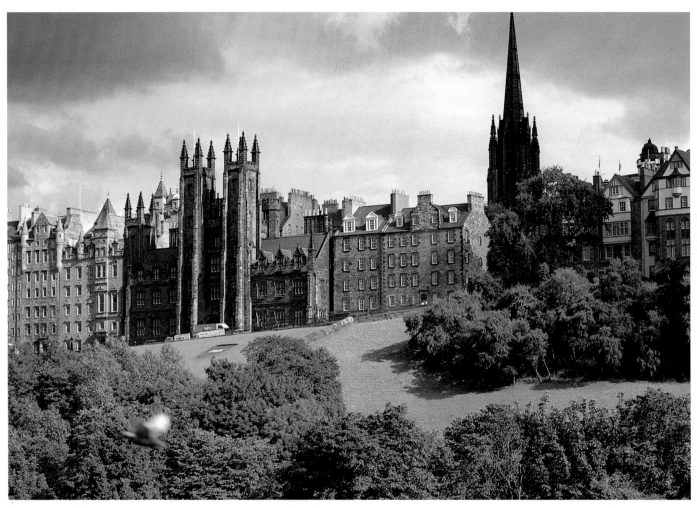

A row of houses in Market St, near to the castle. In the right background is the neo-Gothic spire of the Tolbooth Church, which is visible from many points in Edinburgh.

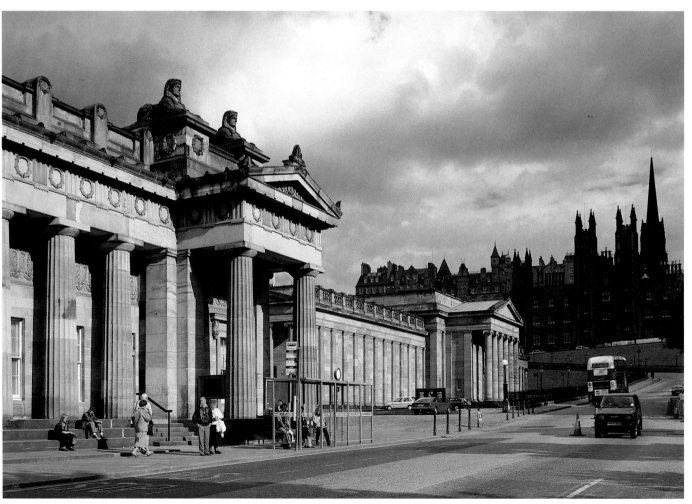

An expression of the enthusiasm for all things Greek that gripped Scotland around 1820, the Royal Scottish Academy in Princes St was built between 1823 and 1836 to plans by William Henry Playfair as a Doric temple. Today it is used to exhibit work by contemporary Scottish artists.

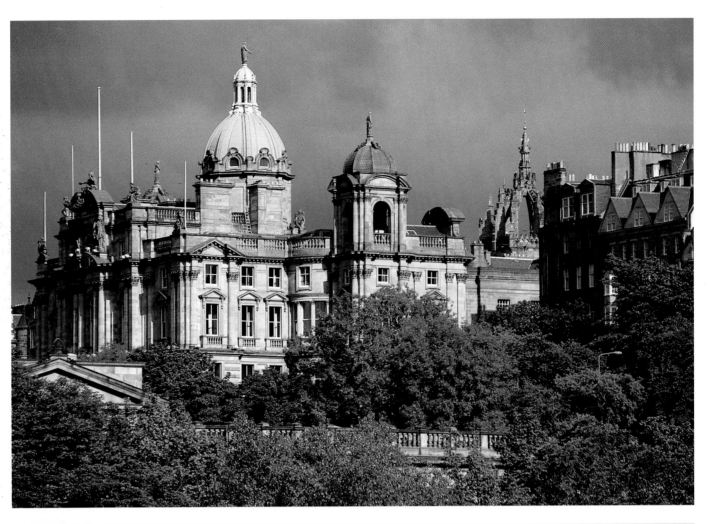

The proud facade of the headquarters of the Bank of Scotland seen from Princes St.

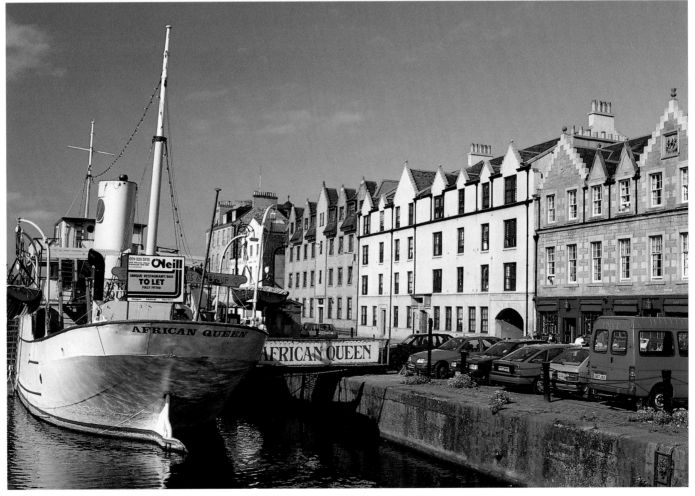

Once the busy port of Edinburgh, Leith now has the atmosphere of a sleepy fishing village.

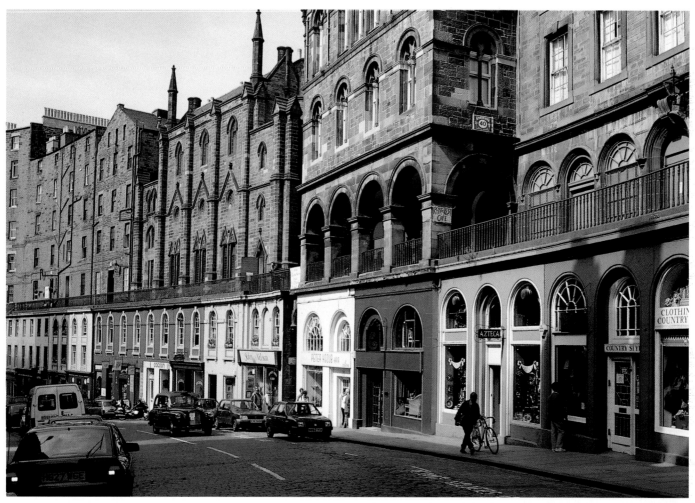

The Grassmarket is a mediaeval square with pubs, antique shops and a hostel for the homeless. In earlier times markets and executions were held here.

Portobello St (the street to the 'beautiful harbour') leads to the suburb of that name and its beaches. This and other foreign names were brought back to Edinburgh by seamen returning from their voyages.

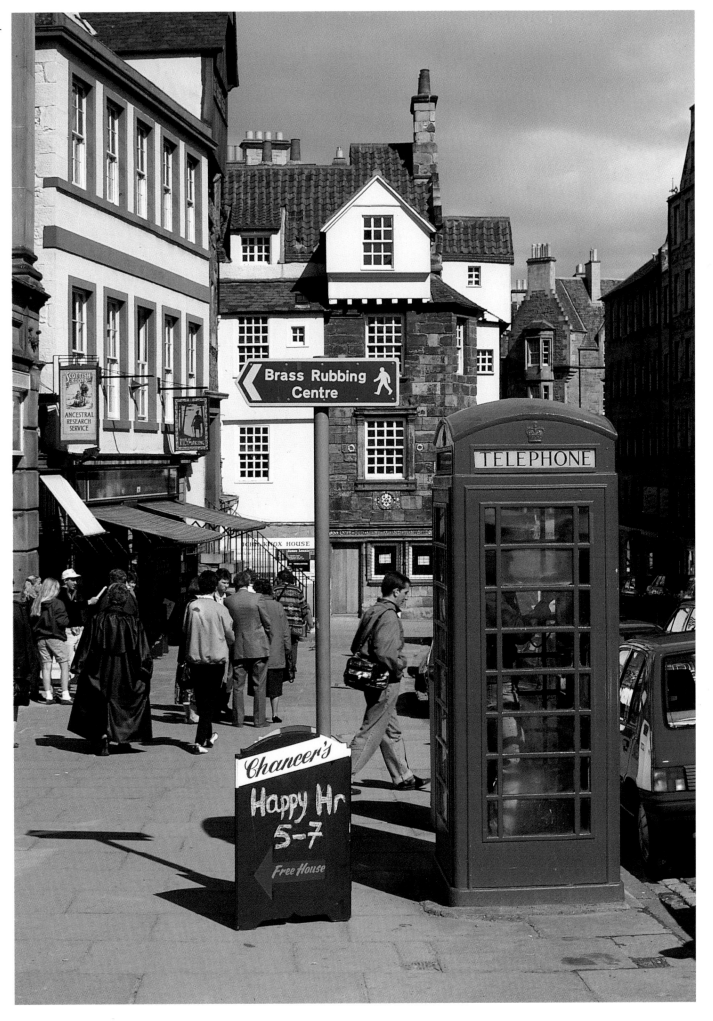

The Royal Mile in the old town is a maze of alleyways with buildings steeped in history such as the house of John Knox (middle background). Today it has many shops and pubs.

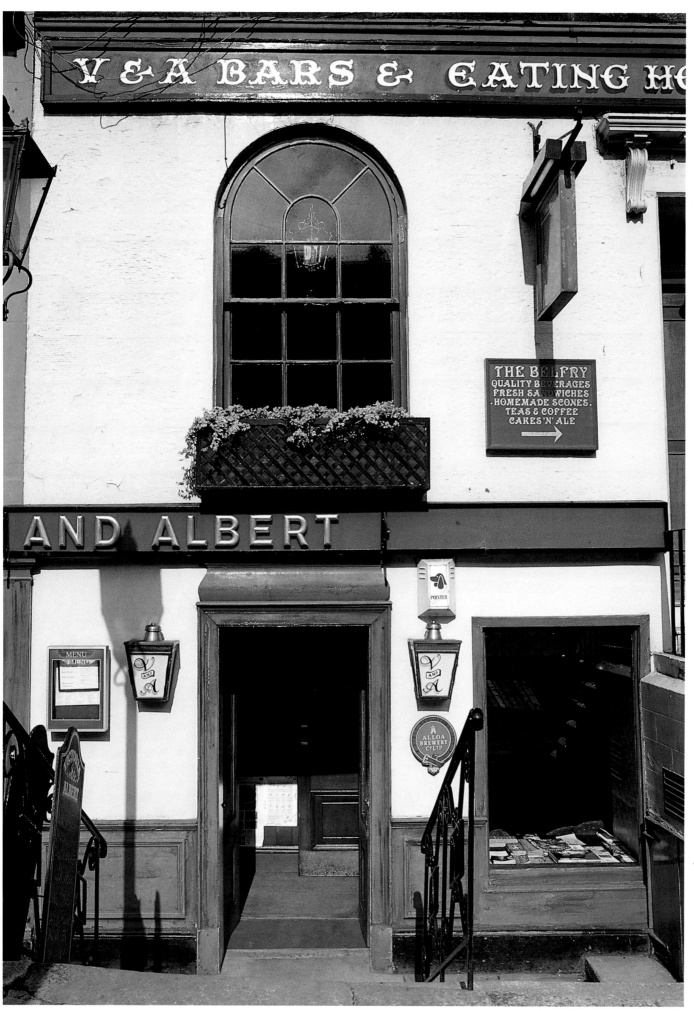

What would Scotland be without its pubs? Loved and patronised by locals and tourists alike, they are more than just a refuge from the notorious Edinburgh wind.

A white stag and famous former customers such as Burns and Wordsworth are the attraction of the White Hart Inn, while the Kenilworth, named after a novel by Sir Walter Scott, has a portrait of the author on its sign.

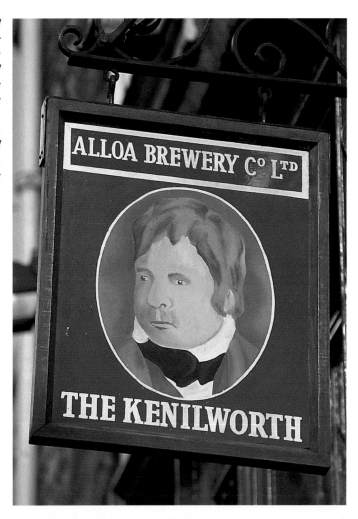

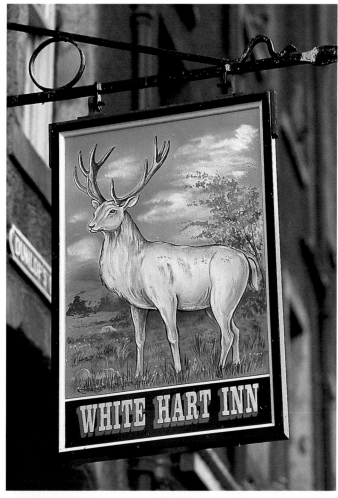

In contrast to the sparse furnishings of many pubs, especially outside the big cities, Edinburgh has a series of splendid drinking establishments. The Kenilworth bar stands in the middle of the room.

Overleaf: the Military Tattoo in the castle courtyard is one of the highlights of the annual Edinburgh International Festival.

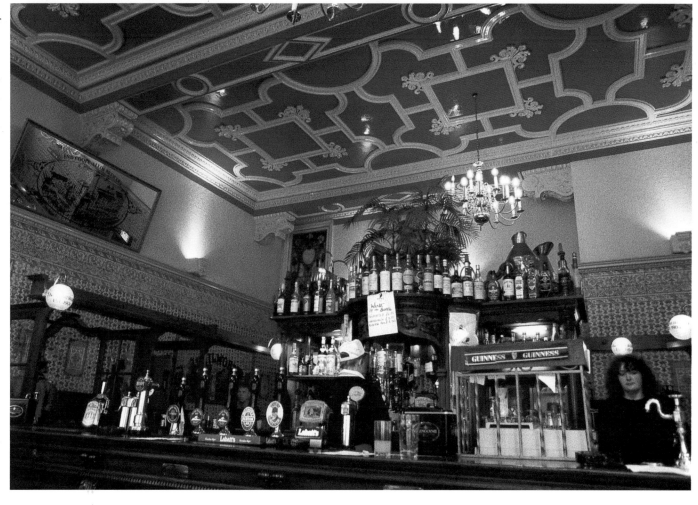

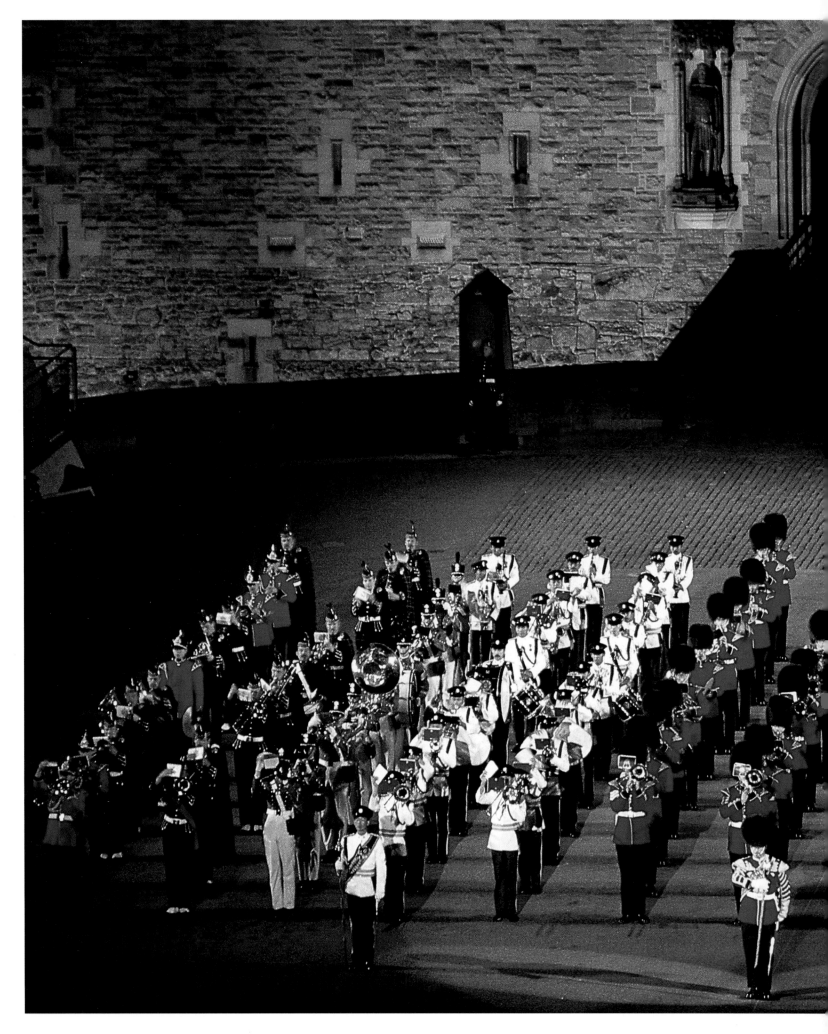

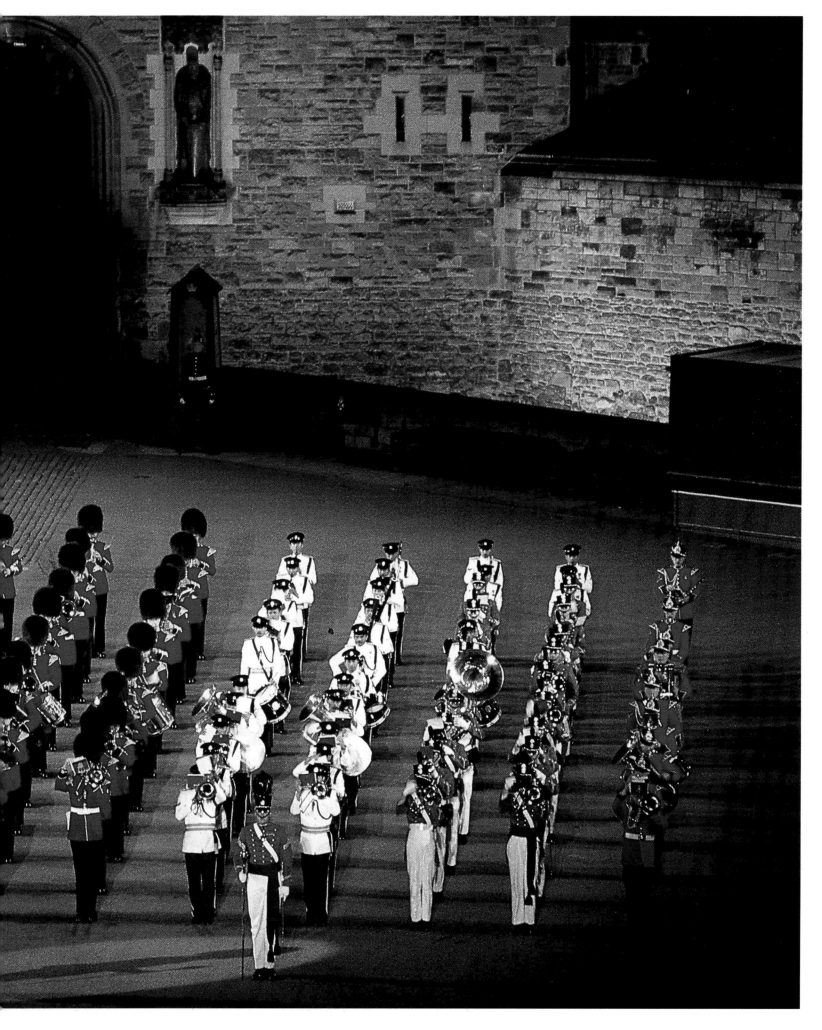

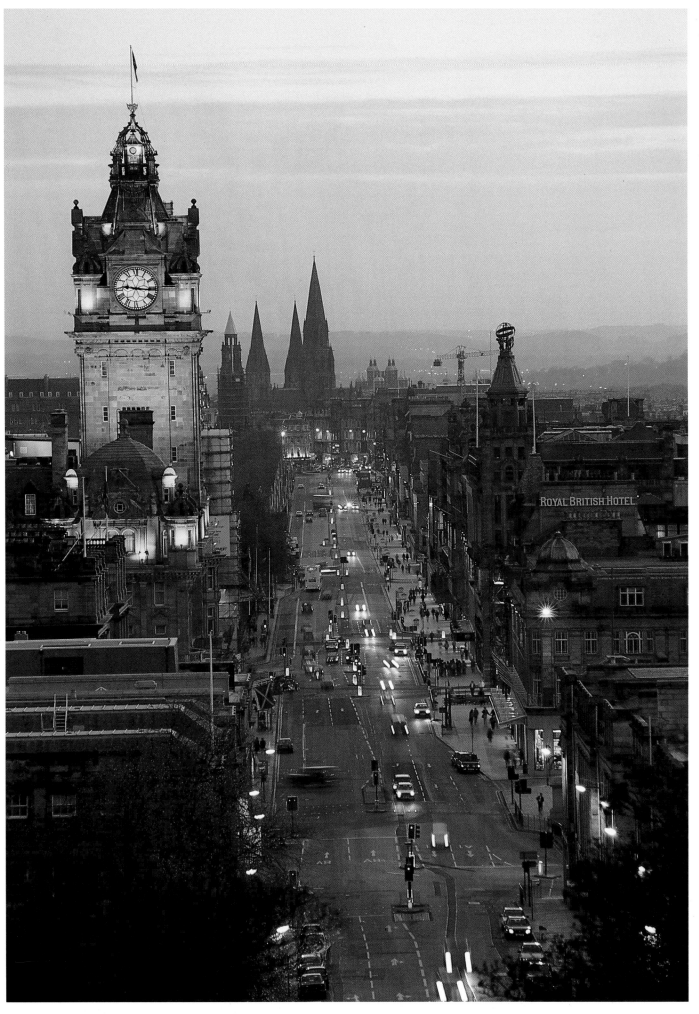

Princes St is one of the finest shopping streets in Edinburgh. One side is lined with busy shops while the other, largely free of buildings, has open views of the castle and old town. Left foreground: the clock tower of the North British Hotel.

to spend their holidays at home rather than abroad, also they eat more meat and fish than the rest of the British, drink less mineral water and are less interested in the environment. Even the number of suicides by turning on the gas is lower in Scotland than in England, presumably because it would put up the gas bill. According to statistics, the Scots prefer cheaper methods such as jumping out of the window or into water.

Doubtless in the past Scottish parsimony was a consequence of the poverty of the country, the poor Highland soil, the battle for existence in the Lowlands and the Borders. When King James VI moved his court to London, there were in his retinue many impoverished nobles who found it difficult to live the life they were accustomed to in the expensive metropolis. Their pride, combined with their poverty, made their thriftiness look ridiculous. Thus arose the myth (for that is what it is) of Scottish miserliness, which, despite the growing affluence which came in the wake of the industrial revolution, still refuses to die.

Loyal to the Stuarts

Twice, in 1715 and 1745, the peaceful development of Scotland was disturbed by uprisings of the Jacobites, as the supporters of the Stuarts were called after their King James (Latin *Jacobus*). The first of these, intended to stop the succession of the House of Hanover, was quickly over. With French assistance the son of James II, Prince James Francis Edward, known as the 'Old Pretender', arrived in Scone, the old Pictish capital, where many Scottish kings were crowned on the Stone of Destiny (long in Westminster Abbey but returned to Scotland in 1996) and proclaimed himself king; very soon after he was forced to flee back to France.

The '45 rebellion under his son, Prince Charles Edward Louis Philip Casimir Sylvester Stuart, was an equally pathetic failure, but turned into a romantic story, an indispensable element of Scottish mythology. More books have been written about the 18 months the prince, acclaimed by loyal Jacobites, spent on Scottish soil than on any other event in Scottish history. Beds where he slept and caves where he hid are still shown today, rings and locks of hair kept as mementos of 'Bonnie Prince Charlie'. Not that Charlie, with his long Stuart nose and the dark eyes of his mother, Maria Clementine Sobieski, was all that 'bonnie'.

In July 1745 two French frigates had set him and his companions down on the Hebridean island of Eriskay. But Louis XV, who had cynically encouraged Prince Charles to attempt to recapture the English crown, was not prepared to risk anything in the enterprise himself. Stuart kings were more useful to France as political pawns in exile than on the throne of Britain. Opinion in Scotland was divided. 'Go home, Your Majesty,' the chief of the Macdonald clan cried. 'I am come home,' replied the prince, then proceeded to proclaim his father, the Old Pretender, James III of England and James VIII of Scotland, and set off to gather his supporters. It was above all Catholics who rallied to his flag, a few Highland lairds followed by their clansmen. Soon his army, with which he marched south across the border into England, had swelled to 2500 men.

Initially the Hanoverian troops put up little resistance, but the cities that had declared themselves for Prince Charles were soon back in the hands of the English king. Charles's soldiers were useless, his officers argued amongst themselves and there was a lack of military planing and French assistance. The Hanoverian troops, reinforced with new German mercenaries and Scots, were soon on his trail. The Jacobites withdrew to the Highlands, and on 16 April 1746 came the decisive battle on Culloden Moor. It took only twenty minutes for the Duke of Cumberland, the third son of George II, to defeat the 3000 men of the Stuart army with their white cockades, who were brutally slaughtered. The prince, taken to safety by followers who remained loyal, hurried from

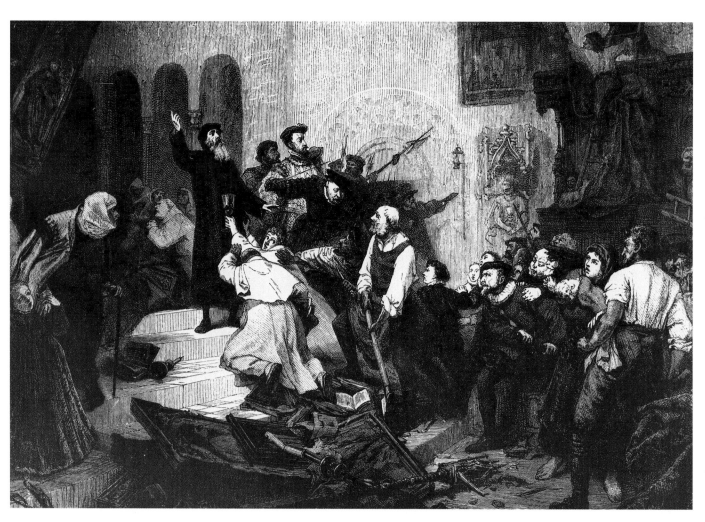

one hiding place to the next, from one carousal to the next – the campaign had given the prince a taste for things Scottish at least as far as whisky was concerned – finally returning to France to annoy Louis XV with his demands for an army to invade Britain. It was a heavy blow for Bonnie Prince Charlie when he learnt that his brother, his heir, had become a cardinal. He knew that Britain would never accept a king whose successor would be a Roman cardinal.

A land transformed

Prince Charles played out his royal role like a spoilt, capricious child, refusing to accept reality, to see either the traitors in his own immediate entourage or the sacrifices and desperate plight of those who had supported him in Scotland. One former follower later described him as cowardly, brutal, grasping, slovenly and lazy – 'he was no gentleman'. He would have been impossible on the English throne, would have restarted the wars of religion. It has been said of him that he was 'a Protestant in Rome and a papist in Britain', that is, always the wrong thing in the wrong place. It was his flight from his pursuers – no Scot betrayed him for the £30,000 that was on his head – that transformed him into a hero, his immortality guaranteed by a host of novels and all the melancholy Scottish songs such as 'Will ye no come back again', 'Speed, bonnie boat' or 'Charlie is my darling'. Edinburgh, on the other hand, which only a short time before had accorded the prince a rapturous welcome, made 'Butcher' Cumberland a freeman of the city and Glasgow University gave him an honorary doctorate. It was the end of loyalty to the Stuarts, though at the same time the beginning of the romantic legend.

'We Scots were always far more divided among ourselves than united against the English,' wrote the Scottish Labour member of parliament, Tam Dalyell. The history of

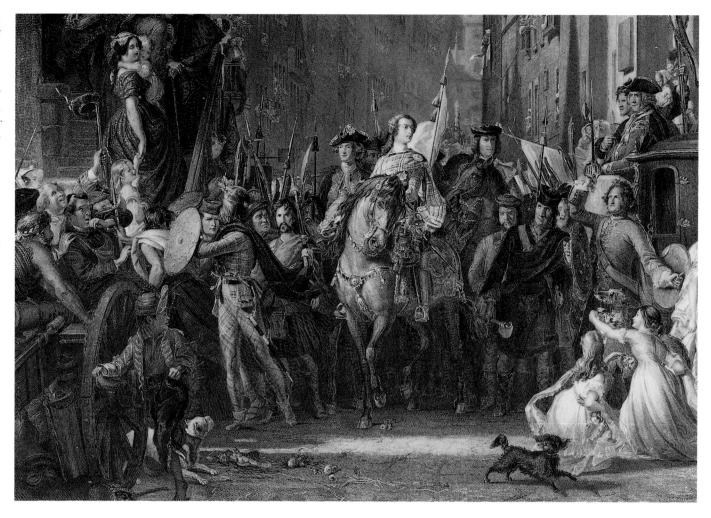

Scotland prior to the union of the two parliaments consists of a succession of acts of violence. Thus in about 1577 the Macleods attacked the Macdonalds on the island of Eigg, murdering 395 people who were hiding in a cave, while in 1691 the Campbells killed the Macdonalds in the massacre of Glencoe while the Scottish parliament looked on, powerless to intervene. Once, after a presumed insult, a clan chief of the Macdonalds invited a Macdonnell to dinner and surprised his guest by using the head of the Macdonnell's son as table decoration. It was only after the Union that Highlanders and Lowlanders began to regard each other as members of the same nation. Until then, for the Scots-speaking inhabitants of the Lowlands and the east coast, the Gaelic-speaking Highland Celts were barbarians. Now roads were built, the Highlands opened up to civilisation for the first time. 'As if by a miracle,' wrote the English historian, Hugh Trevor-Roper ironically, 'the character of the Highlanders also changed. In retrospect a lazy people and illiterate pack of thieves was transformed into a romantic and picturesque people.'

The 18th century was Scotland's 'Golden Age'. The Union with England of 1707, by which the Scottish and English parliaments were dissolved and replaced by a British one, worked to Scotland's advantage in every way, even though those who are fighting for her independence are unwilling to admit it. Whilst through it England secured her northern frontier, Scotland benefited from participation in England's worldwide trade and industry and shipbuilding blossomed. The burden of English taxation was offset by a period of internal security and stability such as the Scots had never known before. James Watt invented the steam engine, Thomas Telford built the Caledonian Canal, John McAdam developed the road surface named after him, Robert Adam built in Edinburgh the first 'new town' since the days of classical antiquity. From Edinburgh John Hume and Adam Smith influenced intellectual life throughout Europe. Back in the 17th century John Napier had developed logarithmic tables and in the 19th and

20th centuries Scots led the way in science through the introduction of chloroform as an anaesthetic (Sir James Simpson), the discovery of penicillin (Sir Alexander Fleming) and the invention of the telephone (Alexander Graham Bell). Charles Darwin read his first scientific paper in Edinburgh and many of the great minds of the age taught at the university there.

Scotland discovered by the Romantics

The poet James Macpherson (1736–96) published a heroic epic consisting of poems supposedly from the early Gaelic period, which he claimed to have collected in the Highlands and translated himself. The general opinion today is that the work is basically a forgery, alien to older Gaelic literature in both spirit and rhythm. But it was precisely this Romantic sound and the sentimental atmosphere of a primaeval age lost in the mists of time that delighted Macpherson's contemporaries and made his *Poems of Ossian* – Ossian was a legendary hero and bard, son of Fingal, who was supposed to have lived in the 3rd century AD – one of the most influential works of European Romanticism. They were particularly important for the German writers Herder and Goethe. Macpherson's real sources of inspiration, however, were the English Bible, Milton's poetry and the mournful tones of Scottish preachers from the Highlands.

Ossian is set in a melancholy landscape vaguely reminiscent of the Scottish Highlands, where noble-minded children of nature who speak in elevated diction, corresponding to the theories of Rousseau and the Encyclopaedists, perform heroic deeds. At the same time these figures were flattering to national pride, since the discovery of a great Gaelic epic could only strengthen the Scottish claim on the ancient legends, whose origins, however, probably lie in Ireland. There is a certain irony in the fact that enthusiasm for *Ossian* completely eclipsed the work of contemporary writers who at the time were investigating the sources of the Gaelic still spoken in the Highlands. It is quite likely it was they who made possible Macpherson's success, for which he was even honoured with a tomb in Westminster Abbey.

However, the true father of the new image of Scotland was the writer Sir Walter Scott (1771–1832). It was he who brought about a veritable revolution in the attitude of his generation to their Scottish homeland and history. Even today he is to be seen in Princes Street Gardens at the foot of Edinburgh Castle, a statue seated beneath a canopy of stone, looking as if he were sad that the world no longer takes any notice of him. His novels and volumes of verse gather dust on the shelves of the second-hand bookshops, yet once he was considered one of the greatest best-seller authors of all time. Abbotsford House, where he lived, remains a popular tourist attraction to this day.

Scott was born in the Border country of the Tweed and the Cheviots, which he described in countless ballads and novels. His background was modest. As a boy he spent whole days at his grandfather's farm, went into the hills with the shepherds, observed sheep, kestrels, plovers. Once a thunderstorm broke out and his aunt went to look for him. She found the little boy lying on his back in the heather. As the lightning flashed across the sky he clapped his hands, crying 'Bonnie! Bonnie!' This enthusiasm, characteristic of the times, for the wilder aspects of nature was something which he retained later in life and which helped him fire the imagination of his generation. Scott's first major work *Minstrelsy of the Scottish Border*, a collection of old Scottish ballads, was an immediate and resounding success.

For his next manuscript his English publisher, Constable, paid him an advance of £1000, an enormous sum for those days, without having read a single line. This was the romantic and patriotic epic of faithless Lord Marmion and Lady Clare set against the background of the gloomily grandiose landscape of Northumberland and the convent of Lindisfarne on Holy Island at the time of the Reformation under Henry VIII. Even more sensational was the success of his verse narrative *The Lady of the Lake* (1810). On

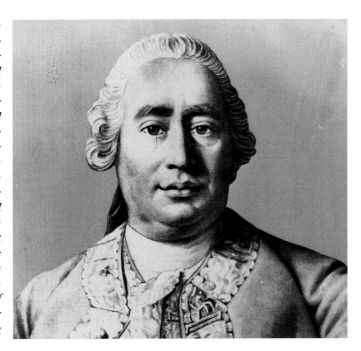

Well-known figures from Scotland. Top left: the philosopher and historian David Hume (1711–76); top right: Alexander Graham Bell (1847–1922), the inventor of the modern telephone; middle left: Adam Smith (1723–90), the founder of classical economics; bottom left: James Watt (1736–1819), the inventor of the steam engine; bottom right: the discoverer of penicillin, Sir Alexander Fleming (1881–1955).

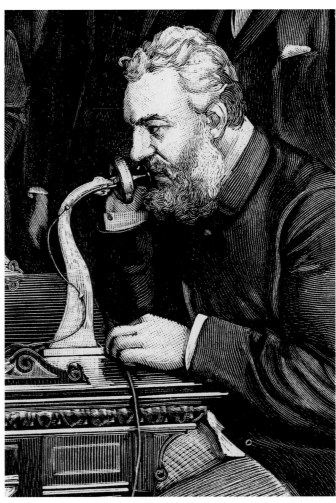

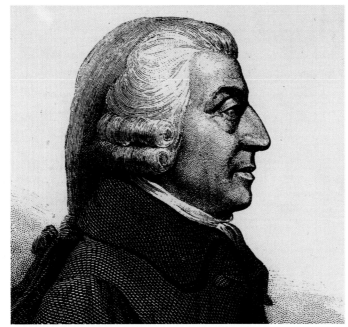

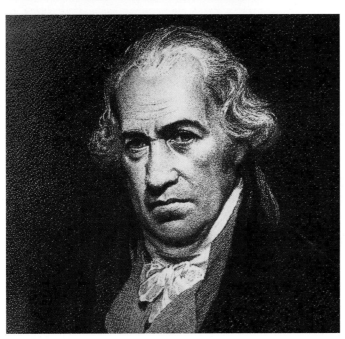

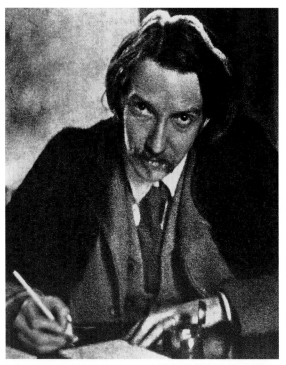

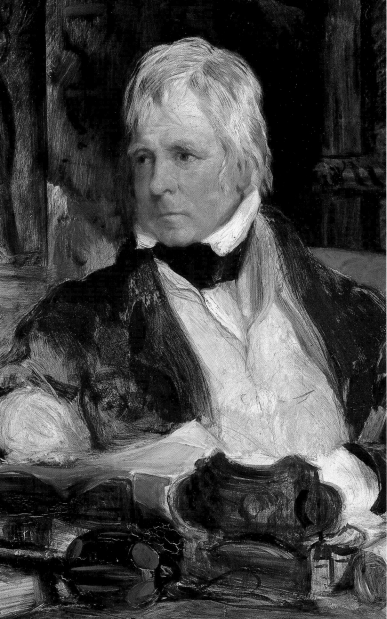

Writers from Scotland, known throughout the world. Top left: Robert Louis Stevenson (1850–94), author of Treasure Island; middle left: the author of essays on history and culture, Thomas Carlyle (1795–1881); top right: Sir Walter Scott (1771–1832); bottom right: Robert Burns (1759–96); bottom left: Burns's birthplace in Alloway.

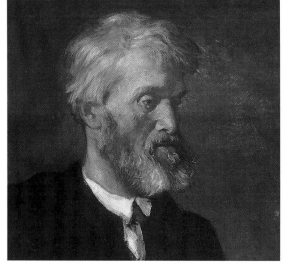

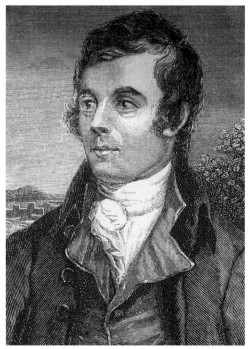

In the 19th century Scotland's romantic scenery was a popular subject for artists. This picture by George Vicat Cole (1833–93) can be seen in the Gavin Graham Gallery in London.

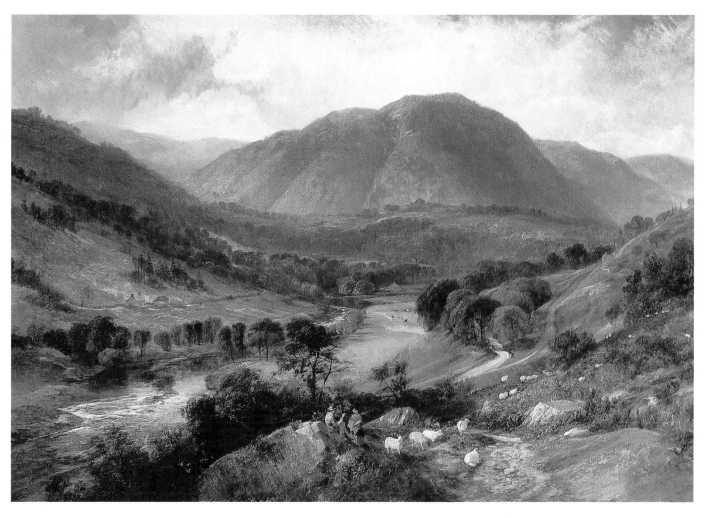

an island in Loch Katrine live Ellen and her father, William Douglas, who has been banished by the king, James V, but is protected by the Macgregors. The poem describes the meeting of the king, who has lost his way while hunting, with fair Ellen, and his fight with Roderick Dhu, the chief of the robber Macgregor clan, who turns out to be nobler than he has been painted.

With book in hand, the whole world set off on foot and on horseback to follow the trail of the heroes and heroine by Loch Katrine and in the glens and gorges of Macgregor country. A hotel was built nearby. In *Beyond the Tweed* the great German novelist, Theodor Fontane, who made an excursion to the area in the course of a journey through Scotland in 1858, noted how visitors saw the landscape not as it was, but through the eyes of Sir Walter Scott: 'One can certainly call the the Trossachs a high point, but their beauties have been a little exaggerated, if not simply for the profit of a few hotel owners, then at least out of understandable enthusiasm for the poet who described the area. The error people fall into is to confuse the description with the thing described, to transfer the excellence of the former to the latter.'

The Scott pilgrimages, which, like Theodor Fontane, many of the important literary figures of the 19th century undertook, presaged the beginning of modern tourism with its Bed and Breakfasts and crowded camping sites. Prior to Scott no one had thought Scotland any more worth a visit than they would have gone to Italy to lie on the beach. Samuel Johnson, who travelled through the Highlands in 1757 with his biographer, James Boswell, complained that Scottish country roads had little in the way of distraction to offer the traveller since he hardly met, or was overtaken by anyone. Jane Austen, Dickens, Tennyson, Pitt the Younger, the Duke of Wellington, Gladstone were all Scott fans. Goethe regarded him highly – he had translated his early drama, *Götz von Berlichingen*, into English; Tieck, Hauff, Gogol, Balzac were all influenced by him; Donizetti wrote an opera on his *Bride of Lammermuir*. But surely the highest

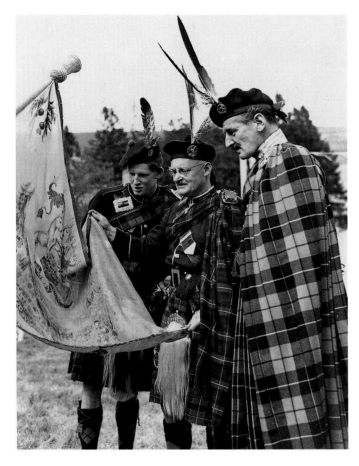

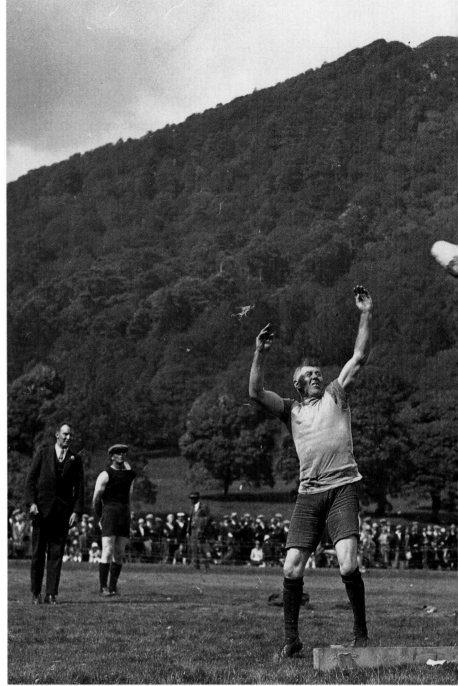

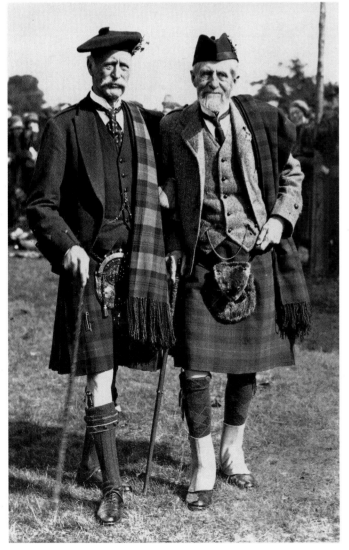

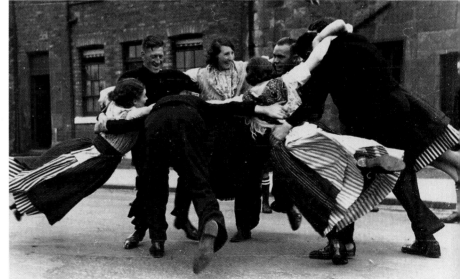

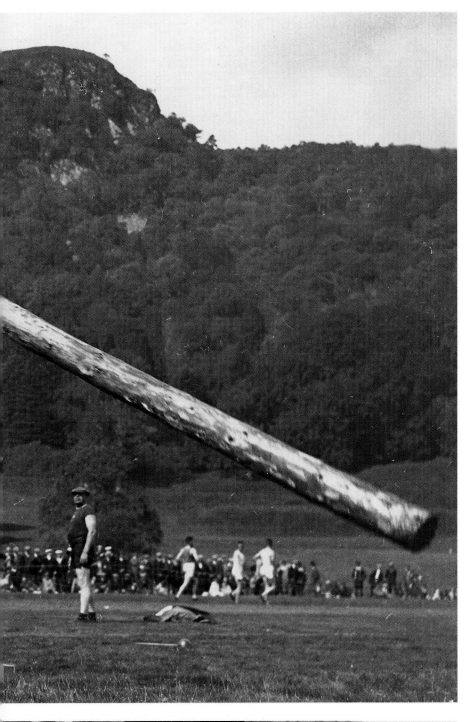

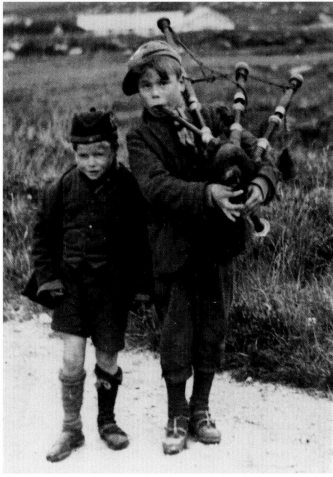

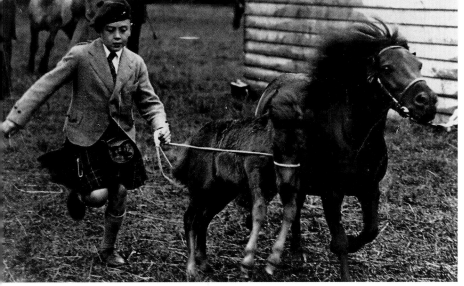

Top left: admiring the flag, over a hundred years old, at a gathering of Clan Lonach; bottom left: two Scots display their Highland dress (1933); top middle: tossing the caber at the Highland games in Inveraray; the important thing is to throw the tree trunk, up to 7m long, so that it turns over in the air; bottom middle left: dancing in the street in a coastal village to celebrate the end of the fishing season (1936); bottom middle right: boy with Shetland pony (1930); top right: wedding ceremony in Gretna Green; bottom right: brothers with bagpipes (1930).

recognition of his achievements came from the young Queen Victoria and her Prince Consort, Albert, who turned Scotland into a fashionable tourist destination. Victoria went into raptures over Edinburgh, visited Loch Katrine and followed Scott's advice to see Melrose Abbey by moonlight. In her diary the queen wrote of the 'solitude, Romanticism and wild beauty of the proudest, most magnificent landscape in the world', which she even preferred to her beloved Swiss Alps. For a mere £10,000 Prince Albert purchased Balmoral, which remains to this day the summer holiday residence of the royal family.

Scott, however, with his elaborate descriptions of nature and re-creations of historical scenes, is less accessible to the modern reader than Robert Burns (1759–96), despite the difficulty of his dialect verse for non-Scots. A farmer's son from Ayrshire, he was the poet of human freedom and dignity, such as was idealised in the French and American Revolutions. He only lived to be thirty-seven. He resisted the temptation succumbed to by other writers who employed their local dialect and avoided the excesses of sentimentality, nature mysticism and world-weariness. The young poet with the well-thumbed book in his pocket describes the mouse disturbed by his ploughshare with the realism of a country-dweller and sees the mouse's lot as part of a common destiny uniting 'mice and men', one person and others, mankind and nature, joy and sorrow. Burns loved life and, with all his Marys and Bessys, indulged in the 'delightful passion' which found expression in his many legitimate and illegitimate children, drew down on him the condemnation of strict Calvinist ministers and drove some girls to suicide. In his satirical poems he castigated hypocrisy both religious and secular, narrow-mindedness and duplicity. Under the influence of the ideas of his time he preached a Biblical Christianity with goodness and humanity as its central guiding principles.

Paradoxically, the old Soviet Union elected him one of its prophets. Visitors from Iron Curtain countries used to follow up their pilgrimage to the grave of Karl Marx in

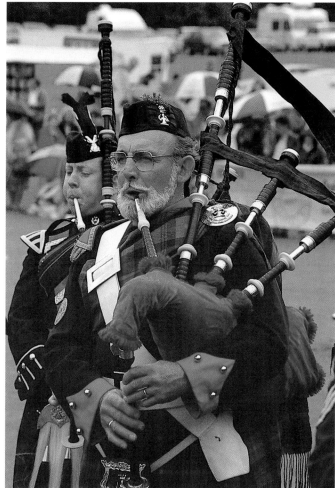

Right: two of the fourteen pipers of the Atholl Highlanders in their traditional uniform. Their grand parade is held at Blair Castle on the last Sunday in May.

London with a visit to the labourer's cottage in Alloway where Burns was born. That despite the fact that Burns was the archetypal Scottish democrat, who valued freedom and human dignity above all else. Although he suffered great poverty and social injustice and supported Tom Paine's 'rights of man', he can scarcely be acclaimed as a precursor of communist ideas.

It is not without irony that the poet who celebrated whisky and fought against its taxation was later made an excise officer whose duties included watching for illegal stills and smugglers. He would turn in his grave if he knew that today the British state levies an 85 percent tax on his 'Scotch drink'. Every year on 25 January Scots throughout the world celebrate his birthday with a Burns supper. The three obligatory highlights are the entry of the haggis, the 'Great Chieftain o' the Puddin-race', accompanied by a bagpiper, a speech to the 'immortal memory', wittily serious or stupefyingly boring, depending on the speaker, and the solemn uniting of hearts, hands and voices in 'Auld lang syne', written by Burns. As with Scott, there is a not inconsiderable amount of tourist industry associated with him. Unfortunately, poor Rabbie Burns is also the source of the image of the Scots as amusing but bibulous types.

Dr. Jekyll and Mr. Hyde

The two sides of Scotland are often expressed in the two neighbouring cities, Glasgow and Edinburgh. Edinburgh is Scotland's 'Dr. Jekyll', the capital, the seat of the important institutions, the financial centre, the city of doctors and lawyers, the 'Athens of the North': in part an elegant product of the 18th century on which the genius of Robert Adam, the architect who transformed the prevailing Palladian style, has left its mark. The capital is built on a generous scale, refined, superior, aristocratic, class-conscious, famous for its pianos, overcoats, fish and chips and the yearly festival which

has been bringing in visitors from all over the world for well over fifty years. It also brings in money, even if the city fathers have for years been wriggling out of spending it on the opera house that is so urgently needed. The result is that outside the festival season the good citizens of Edinburgh go to the excellent Scottish Opera in Glasgow. Conversely, many a Glasgow businessman goes back home to Edinburgh at the end of the working day because he finds life pleasanter there. You can recognise someone from Edinburgh, they say, by the way they hold onto their hats when they go round a corner. There is always a chilly and blustery east wind blowing in Edinburgh.

Glasgow, on the other hand, is – at least according to the snooty inhabitants of the capital – permanently cloaked in mist and rain. Even Glaswegians have been known to say of their city, 'It's a great place to get out of.' They mean it, however, in a double sense; on the positive side, one can reach Loch Lomond and the Highlands very quickly from the city. For a long time Glasgow embodied the 'Mr. Hyde' of Scotland: the city of crime and alcoholism, the worst slums in Europe, closed factories and urban decay. In something approaching a miracle, all this has been done away with in recent years. An important role in this was played by the 1988 Garden Festival beside the Clyde, where in 1914 a third of all merchant ships in the world were still built. In preparation, the whole area was razed to the ground. Then in 1990 Glasgow was named Cultural Capital of Europe. The city had always possessed a vigorous cultural life of its own, independent of Edinburgh, but this was the external stimulus needed to help rouse people from their typical British lethargy. The first thing that had to be done was to liberate the spirit of enterprise, which had for too long been shackled by the prevailing political outlook. Glasgow said goodbye to its old attitudes, its obsessive image of itself as the city of shipping, shipbuilding, steelworks and heavy industry, as well as to the spirit of the Victorian British Empire, which persisted longer in Glasgow than elsewhere. New industries sprang up, industries based on modern technology which were scarcely any different from their continental competitors.

Sometimes the farewell to the past has been quite drastic: parts of a rather pleasant district around Charing Cross simply disappeared, an old Presbyterian church was turned into a disco with the frivolous name of 'Cardinal's Folly'; now the restored tenements and tastefully converted warehouses in the city centre house owner-occupiers, a social class previously virtually unknown in that bastion of council houses and rented apartments. Home-ownership in Scotland has now broken through the 50-percent barrier and is gradually coming closer to the higher rate of the rest of Britain. The sale of council houses to sitting tenants, begun under the Conservatives, has become extremely popular. The worst of urban decay in the form of modern multi-storey blocks, has at least been pushed out to the periphery and alcoholism is on the decline, but gangs and crime are still a considerable problem and 50 percent of the children leave school without qualifications. Despite this, there is no doubt that the 21st century has arrived in Glasgow. Hard-working Jewish and Italian immigrants, a high percentage of Indians and Pakistanis from the Commonwealth countries and East Africa with their entrepreneurial spirit, and blacks (relatively few) from the Caribbean have all contributed to Glasgow's progress, of which the golden domes of a mosque among forlorn-looking Victorian church spires are truly symbolic.

As the multicultural structure of Glasgow indicates, social distinctions go unrecognised there. 'Have ye got the time oan ye, mac?' you will be asked in the street. The warmth of the Glaswegians does your heart good, if you're prepared to respond and don't treat them condescendingly. 'Don't order the soup,' said one blonde, motherly waitress, 'it tastes awful.' And when she brought the teapot, 'Watch out, it's got a leak. I've put it on a plate. The skinflints here just refuse to buy a new one.'

Glasgow, Britain's third-largest city, is bubbling over with life: there is the port, from which Scots sailed all over the world; there is the national football stadium, Hampden Park, which has larger and more passionate crowds than anywhere else in Britain; and

continued on page 53

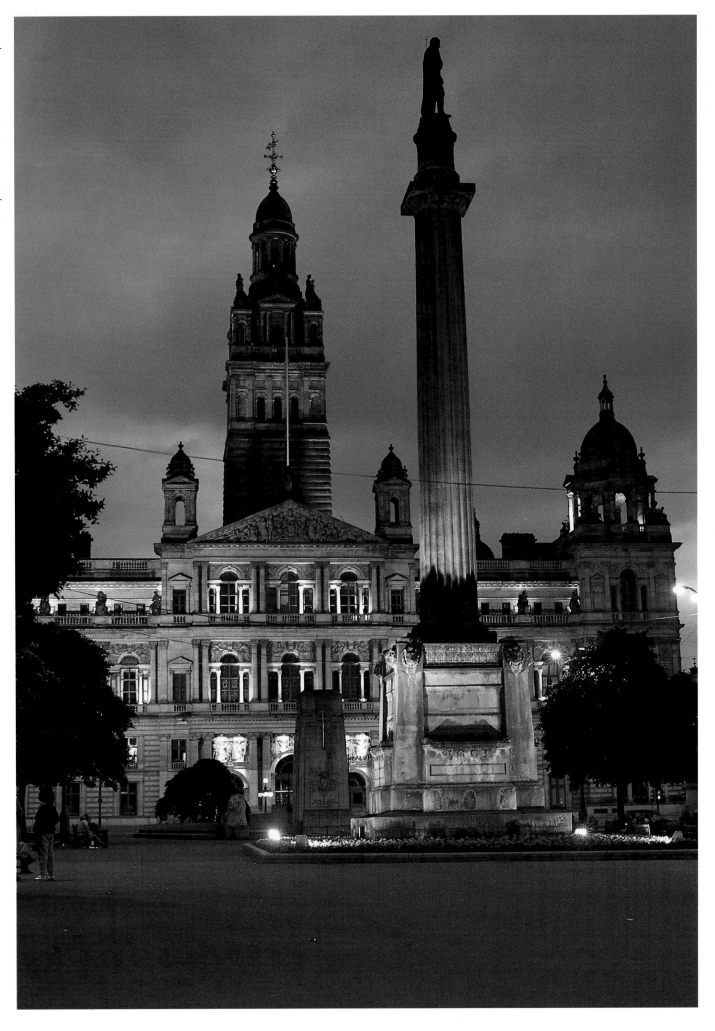

High on his pillar, Sir Walter Scott looks down on the statues of many other famous Scots in George Square in Glasgow. He created the genre of the historical novel and turned Scotland into a tourist destination. In the background is the imposing façade of City Hall (1883–88).

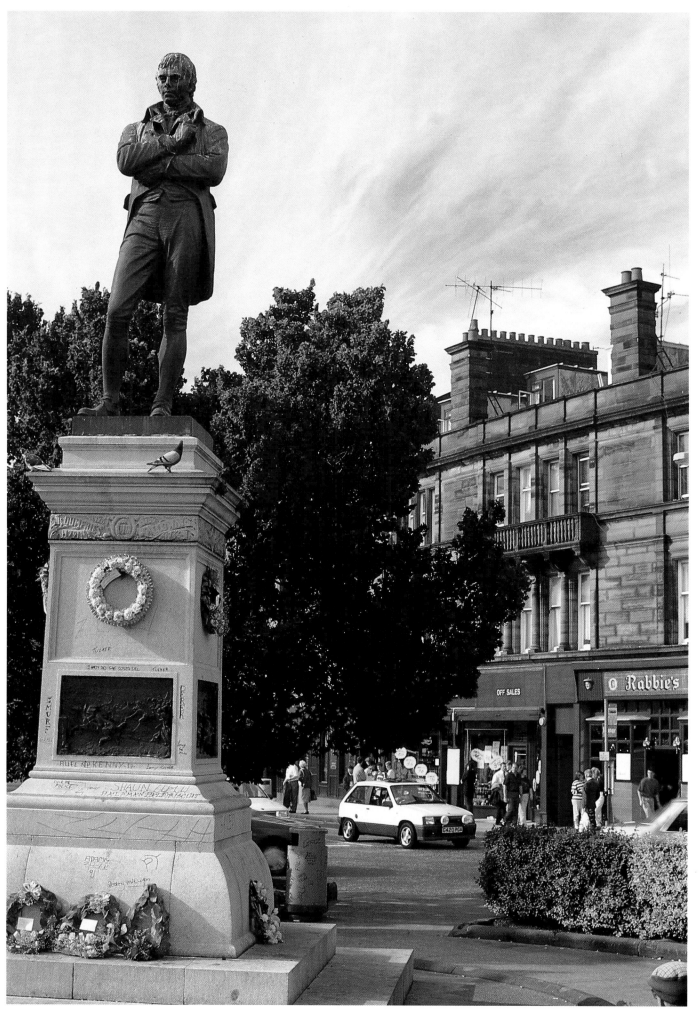

The visitor will come across Robert Burns in other places as well as Ayr. There are many museums and memorials to his life and works. His birthday, 25 January, is celebrated by all Scots with haggis and whisky.

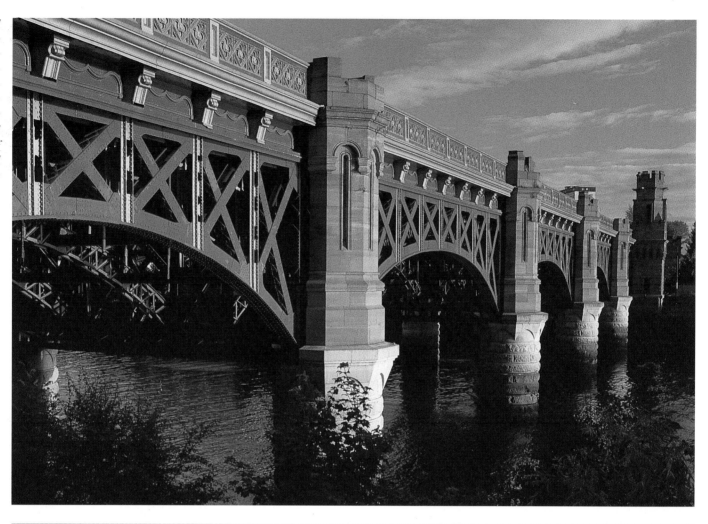

The deepening and straightening of the Clyde under the direction of James Smeaton and James Watt (starting 1768) was an important factor in the rapid industrialisation of Glasgow. Wood, coal and iron were transported on it to the factories.

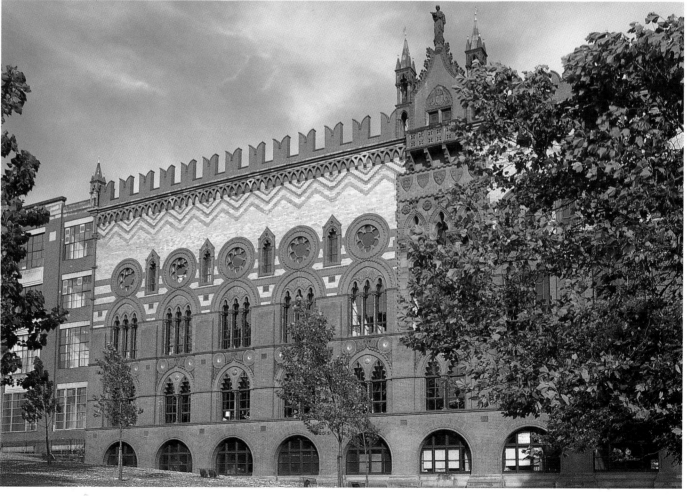

'What do you think is the most beautiful building in the world?' – 'The Doge's Palace in Venice.' – 'Then build it here.' With those words the Glasgow carpet manufacturer, William Templeton, is said to have commissioned this eccentric factory from the architect William Leiper; it was completed in 1889.

Overleaf: the Queen's View above Loch Tummel (Perth and Kinross). When she saw it, Mary Stuart is said to have asked her harpist to compose a song in memory of it.

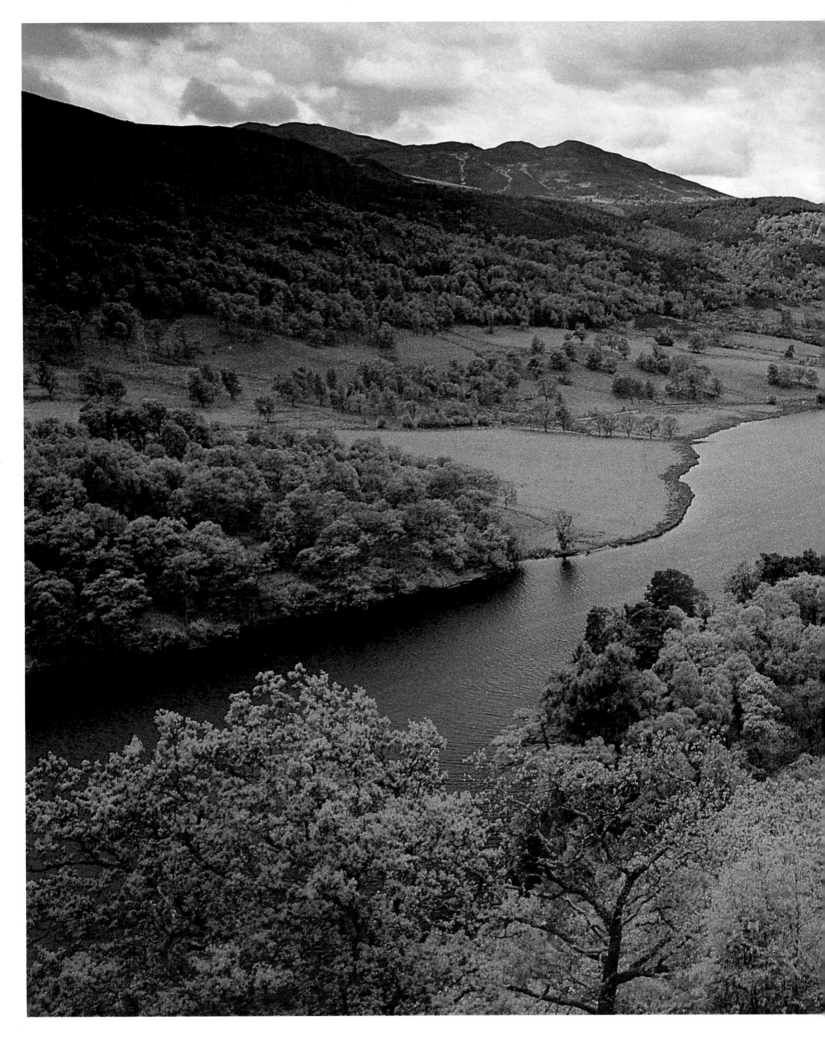

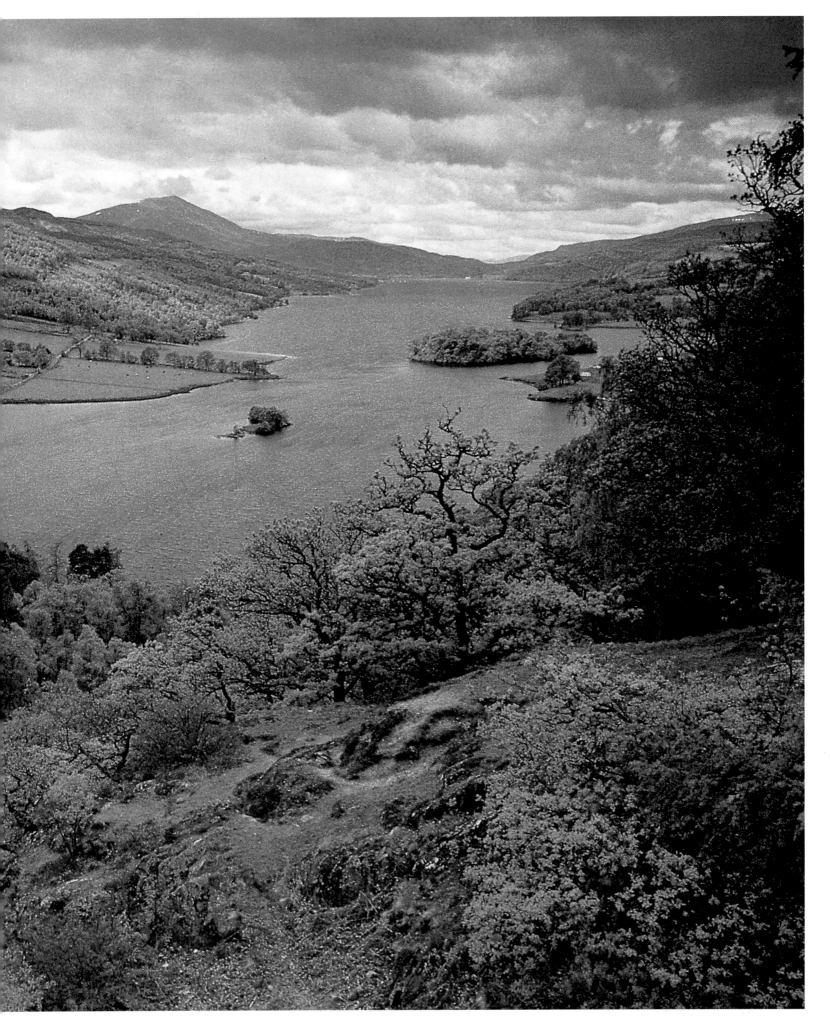

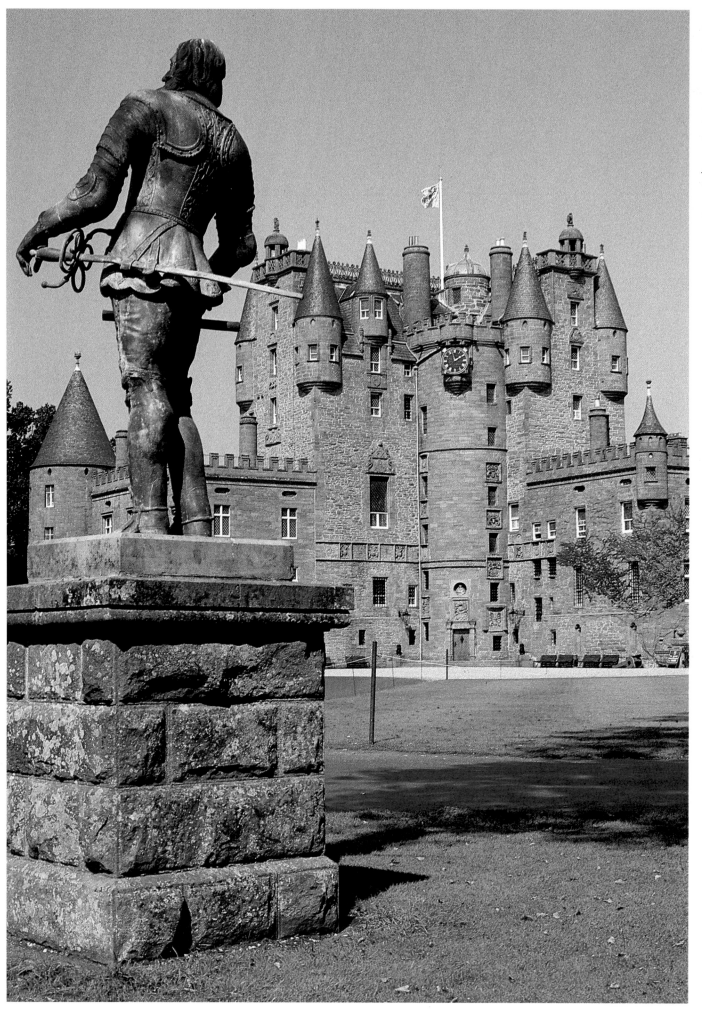

Glamis Castle, north of Dundee, seems to have everything a Scottish castle ought to have: lots of turrets and towers, magnificent rooms, a well-tended park and an eventful history. The main parts of the former hunting lodge of the Earls of Strathmore go back to the 17th century.

Culross in Fife enchants the visitor with its many buildings from the 16th to 18th centuries. Façades both plain and unusual (left) line the streets beside Culross Palace (right), famous for its panelled rooms, dormers and pedimented staircases.

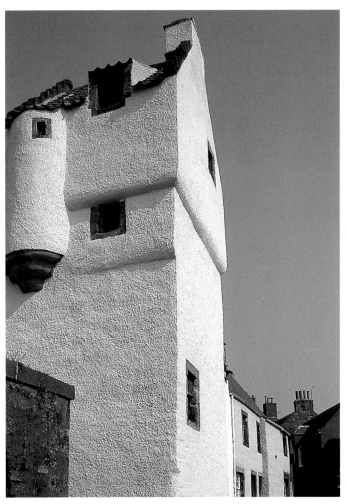

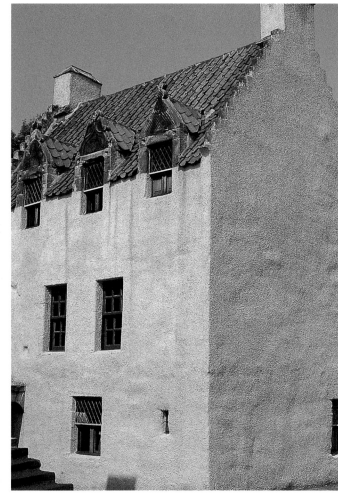

The whole town of Culross has been restored under the guidance of the National Trust for Scotland.

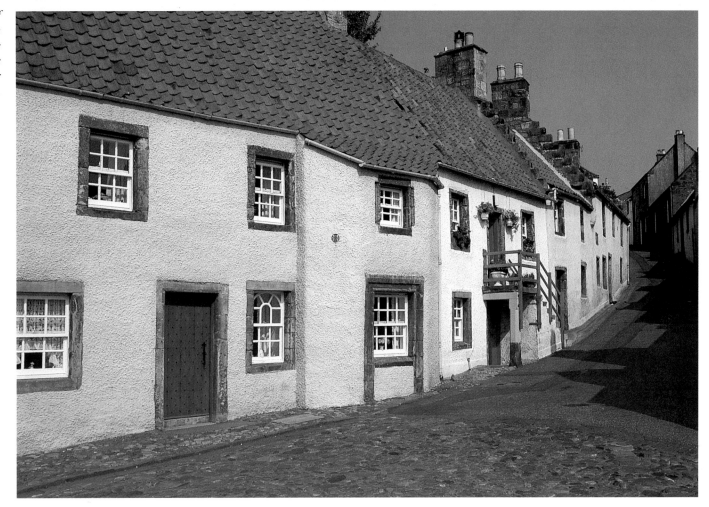

51

A house in Culross: bare stone, red pantiles and the chimney at the gable, all typical features of houses in the north of Britain.

there are Ibrox and Celtic Park, where matches between Glasgow Rangers and Glasgow Celtic (pronounced 'seltic', unlike the original inhabitants of the Highlands, who are 'kelts') continue the religious wars on the football field with the same deadly earnest which still today divides the two communities in Northern Ireland.

Rangers, founded in 1873, is the Protestant club. The Catholics, the majority descendants of the Irish immigrants of the last 150 years, support Celtic, founded in 1888, and are as loyal to their club as to the Pope. Inside the stadiums and on the streets approaching them the fans are segregated; anyone who gets caught up in the wrong group is lost. It recalls Dante's Florence when the papal Guelfs fought with the emperor's Ghibellines. The colours sported by the two sides are symbolic, the green-and-white of Celtic suggesting Ireland (supporters fly the Irish tricolor), the blue-and-white of Rangers (with some red in their socks) loyalty to the Union Jack. No one who has never experienced it can imagine the frenzy of the 40,000 fans waving their flags and scarves. However, the fierce and sometimes bloody fighting in the streets, pubs, trains and buses that used to precede and follow these encounters has been very much reduced in recent years through a ban on alcohol, altered kick-off times and crowd segregation.

Glaswegians, vital, energetic, always on the move, have long been a mixture of Highland and Lowland Scots. Whilst the architecture of Edinburgh is dominated by the 17th and 18th centuries, Glasgow is above all the city of the Victorian era. It is also the birthplace of Charles Rennie Mackintosh, one of the founders of European *art nouveau*, who influenced the Vienna *Secession*. His work contains references to traditional Scottish castles and houses, but is also inspired by the sweeping lines of Celtic illumination and decorative metalwork, lifting it above the over-ornate, self-satisfied architecture of the late-Victorian period.

Difficult neighbours

Samuel Johnson, as witty as he was cantankerous, voiced the typical English attitude to Scotland in the later 18th century. He found it strange and barbaric, its landscape monotonous, a country where the lack of its own historical tradition and written history was noticeable. History for the Celts is a matter of feeling, romantic, influenced by myths and their centuries of being underdogs. The English have never had much sympathy for it; nor can they understand why the Scots cannot forgive and forget events that belong to the distant past. Johnson's surprise to find the Scots eating oats 'which in England is generally given to horses' was only to be expected. As the widespread popularity of porridge shows – that delicious breakfast dish they make so well in Scotland with water and salt instead of milk and sugar, as in England – in this the great man was mistaken.

He did, however, coin a phrase which is still valid for Scotland today: 'The noblest prospect which a Scotchman ever sees is the high-road that leads him to England.' And, one might add, the ships, railways and aeroplanes that facilitate modern emigration. The exodus from the Highlands in the 18th century coincided with the beginnings of industrialisation. Whilst in the Lowlands new methods of cultivation led to a boom in agriculture, the estate owners in the Highlands found it less strenuous and more rewarding to lease out their land to graziers for sheep walks. Hundreds of small tenants and cottars were driven from their homes. The cynical expression for it was 'clearances', as if it were a forest being felled, and it has remained deeply embedded in the Scottish psyche to this day. Many of the homeless crofters emigrated to England, Canada, the United States and elsewhere.

This period also saw the population explosion in Great Britain, the result of progress in medicine and the consequent lowering of the death rate. Cities such as Glasgow grew with great rapidity and William Blake's 'dark satanic mills' appeared: first the cotton-

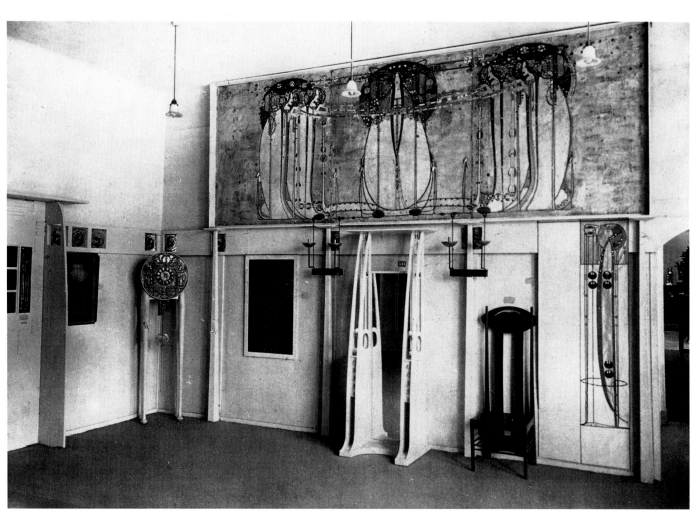

spinning machines invented by Richard Arkwright and Samuel Crompton, initially powered by water then by James Watt's steam engines (up to 1850 'King Cotton' was Scotland's main source of income); then came the coke furnaces of the railway age and finally the furnaces developed by Siemens and Bessemer to make steel for shipbuilding. The disappearance of the gigantic chimneys towering against the skyline along the Clyde is an indication of the great leap forward into the modern world which Glasgow has managed to make in recent years.

Great Britain, the country that pioneered the first industrial revolution, has ceded its leading role in the world to others. It is indicative that in the exploitation of North Sea oil, the basis of the revitalisation of the Scottish economy after 1980, American, English, Norwegian and Dutch firms are at the forefront of technology. Even if it does not serve Scotland alone, as the Scottish Nationalists would prefer, the oil coming from the fifty-four North Sea fields in Scottish coastal waters is of considerable benefit to its industry. Unemployment, which in recent years has been up to 3 percent higher than in other parts of Britain, was at 6.1 percent in 2000, compared to 5 percent in the United Kingdom as a whole; in Aberdeen, the 'Klondyke of Black Gold' the figure was only 4 percent. North Sea oil has created 100,000 jobs for Scotland.

The industrialisation of the 19th century found political expression in Scottish liberalism, espoused by leading industrialists, the legacy of which was taken over in the 20th century by the Labour Party, but also by the Conservatives. From only three in 1910 the number of Scottish Labour MPs had risen to fifty-five in 2001.

Scotland is the bastion of the Labour Party in Britain, with the core of its support in the old industrial and mining areas. Keir Hardie, the miner from Ayrshire, was the spiritual father of old-style British socialism and inspired its radical tradition.

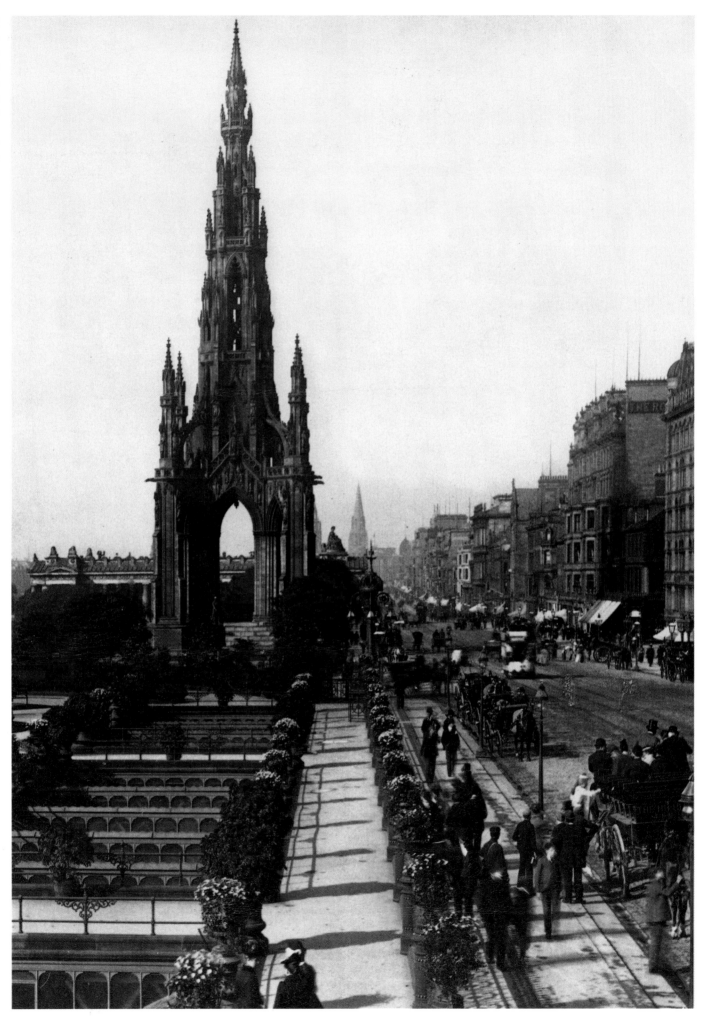

The 60m-high Scott Monument on Princes St in Edinburgh, built 1840–44 by George Meikle Kemp. It houses a marble statue of the writer, surrounded by sixty characters from his novels.

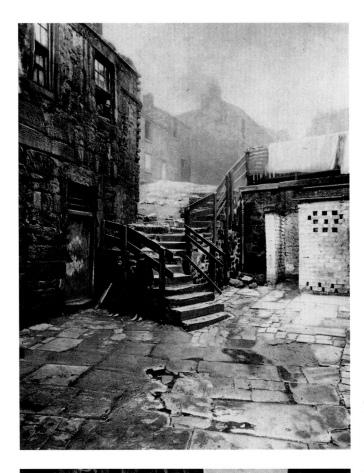

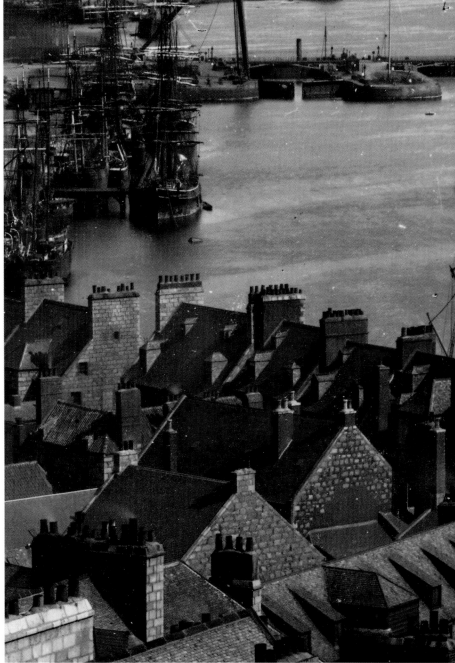

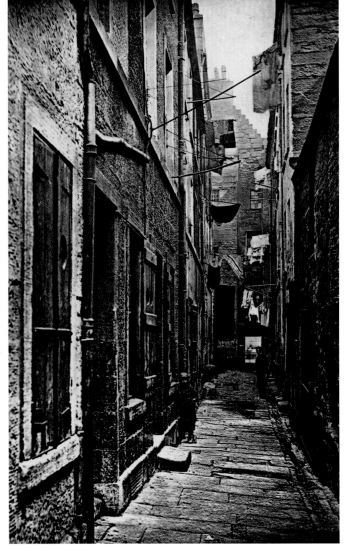

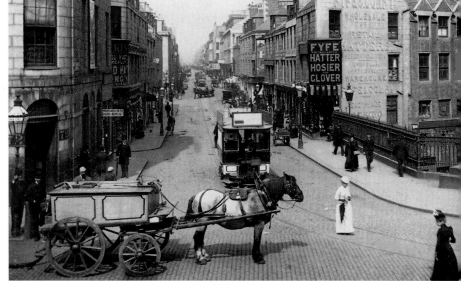

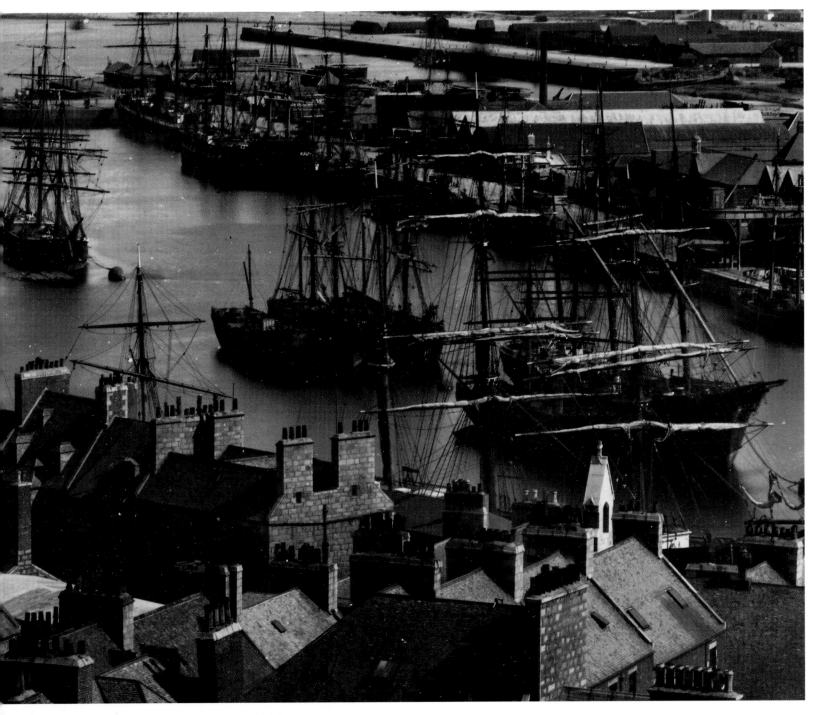

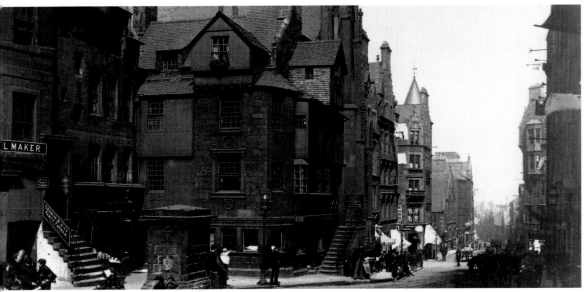

Impressions of Scottish cities in the 19th century. Top left: close no. 267 in Glasgow High St (1897); bottom left: close no. 65 High St (around 1865). 'Close' was the name for the back yards that could only be reached by passageways that were closed at night. Top right: Victoria Dock in Aberdeen seen from the Municipal Tower (around 1880–90); bottom middle: St Nicholas St in Aberdeen with a water-cart in the foreground (around 1890); bottom right: the house of John Knox on the Royal Mile in Edinburgh (1895). Merchants and craftsmen, lords and ambassadors all used to live in this famous street, which has four different names in its course between the castle and the Palace of Holyrood.

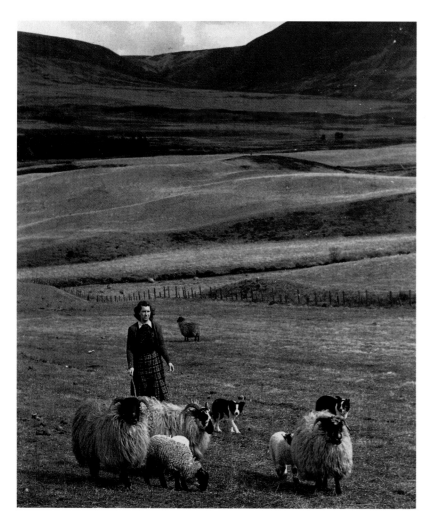

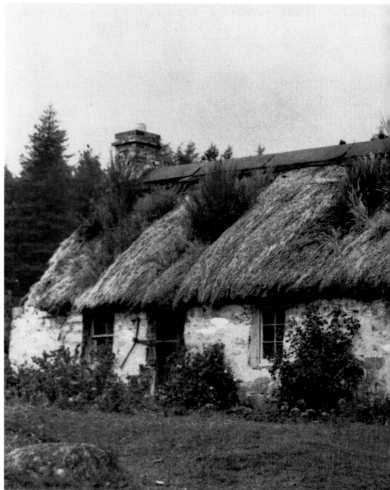

With seventy-two seats out of a total of 651 in the House of Commons, Scotland is not under-represented at Westminster, even though the Scots like to portray their country as the most neglected part of Britain. Eternal malcontents, they are forever trying to get a better deal for themselves from the central government in London. The fact remains, however, that for every £95 per head of taxpayers' money spent on England, £122 per head is spent on Scotland. For some time now the government has been trying to find a satisfactory solution to Scotland's problems. And, cynics maintain, they are quite likely to succeed, because there are so many Scots in the current cabinet in Westminster.

Industrialisation, above all in the central belt, set off a flight from the land in the Highlands. Even today a large part of the population there lives from sheep-farming. Left: near Forfar (1950); middle: abandoned cottage (1930).

A United Kingdom without Scotland?

'Things fall apart; the centre cannot hold,' wrote Yeats. Britain's decline from its former status as a world power has only served to increase popular discontent on the Celtic fringe with the centralised system of government. The geographical and historical division of Britain into a large England and a small Scotland (and an even smaller Wales) is not suited to a federal structure, which presupposes more or less equal partners. One consequence of this was the foundation in 1934 of the Scottish National Party (SNP) demanding complete independence. Its first member of parliament was elected in 1945, though the real expansion of the independence movement came in the 1970s. By 1979 they had eleven MPs in Westminster, though that was a number they were never to reach again; the current number at Westminster (2001) is five. During their best periods their share of the vote rose to 30 percent of the Scottish electorate. However, given the first-past-the-post electoral system in Britain, this did not bring them the breakthrough that would have been possible with proportional representation. But even at the high point of the separatist movement, only 19 percent

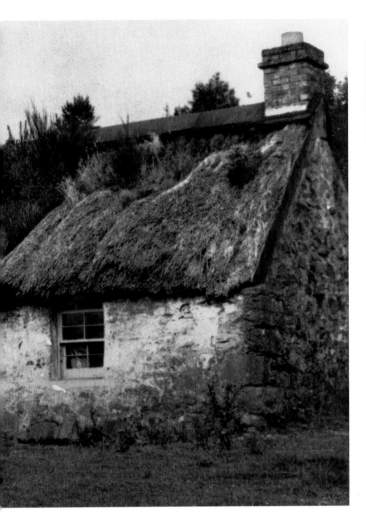

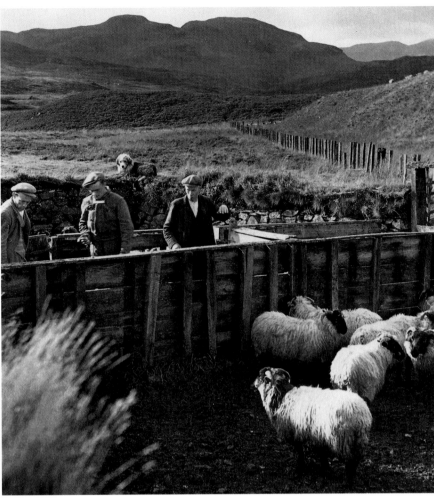

Highland sheep being dipped and inoculated against liver fluke in Glen Buckie, near Strathyre.

of Scots were in favour of a complete break with Westminster, that would have led to Scottish passports and an independent foreign policy within the European Union. The majority want to retain union with England and the crown, and keep the important powers in London.

Concerned at the success of the SNP, both Labour and Conservatives had produced proposals for increased Scottish self-government. Eventually Labour and the Liberal Democrats proposed a referendum to decide on the question of a Scottish parliament, which, however, was rejected by the Conservatives as being a half-way stage to a complete break-up of the United Kingdom. The nationalist upsurge in Scotland is the expression of a protest against the inability of the government in London to solve the problems of inflation, lack of investment and poor working conditions in a way that is satisfactory for Scotland. The thrifty Scots have probably worked out that the creation of a Scottish executive on top of the 10,000 civil servants in the Scottish ministries in London and Edinburgh would be an enormous additional financial burden.

One problem is the new economic divide between Highland and Lowland Scots, not dissimilar to the North–South divide in England. It is made even more confusing by the fact that more and more laid-back Highlanders are compelled to live in the Lowlands, that is, among the 'Glaswegians' with their fiery Celtic temperament. After a few glasses of 'heavy', the contempt they feel for each other is often expressed in rather vigorous manner.

When, after eighteen years of Conservative rule, the Labour Party won the election in May 1997, they kept their manifesto promise and held a referendum on devolution. Now, after 300 years, the Scots have their own parliament again and are enjoying their freedom from the 'dictates of Westminster'. However, there are still Scottish MPs at Westminster and, with their rebellious Celtic temperament, they are less able to restrain themselves from intervening in purely English matters than their English counterparts

in Scottish ones. Even worse, the 'good-natured' English have to put up with the disadvantages of being in the majority: they have practically no say in the distribution of the £8,000,000,000 extra taxpayers' money they are 'allowed' to spend on the Scots. In addition, the Labour majority in the Edinburgh parliament is trying to put further financial pressure on the central government, in order to bolster their popularity in Scotland. This could well play into the hands of the Scottish Nationalists, since the English majority is playing with the idea of countering Scottish extortion with a federal division of England. In secret, however, the Scots value their membership of the United Kingdom.

Hardly anywhere else is the contrast between civilisation and nature so stark as in the loneliness of the Highlands.

Overleaf: Set in the middle of the barren Highland landscape, Inverewe Gardens near Poolewe surprises the visitor with a riot of colour and a multitude of exotic plants.

The Highlands, a beautiful but inhospitable land, the same elements repeated again and again in ever new combinations. Lochs lying quietly in a glen or winding between rocky hills, hardly distinguishable from the open sea, the arms of which stretch far inland. Top left: Loch Leathan on Skye.

The Highlands, source of heroic epics and myths, tales and songs, from Ossian, the Gaelic bard of James Macpherson's epics that set off a wave of enthusiasm throughout Europe in the 18th century, to the 'Highlander', a hero of the 20th-century cinema. Bottom left: heather, rocks and water by Gualin House.

The Highlands, a paradise for hill-walkers and rock-climbers. Occasionally one may come across old drove roads which were used in two directions: to drive the cattle to the markets in the Lowlands, but also by cattle thieves to drive their prizes back into the impenetrable fastnesses of the Highlands. Top right: near Laxford Bridge.

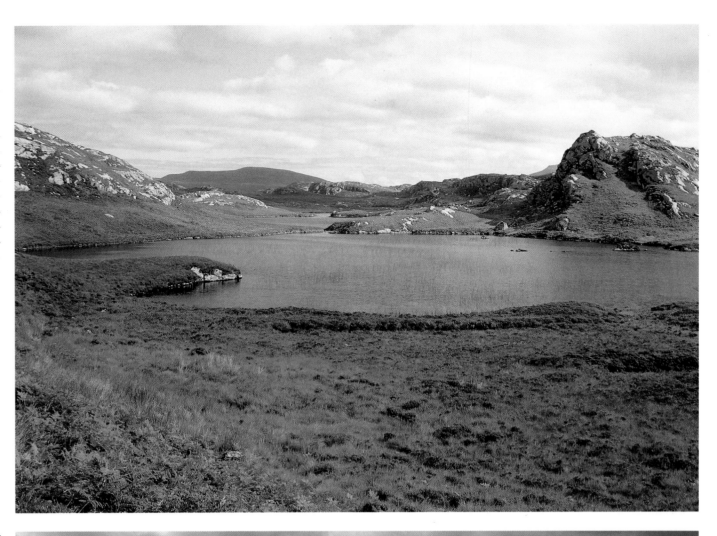

The Highlands, a Mecca for hunters and fishers. Countless hunting lodges offer accommodation and a gillie to guide you to the best pools or glens where the deer hide. Bottom right: the Kyle of Durness on the north coast.

Overleaf: the Old Man of Storr rising 45m in front of a grandiose panorama on Skye; a challenge for rock-climbers, a teaching aid for geologists and an experience for everyone.

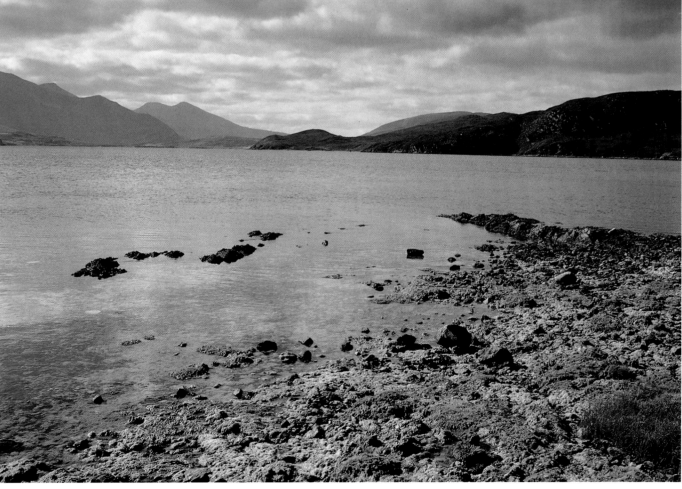

65

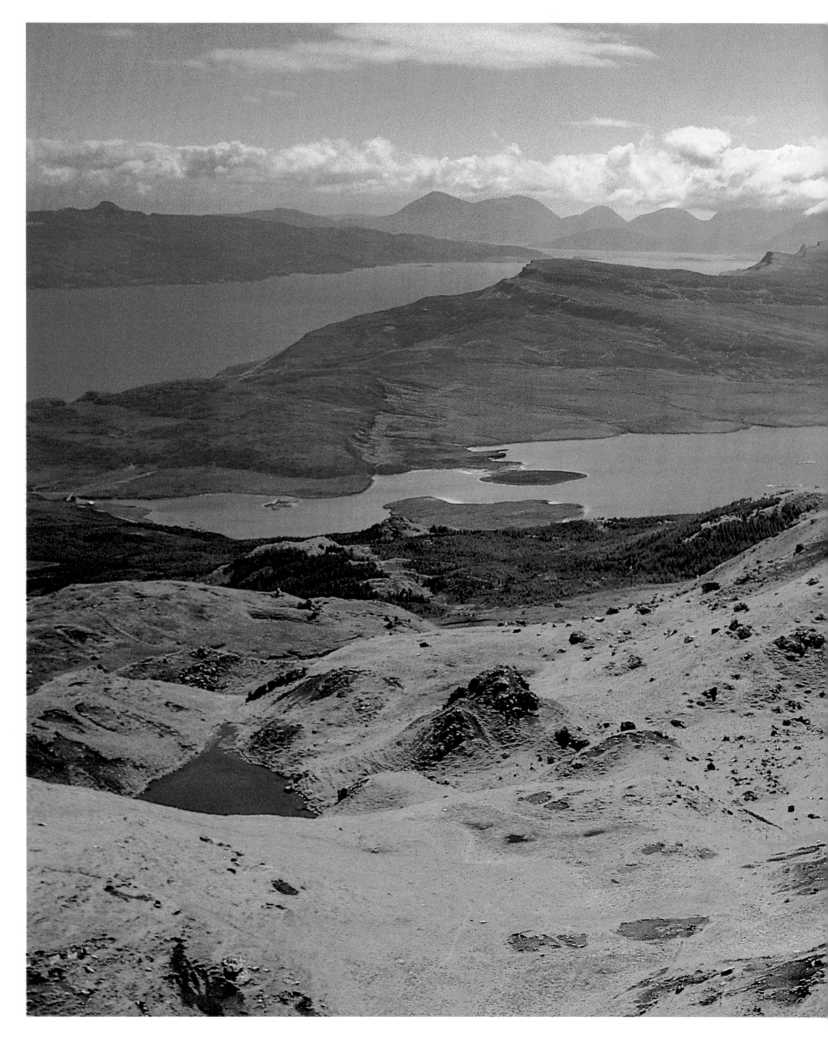

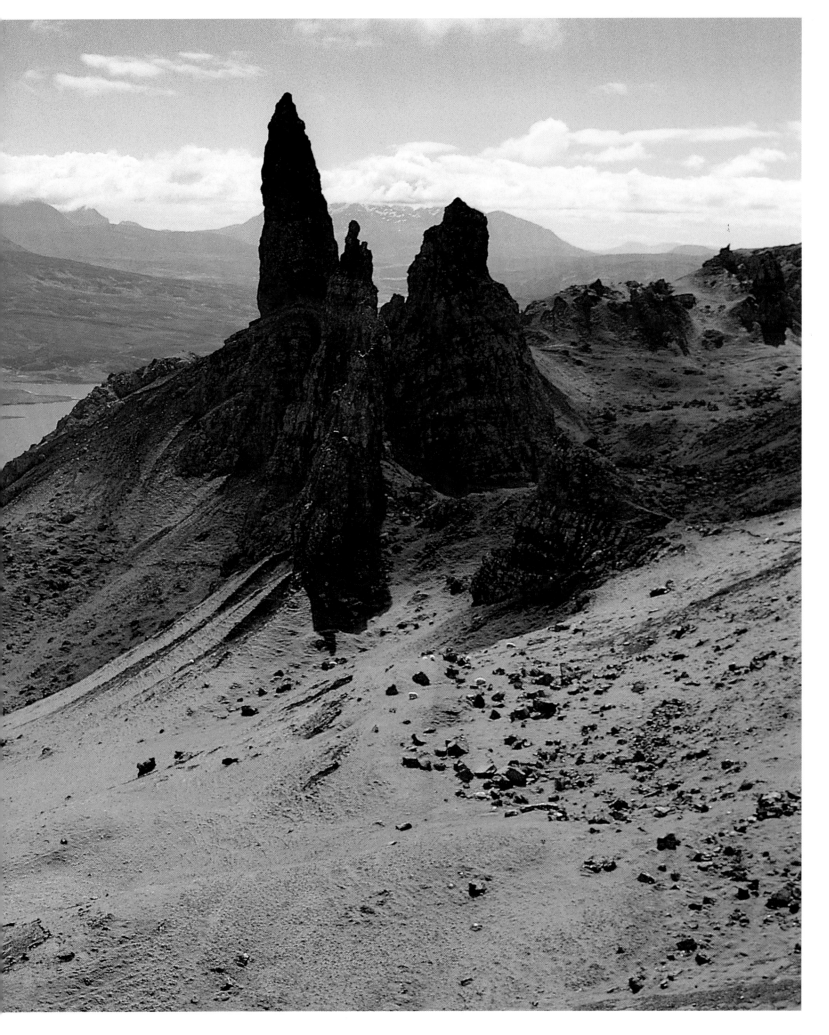

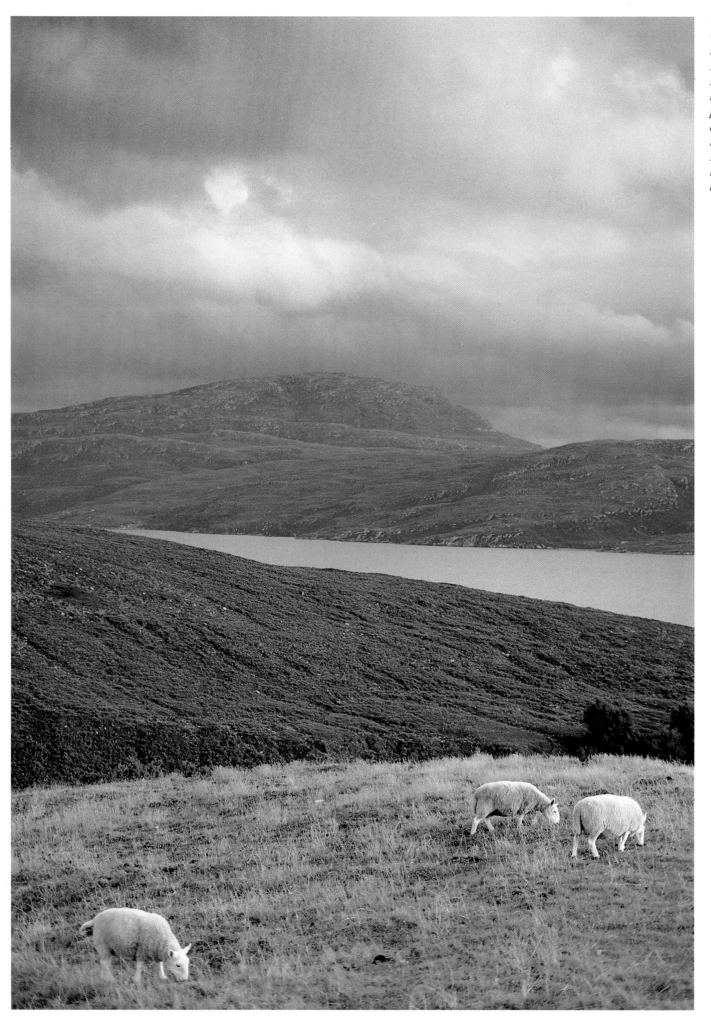

The 19th-century Clearances drove thousands from the Highlands because sheep runs and hunting were more profitable for the estate owners. Today tourism is the chief source of income for the area. Left: sunset over Loch Broom.

'Five seasons a day' is an apposite description of the Highland weather. The landscape is constantly changing with the light and the sky, where cloud formations rapidly build up, only to be scattered again by the wind. Top left: Glen Truim.

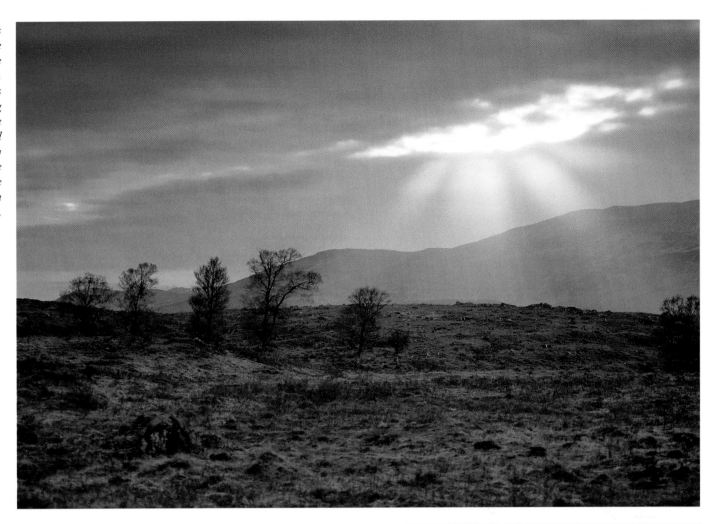

Trees are a rarity in this barren landscape. Bottom right: Loch a Chroisg.

Overleaf: Attached to the mainland by a stone bridge, Eilean Donan Castle stands at the mouth of Loch Duich. The 13th-century fortress was badly damaged in 1719 and only restored between 1912 and 1932.

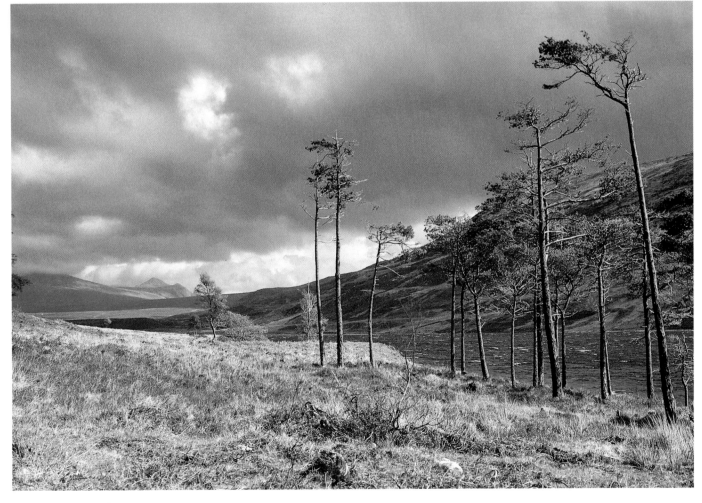

69

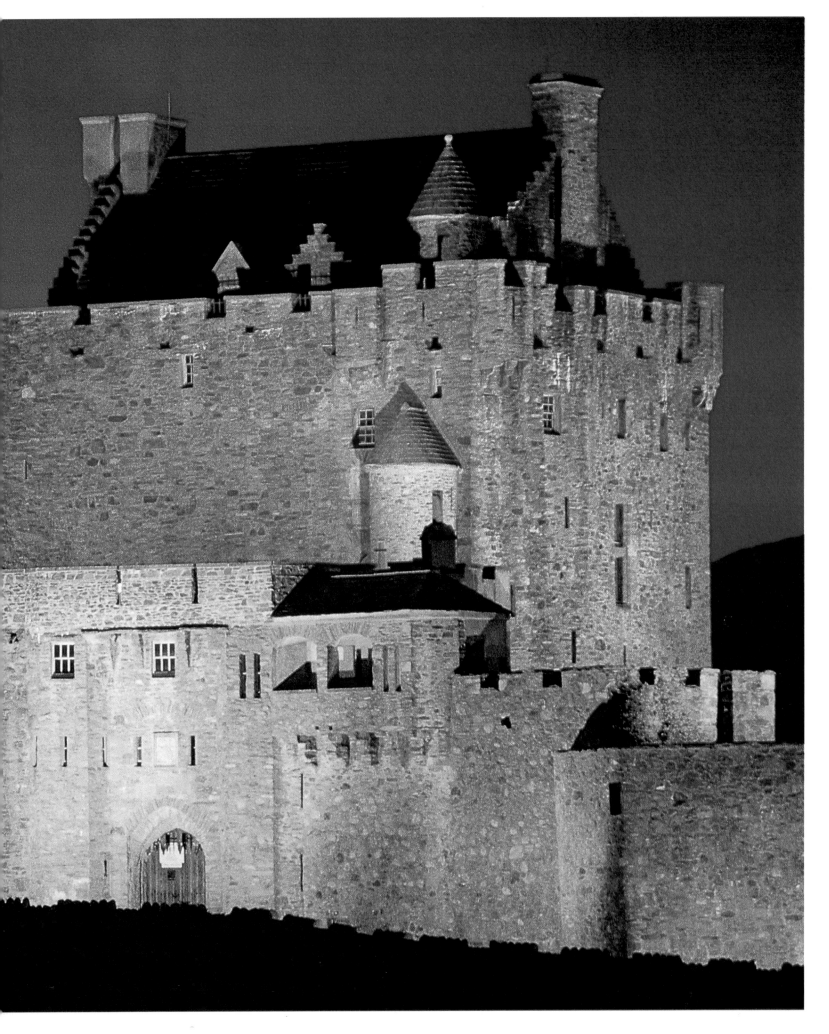

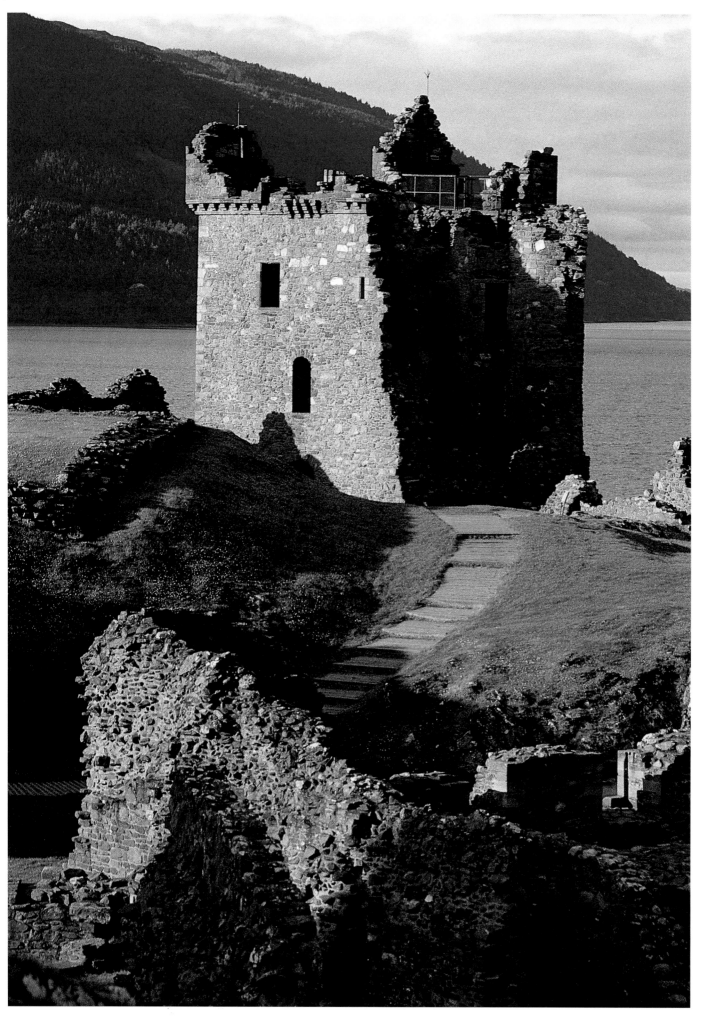

Castle Urquhart in its picturesque setting on Loch Ness. Its other attraction is as the most likely place to spot 'Nessie'. Several scientific expeditions have set out from this bay in their search for the legendary monster.

'...beaten upon and buffeted by all the winds of heaven'

Travellers' accounts and poems about Scotland

'Fingal!' replied the youth, 'it is the son of Semo! Gloomy and sad is the hero! his hand is on his sword. Hail to the son of battle, breaker of the shields!'

'Hail to thee,' replied Cuthullin,

'Hail to all the sons of Morven! Delightful is thy presence, o Fingal, it is the sun on Cromla; when the hunter mourns his absence for a season, and sees him between the clouds. Thy sons are like stars that attend thy course. They give light in the night. It is not thus thou hast seen me, o Fingal, returning from the wars of thy land: when the kings of the world had fled, and joy returned to the hill of hinds!'

'Many are thy words, Cuthullin,' said Connan of small renown. 'Thy words are many, son of Semo; but where are thy deeds in arms? Why did we come, over ocean, to aid thy feeble sword! Thou flyest to the cave of grief, and Connan fights thy battles. Resign to me these arms of light. Yield them, thou chief of Erin!'

'No hero,' replied the chief, 'ever sought the arms of Cuthullin; and had a thousand heroes sought them, it were in vain, thou gloomy youth! I fled not to the cave of grief, till Erin failed at her streams.'

'Youth of the feeble arm,' said Fingal, 'Connan cease thy words! Cuthullin is renowned in battle; terrible over the world. Often have I heard thy fame, thou stormy chief of Inis-fail. Spread now thy white sails for the isle of mist. See Bragela leaning on her rock. Her tender eye is in tears; the wind lifts her long hair from her heaving breast. She listens to the breeze of night, to hear the voice of thy rowers; to hear the song of the sea! the sound of thy distant harp!'

Fingal's Victory and Homecoming

JAMES MACPHERSON, *POEMS OF OSSIAN*, 1762

If thou wouldst view fair Melrose aright,
Go visit it by pale moonlight;
For the gay beams of lightsome day
Gild, but to flout, the ruins grey.
When the broken arches are black in night,
And each shafted oriel glimmers white;
When the cold light's uncertain shower
Streams on the ruin'd central tower;
When buttress and buttress, alternately,
Seem fram'd of ebon and ivory;
When silver edges the imagery,
And the scrolls that teach thee to live
 and die;
When distant Tweed is heard to rave,
And the owlet to hoot o'er the dead man's
 grave,
Then go – but go alone the while –
Then view St David's ruined pile;
And, home returning, soothly swear,
Was never scene so sad and fair!

Melrose Abbey

SIR WALTER SCOTT, *THE LAY OF THE LAST MINSTREL*, 1802–3

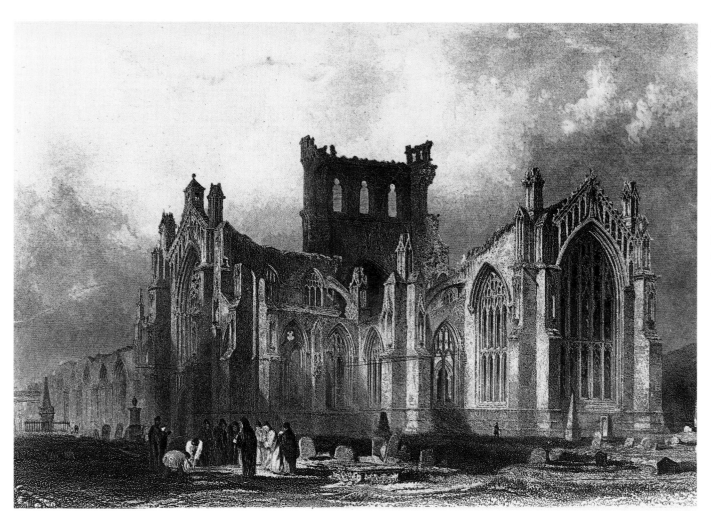

Melrose Abbey: destroyed by Edward II in 1322, rebuilt by Robert the Bruce, burnt by Richard II in 1385, rebuilt again and finally destroyed by the English in 1545. The romantic ruin was used by many poets and painters, for example Sir Walter Scott in his novel The Monastery *(steel engraving around 1840).*

Abbotsford Three English miles to the west of Melrose lies Abbotsford, that 'romance in stone and mortar' as Walter Scott, with a certain air of self-satisfaction, called the house he built for himself. The building as a whole proves unintentionally that 'one thing is not suitable for all' and that the revival of the past, the decoration of a modern construction with rich poetic details from the Middle Ages, can delight and enchant in one place, while in another it is merely a piece of bizarre whimsy. To stay with the image the writer himself chose, this romance in stone and mortar looks as if he had selected a hundred pretty passages from all sorts of ballads in his desk-drawers, fully expecting that putting these fragments together would create the ideal, model romance. It lacks that flash of inspiration that would be strong enough to bind the disparate elements into a harmonious unity. Just as in a poetic game of consequences we write a line with a specific rhyming word, then fold the paper over, so that the line the next person writes will be completely unrelated in meaning to it, so Abbotsford has been built for the sake of fifty or so catchwords. This is not intended as a criticism of its builder; however, one is sorry not to feel impelled, when faced with this stone romance, to break into the tone of love and respect one is used to whenever the name of Sir Walter comes to one's lips.

THEODOR FONTANE, *JENSEIT DES TWEED*, 1860

As so often in Scotland

as so often in Scotland
the sun travelled
dyke over dyke, burning
dead grass golden and ending,

after a wallow of foothills,
on one brown summit;
that flared its moment, too,
and was gone.

G. F. DUTTON, *CAMP ONE*, 1978

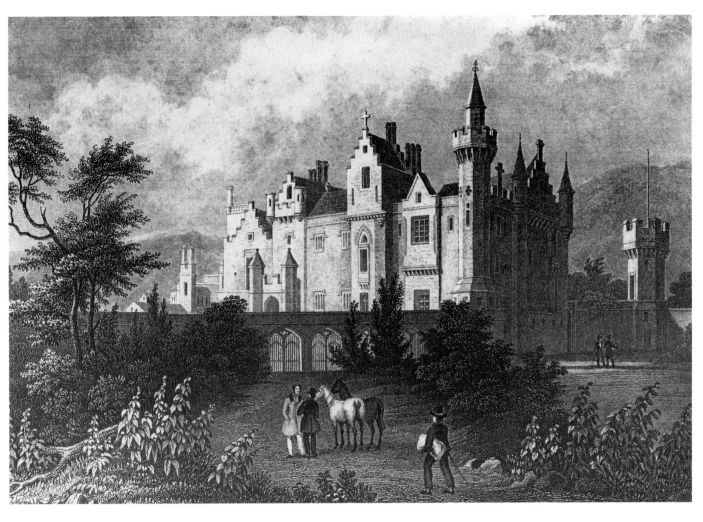

The road to Hermiston runs for a great part of the way up the valley of a stream, a favourite with anglers and midges, full of falls and pools, and shaded by willow and natural woods of birch. Here and there, but at great distances, a byway branches off, and a gaunt farmhouse may be described above in a fold of the hill; but the more part of the time, the road would be quite empty of passage and the hills of habitation. Hermiston parish is one of the least populous in Scotland; and, by the time you came that length, you would scarce be surprised at the inimitable smallness of the kirk, a dwarfish, ancient place seated for fifty, and standing in a green by the burn-side among two-score gravestones. The manse close by, although no more than a cottage, is surrounded by the brightness of a flower-garden and the straw roofs of bees; and the whole colony, kirk and manse, garden and graveyard, finds harbourage in a grove of rowans, and is all the year round in a great silence broken only by the drone of the bees, the tinkle of the burn, and the bell on Sundays. A mile beyond the kirk the road leaves the valley by a precipitous ascent, and brings you a little after to the place of Hermiston, where it comes to an end in the back-yard before the coach-house. All beyond and about is the great field of the hills; the plover, the curlew and the lark cry there; the wind blows as it blows in a ship's rigging, hard and cold and pure; and the hill-tops huddle one behind another like a herd of cattle into the sunset.

The house was sixty years old, unsightly, comfortable; a farmyard and a kitchen-garden on the left, with a fruit wall where little hard green pears came to their maturity about the end of October.

The policy (as who should say the park) was of some extent, but very ill reclaimed; heather and moorfowl had crossed the boundary wall and spread and roosted within; and it would have tasked a landscape gardener to say where policy ended and unpolicied nature began. My lord had been led by the influence of Mr. Sheriff Scott

Winter on the Moors

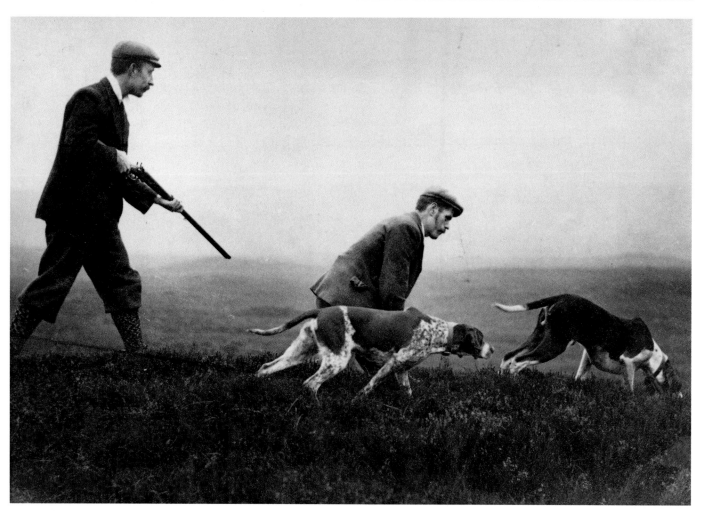

'Reddin' the lines' – preparing the fishing lines with hooks and bait for cod and haddock. Elie in Fife (around 1880).

Hunters find grouse, wild duck, pheasants and partridges in the Highlands (around 1900).

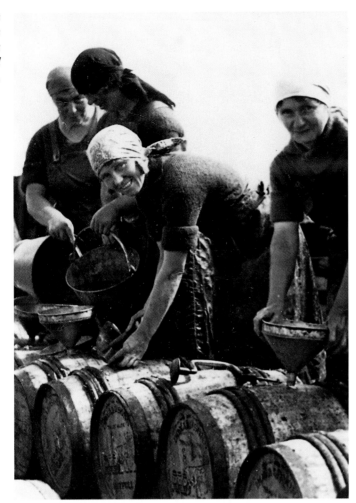

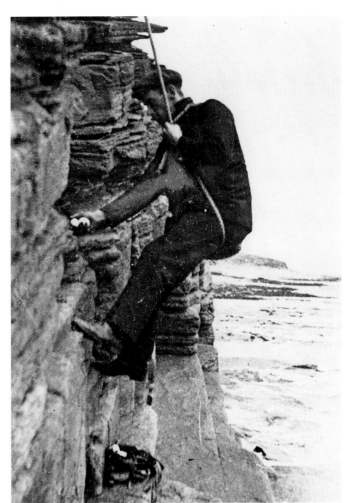

Top left: women pickling herring in Wick. Top right: gulls eggs being collected from the cliffs (1900).

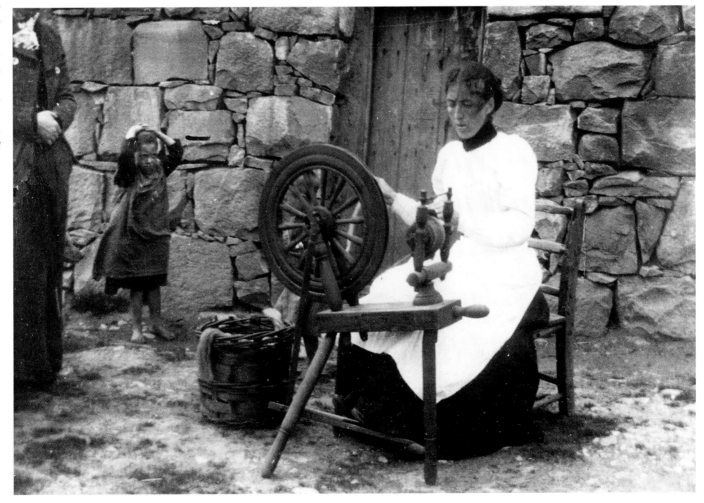

Harris: the material for the famous tweed is still produced by hand today. This cloth is ideal for the Scottish climate, protecting the wearer from wind and rain, keeping them warm in the cold and cool when it's hot.

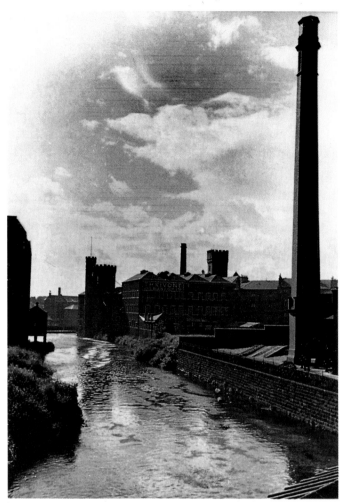

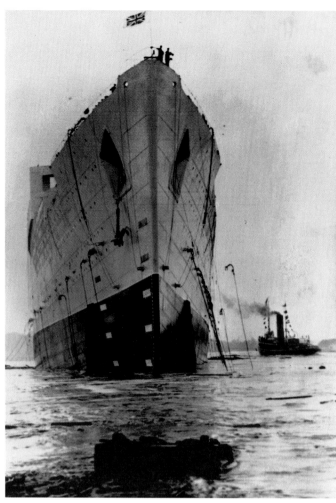

Glasgow, the centre of Scottish industry. Top left: a factory (1935); top right: the launch of the luxury liner Queen Mary, 26 September 1934.

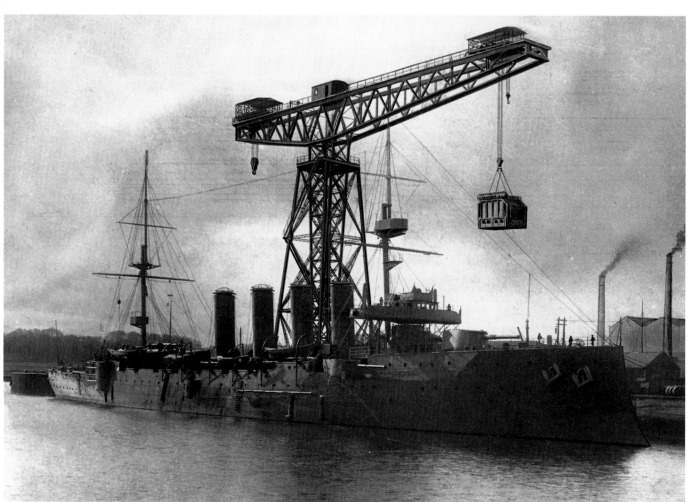

In the 19th century Glasgow had the largest shipyards in the world; before the Second World War 100,000 workers were employed in them. Today there are only a few hundred at the last remaining yard – the Clyde is too shallow for supertankers and container ships.

The Forth Bridge at Queensferry to the west of Edinburgh, a railway bridge built between 1882 and 1890 by Benjamin Baker and John Fowler (1900).

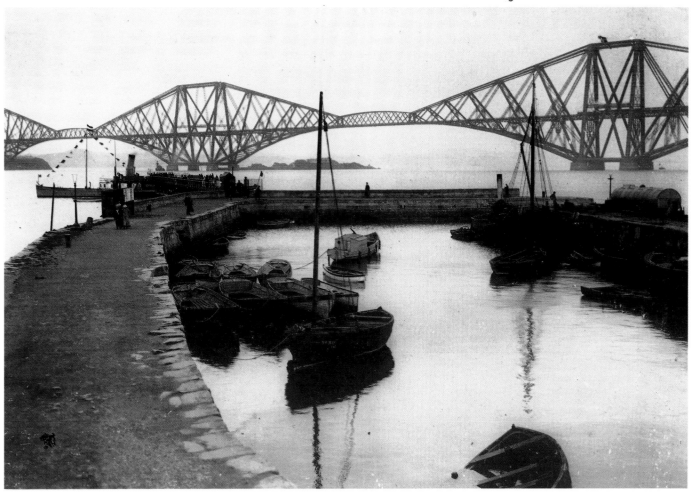

into a considerable design of planting; many acres were accordingly set out with fir, and the little feathery besoms gave a false scale and lent a strange air of a toy-shop to the moors. A great, rooty sweetness of bogs was in the air, and at all seasons an infinite melancholy piping of hill birds. Standing so high and with so little shelter, it was a cold, exposed house, splashed by showers, drenched by continuous rains that made the gutters to spout, beaten upon and buffeted by all the winds of heaven; and the prospect would be often black with tempest, and often white with the snows of winter. But the house was wind and weather proof, the hearths were kept bright, and the rooms pleasant with live fires of peat; and Archie might sit of an evening and hear the squalls bugle on the moorland, and watch the fire prosper in the earthy fuel, and the smoke winding up the chimney, and drink deep of the pleasures of shelter.

ROBERT LOUIS STEVENSON, *WEIR OF HERMISTON*, 1894

The Shetland Isles

Nowhere has the sea more potent influence: many tidal currents set in different directions; nor merely do the incoming tides wash the shores and ebb again, but penetrate the land deeply and invest it, and even steal into the heart of the hills and mountains as though into their native element.

TACITUS, *AGRICOLA*, AROUND 98AD

79

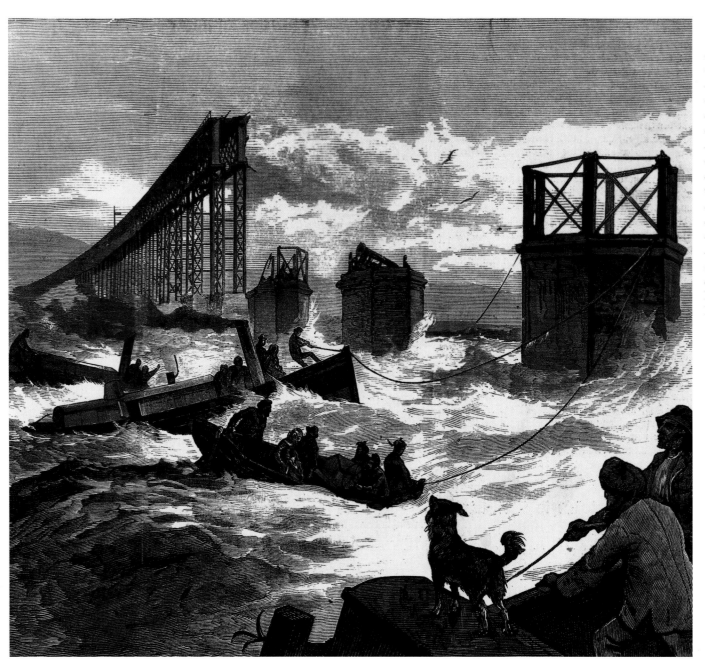

The Bridge over the Tay (28 December 1879)

'When shall we three meet again?'
'At seven o' the clock, when comes
 the train.'
'Upon the bridge.'
'I'll douse the flame.'
'I'll be there too.'
'From the north I'll fly.'
'I from the south.'
'From the sea come I.'

'There our sabbath to celebrate,
And send the bridge plunging into
 the spate.'
'And the train that comes at the
 seventh hour?'
'Is in our power!'
'Is in our power!'

'Built on sand –'
'Sand!'
'Sand!'
'Are all the works of human hand!'

In the northern tower the windows
 look out
Across the raging Tay to the south,
And the watchers there, through
 squall and roar,
Keep their eyes fixed on the
 southern shore.
Will the signal come, will they see
 the light
That says, 'I'm coming, despite
 the night,
Despite the storm and the blinding rain,
I'm coming, the Edinburgh train.'

And the guard on the bridge says,
　'I see a lamp shine
On the other bank, the train's on time.
Now, mother, put away your fears,
Light the tree, Jock'll soon be here,
Let it burn bright as on Christmas Day,
A comforting gleam across the Tay.
He promised you he'd not be late –
Only eleven minutes to wait.'

It is the train. It pants its way
Past the southern tower, 'gainst wind and
　spray.
And Jocky says, 'There's the bridge to come,
But don't you fear, we'll soon be home.
With our head of steam and our well-banked
　fire
We'll get across, though the storm
　blow higher;
However wild the freezing blast,
Our strong machine will force its
　way past.

And then the bridge. Our pride
　and joy!
When I recall the sweat and toil
To ferry us over in the boat
Compared with now, I can only gloat.
Many's the winter's night I've spent
Waiting and hoping the gale would relent,

Watching the lights on the other side,
Kept from my bed by wind and tide.'

In the northern tower the windows
　look out
Across the raging Tay to the south,
And the watchers there, through squall
　and roar,
Keep their eyes fixed on the southern
　shore.
For the howling storm yet louder cries
And now – like fire rained down from
　the skies
The night glows red in a blaze of
　sparks
Over the waves … then once more dark.

'When shall we three meet again?'
'On Blackhill Muir by Dunsinane.'
'At midnight, round the De'il's Stane.'
'I will come.'
'And I'll be there.'
'I'll tell the numbers.'
　'I the names.'
'And I the anguish, grief and pain.'

'Like brittle twigs the girders cracked!'
'Built on sand –'
'Sand!' 'Sand!'
'Are all the works of human hand!'

THEODOR FONTANE, *DIE BRÜCK AM TAY*, 1880

Stirling
Stirling has many factories, all kinds of very beautiful carpets are made here; also the colourful, checked woollen cloth in which the mountain Scots clothe themselves. We visited one of these factories and were once more compelled to admire the invention which in this country makes all kinds of tasks simpler and easier. Something we had not seen before was a machine with which one girl can wind off more than fifty bobbins of wool at the same time. The bobbins were fixed next to each other in a wide circle and the thread from each one attached to the very large reel above them; a wheel enabled the girl to start this very simple machine in a most practical and effortless manner.

Even the dogs are forced to be industrious. We saw a very large and handsome dog, which had to run round in a wheel, like a squirrel, to drive a mill to grind pigments. It did not seem to enjoy the work particularly and seized the opportunity to disappear at incredible speed in the very moment it was supposed to demonstrate its skills to us. Young and old pursued it with hue and cry, but it escaped, to the owner's chagrin and our delight.

Perth
From Stirling a further day's journey took us to Perth. The city is not small, has large, handsome houses and fine, broad streets full of lively crowds. Everything looks prosperous, for here too trade and manufactures are flourishing; the great linen bleaching-greens of Perth are particularly renowned.

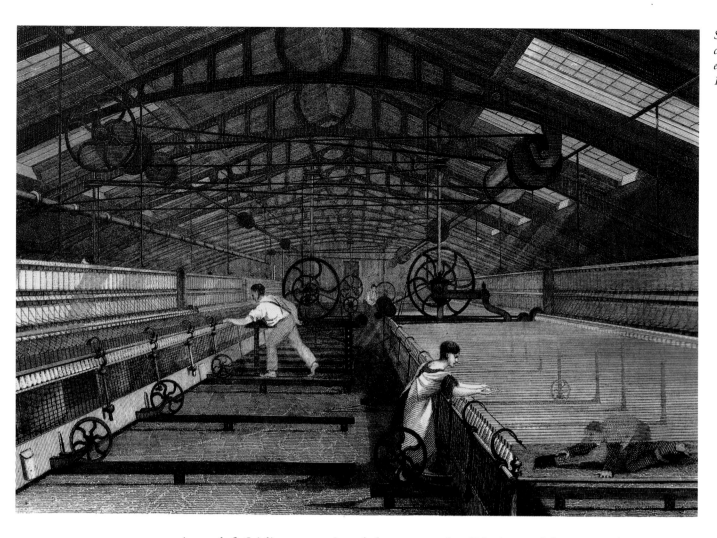

As we left Stirling, we enjoyed the many splendid views of that magnificent region. Gradually the countryside lost its attractiveness, while still remaining well cultivated and fruitful. Sombre, the mountain ranges of the Highlands spread out before us in the blue haze; we toiled up some fairly steep hills, with even higher ones looming beyond them. The road descended a little once more and the mountains retreated, bordering a charming valley enlivened by the waters of the Tay, on the banks of which the city of Perth is built.

Inveraray

The little town of Inveraray and its small harbour with all kinds of vessels lies across the bridge somewhat away from the castle. It has a very neat and dainty look with its straight streets and pretty white houses, from among which rises the imposing bulk of the hotel. Everything looks as if it had been completed only yesterday. And that is almost the case. The town used to lie opposite the castle, but the Duke, who felt it spoilt his view there, had it taken down and re-erected on its present site. That, surely, is something you would only find in Great Britain.

Loch Lomond

A few miles from Arrochar we came, through narrow gorges winding their way between high mountains, to the banks of the largest and most beautiful lake in the Highlands. The surroundings are a mixture of charming countryside and sublime peaks. Now the magnificent, partially wooded mountains crowd in on it, as if they wanted to mirror themselves in its clear waters; then they withdraw and the shining surface is girdled with fields and meadows.

First of all we entered a fresh green wood beside the lake. We drove along beneath arching foliage, enjoying the silvery gleam of the lake with its manifold reflections. A

The Comet, *constructed by Henry Bell (1762–1830) and launched in Glasgow in 1812, was the first sea-going steamship in the world.*

high hill, one of the highest we had so far had to cross, blocked our way; we reached the top, the road descended and before us lay the magnificent lake in all its glory, immeasurably wide, strewn with green islands both small and large [...] The silvery surface was rippling with little waves, and on the other side mighty Ben Lomond rose up vertically, its head disappearing in the clouds.

JOHANNA SCHOPENHAUER, *REISE DURCH ENGLAND UND SCHOTTLAND*, 1818

'Pretty perilous and a good deal odiferous' **Boswell and**
On Saturday the fourteenth of August, 1773, late in the evening, I received a note from **Johnson**
him [Dr. Johnson] that he was arrived at Boyd's Inn, at the head of the Canongate. I went to him directly. He embraced me cordially, and I exulted in the thought that I now had him actually in Caledonia.

He was to do me the honour to lodge under my roof... Mr. Johnson and I walked arm-in-arm up the High Street to my house in James's Court; it was a dusky night; I could not prevent him being assailed by the evening effluvia of Edinburgh. I heard a late baronet of some distinction in the political world in the beginning of the present reign observe that 'walking the streets of Edinburgh at night was pretty perilous and a good deal odiferous.' The peril is much abated by the care which the magistrates have taken to enforce the city laws against throwing foul water from the windows; but, from the structure of the houses in the old town, which consist of many storeys in each of which a different family lives, and there being no covered sewers, the odour still continues. A zealous Scotsman would have wished Mr. Johnson to be without one of his five senses on this occasion. As we marched slowly along, he grumbled in my ear, 'I smell you in the dark!'

Visiting a Highland hovel

MONDAY 30 AUGUST. This day we were to begin our equitation. We might have taken a chaise to Fort Augustus. But we could not find horses after Inverness, so we resolved to begin here to ride. We had three horses for Mr. Johnson, myself, and Joseph, and one which carried out portmanteaus; and two Highlanders who walked with us, John Hay and Lauchlan Vass. Mr Johnson rode very well.

It was a delightful day. Loch Ness, and the road upon the side of it, between birch trees, with the hills above, pleased us much. The scene was as remote and agreeably wild as could be desired. It was full enough to occupy our minds for a while.

A good way up the Loch, I perceived a little hut with an oldish woman at the door. I knew it would be a scene for Mr. Johnson. So I spoke of it. 'Let's go in,' said he. So we dismounted and we and our guides went in. It was a wretched little hovel, of earth only, I think; and for a window had just a hole which was stopped with a piece of turf which could be taken out to let in the light. In the middle of the room was a fire of peat, the smoke going out at a hole in the roof. She had a pot upon it with goat's flesh boiling.

'Roving among the Hebrides'

FRIDAY 1 OCTOBER. There was pretty good weather. The Baillie came up, and asked us to go to Armadale, and stay in Sir Alexander's house, he and his wife having gone to Edinburgh, until such time as we could cross to Mull. So all fourteen of us spent a pleasant and enjoyable day at Armadale.

SATURDAY 2 OCTOBER. We were very social and merry in Mr. Johnson's room this forenoon. We made again a great dinner, and in the evening a great dance. We made out five country squares without sitting down; and then we performed with much activity a dance which I suppose the emigration from Skye has occasioned. They call it 'America.' A brisk reel is played. The first couple begin, and each sets to one – then each to another – then as they set to the next couple, the second and third couples are setting; and so it goes on till all are set a-going, setting and wheeling round each other, while each is making the tour of all in the dance. It shows how emigration catches till all are set afloat. Mrs Mackinnon told me that last year when the ship sailed from Portree for America, the people on shore were almost distracted when they saw their relations go off; they lay down on the ground and tumbled, and tore the grass with their teeth.

Yesterday Mr. Johnson said, 'I cannot but laugh to think of myself roving among the Hebrides at sixty. I wonder where I shall rove at fourscore.'

JAMES BOSWELL, *JOURNAL OF A TOUR TO THE HEBRIDES*
WITH SAMUEL JOHNSON, LL.D., 1785

The lighthouse on the Butt of Lewis, the most northerly point of the Outer Hebrides, a lonely beacon amid wind and rain. When the autumn and winter gales pour in over the Atlantic it has to withstand wind speeds of over 180km per hour.

Overleaf: White sand and deep-blue sea against a backdrop of impressive mountains – only the climate saves this lonely beach of Seilebost on Harris from mass tourism.

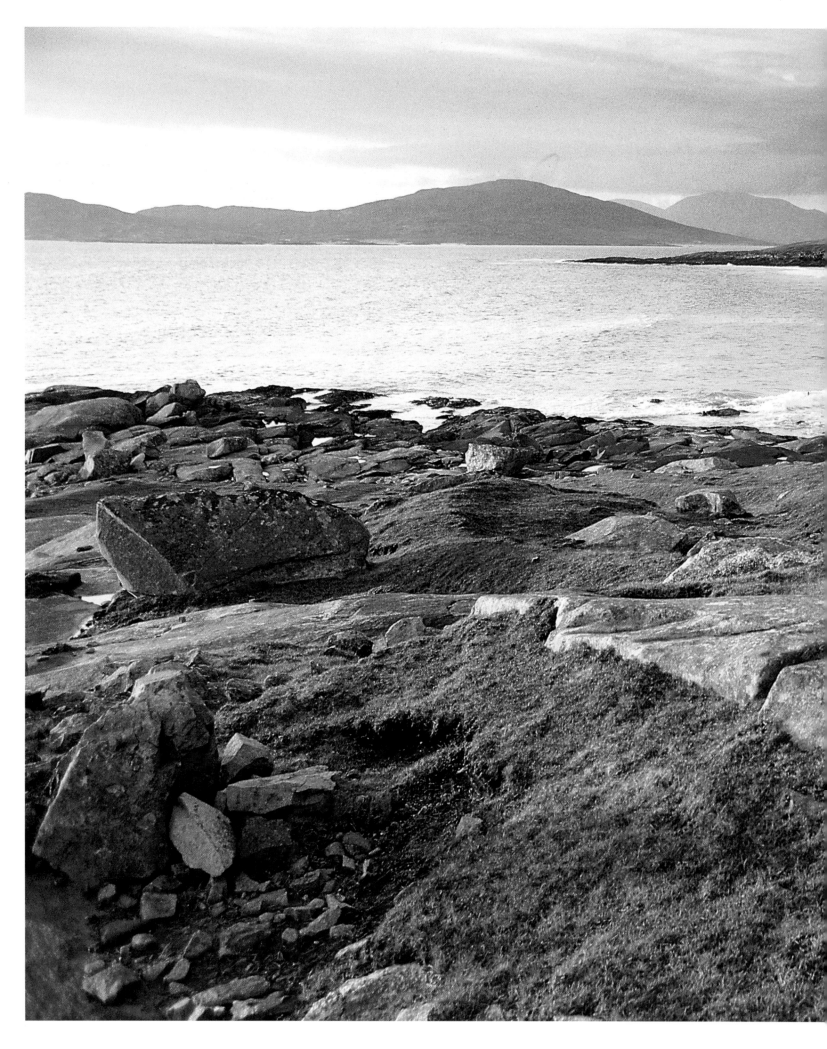

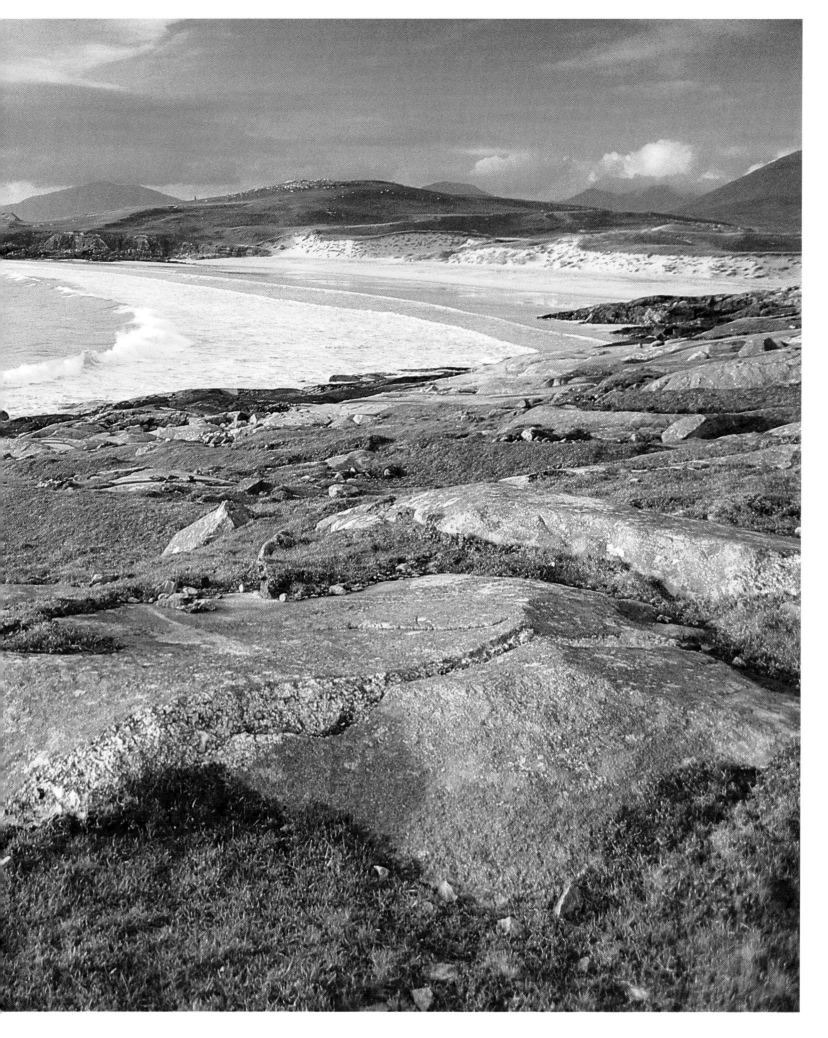

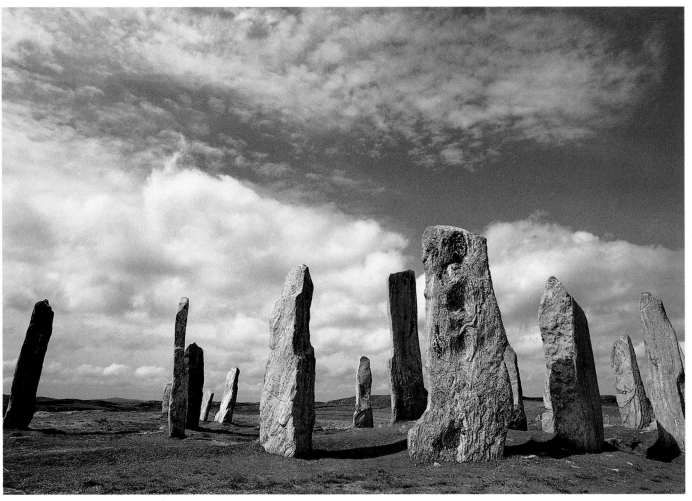

The Stones of Callanish on Lewis were probably erected between 2000 and 1500 BC. The stone circle was used in the rites of cults of the sun and of the dead as well as for observing the sky.

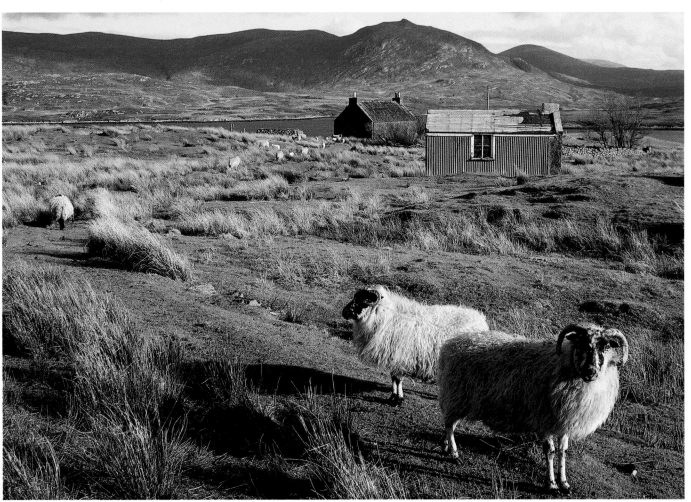

Apart from the materials used for some buildings, as in this corrugated-iron hut near Balallan, little has changed over the centuries on Lewis, where life is characterised by the harsh landscape, the Gaelic language and strict Sunday observance.

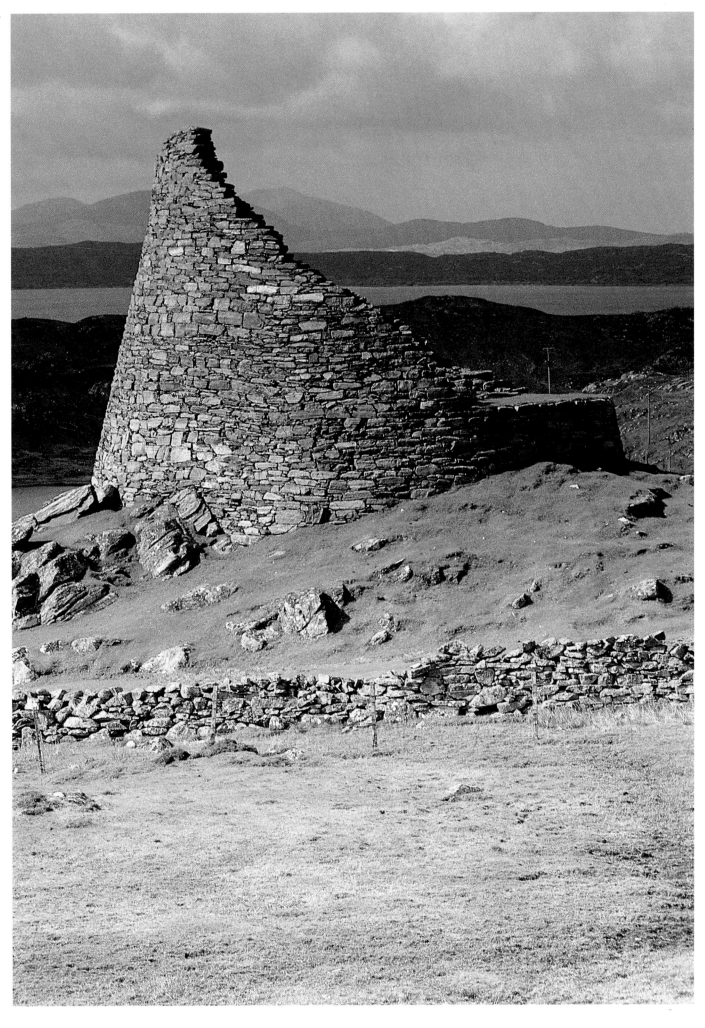

The Broch of Carloway on Lewis is one of the best-preserved Pictish round towers from the 1st to the 4th centuries.

Black-headed sheep produce the wool for Harris tweed. Three-quarters of the cloth, guaranteed by the symbol of the Maltese cross on an orb, goes for export.

Wide horns, tousled tawny hair and small size are the most striking characteristics of the tough Highland cattle.

Top left: the 'black house' at Arnol on Lewis, a typical old Highland cottage. The smoke rises from the peat fire in the middle of the floor, insulating the roof.
Top right: Harris tweed is still produced by home-workers on old handlooms, as here in Plockrapool.

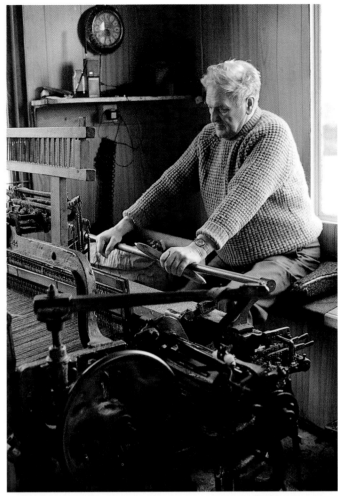

Will this little girl on the barren island of North Uist be prepared to put up with the hard life when she grows up? The numbers of those moving away are high.

Overleaf: the idyllic harbour of Kirkwall, the capital of the Orkneys, confirms the saying that the Orcadian is a farmer with a boat, the Shetlander, on the other hand, a fisher with a cow.

91

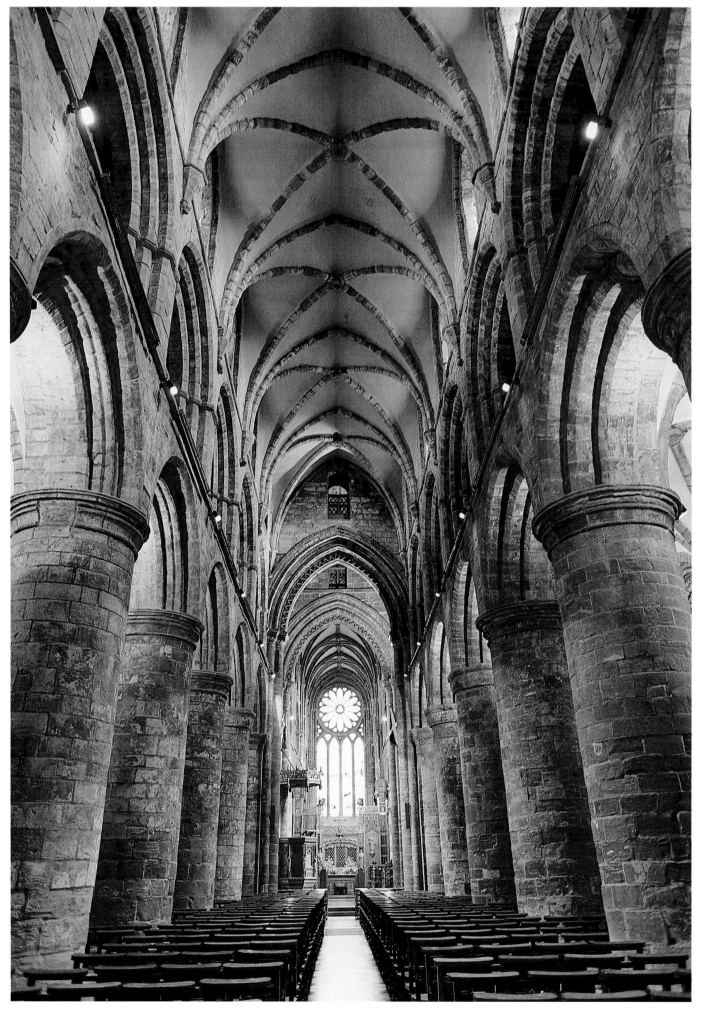

The construction of St Magnus Cathedral in Kirkwall lasted from 1137 until the 15th century. The romanesque pillars and early Gothic vaulting combine harmoniously in a building which survived the Reformation and Cromwell's soldiers undamaged.

St Magnus Cathedral, Kirkwall: remarkable details such as the memorial in the interior with its reminder of death and promise of a crown as a reward for virtue and humility (top left), and the side portal in the west front (top right).

The traveller in Scotland will find many hotels in historic buildings, or at least with a historical façade; here the Albert Hotel in Kirkwall.

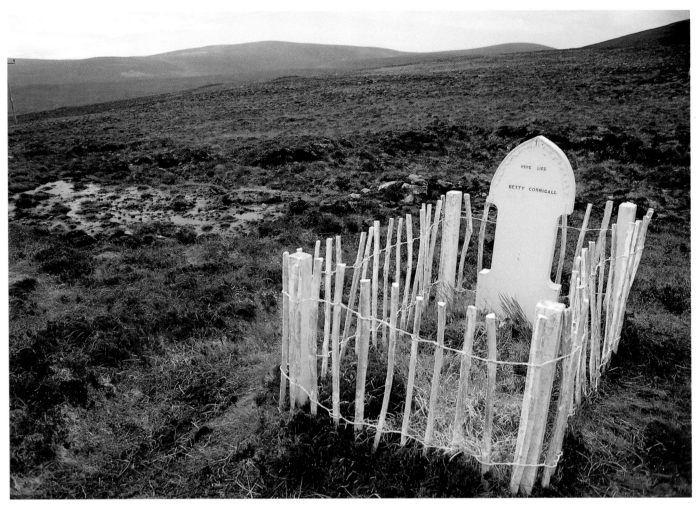

Pregnant and abandoned by her sailor lover, Betty Corrigall, a young girl on the island of Hoy, took her own life. Since at that time suicides could not be buried in consecrated ground, she has a lonely grave on the moors; the gravestone is a later addition.

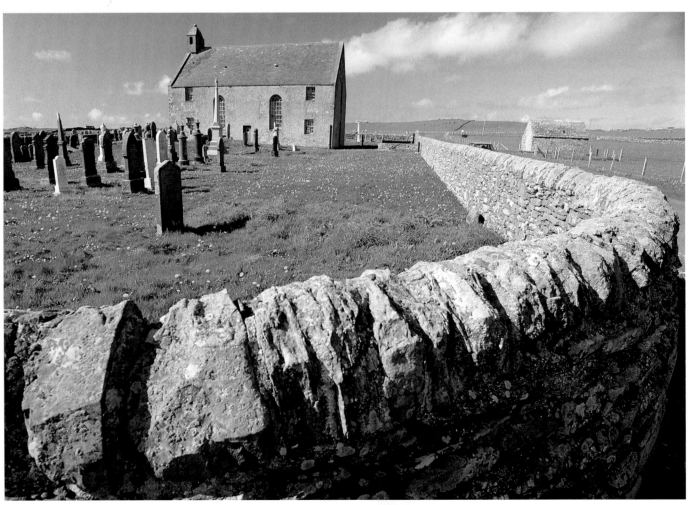

The visitor to the Orkneys is surprised to find many small churches standing alone in the landscape, as here by Marwick Head.

96

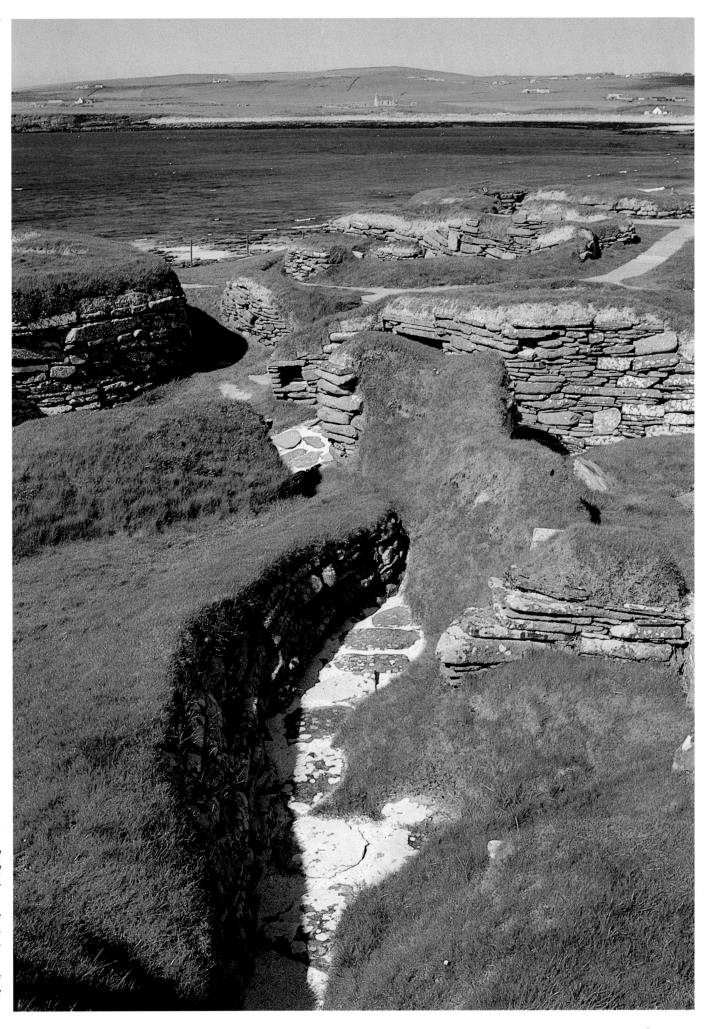

Skara Brae is one of many Stone Age excavations on the Orkneys. This settlement grew up between 3100 and 2450 BC and contains seven houses with stone furnishings and tools.

Overleaf: rough, barren moorland and steep cliffs of red sandstone characterise the island of Hoy, whose distinctive feature is the 120m-high stack known as The Old Man of Hoy. The first ascent in 1966 is said to have taken three days.

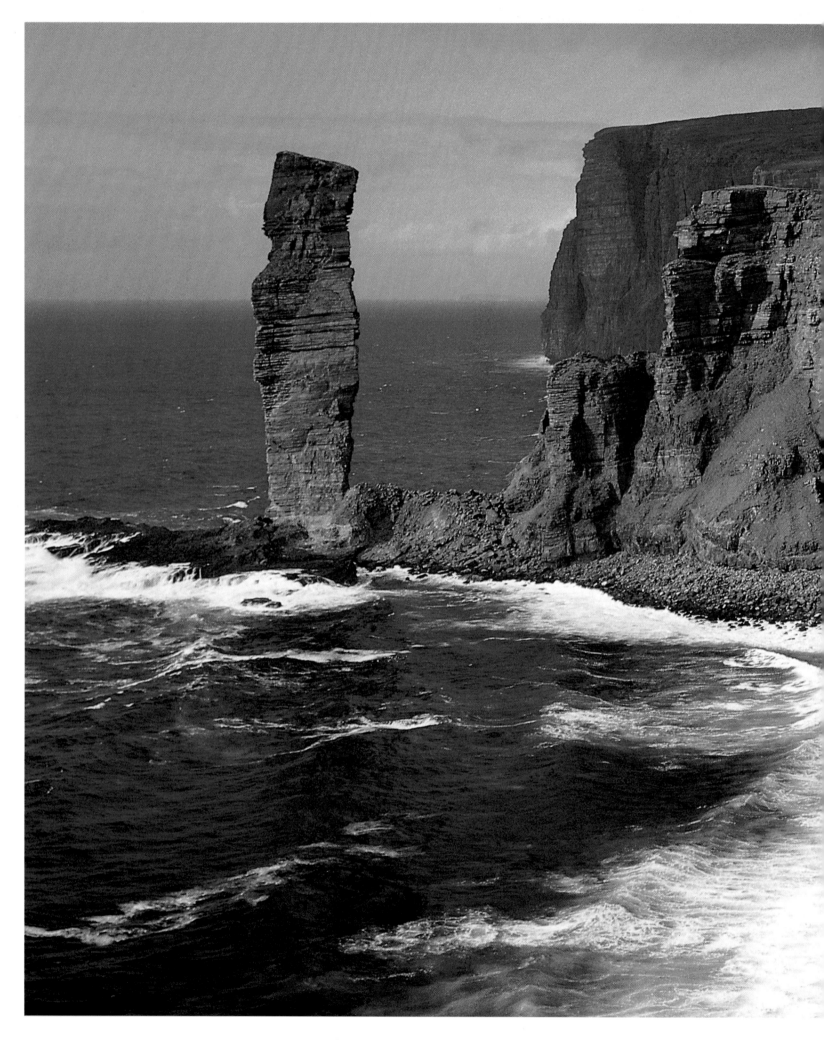

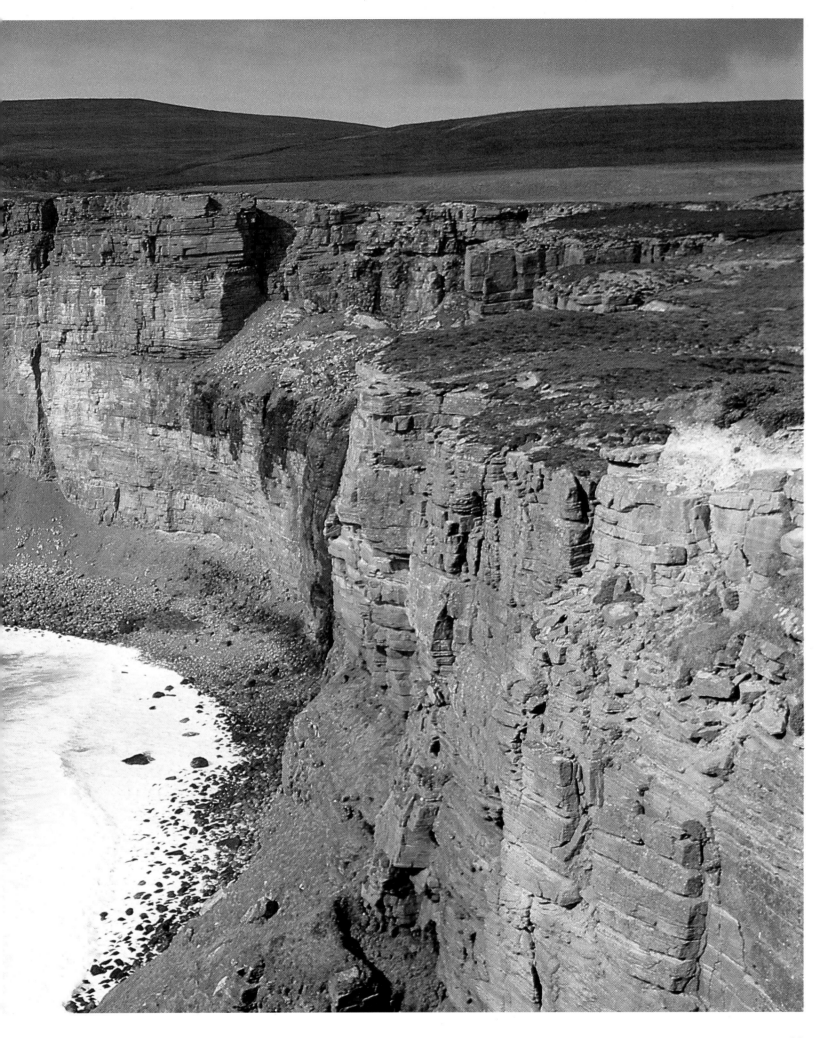

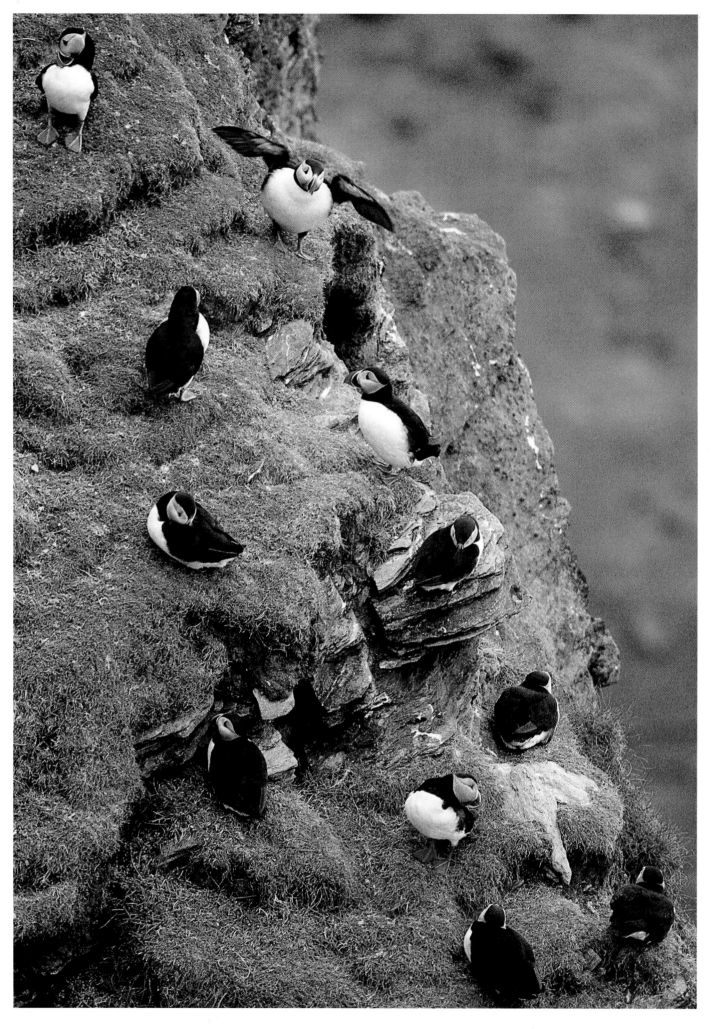

A puffin colony on the Shetlands. For breeding sites, puffins prefer cliffs or grassy slopes where they can make their burrows that go a metre back into the hillside.

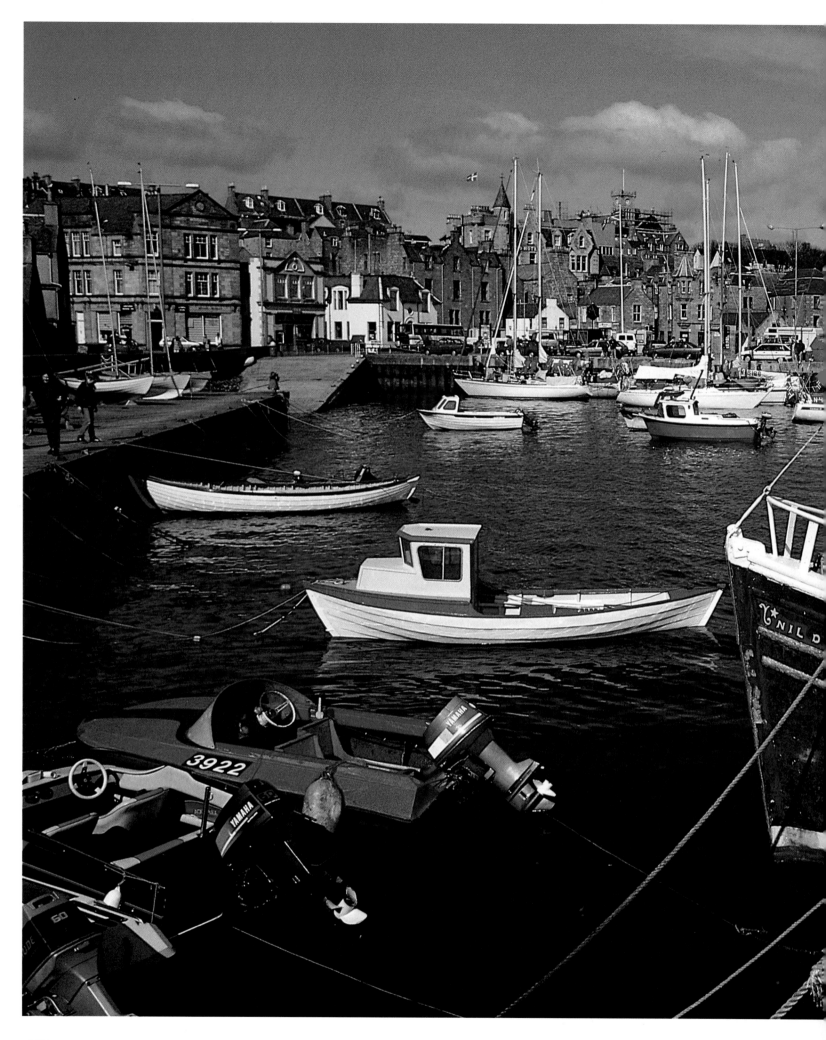

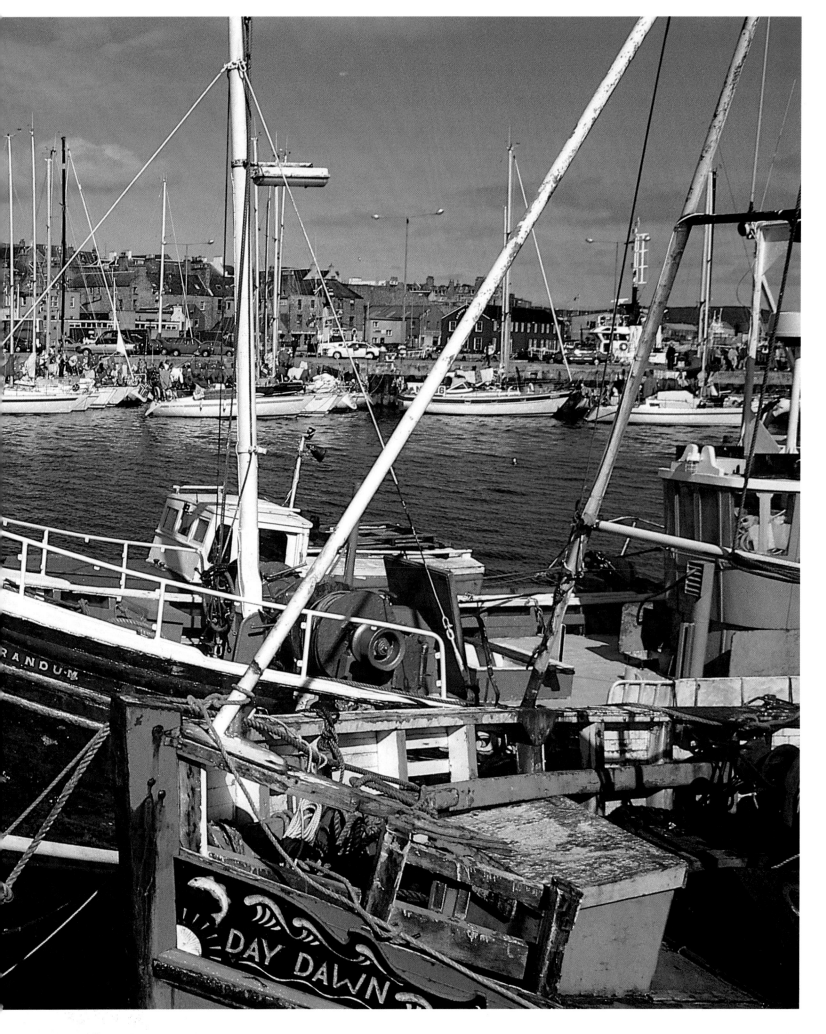

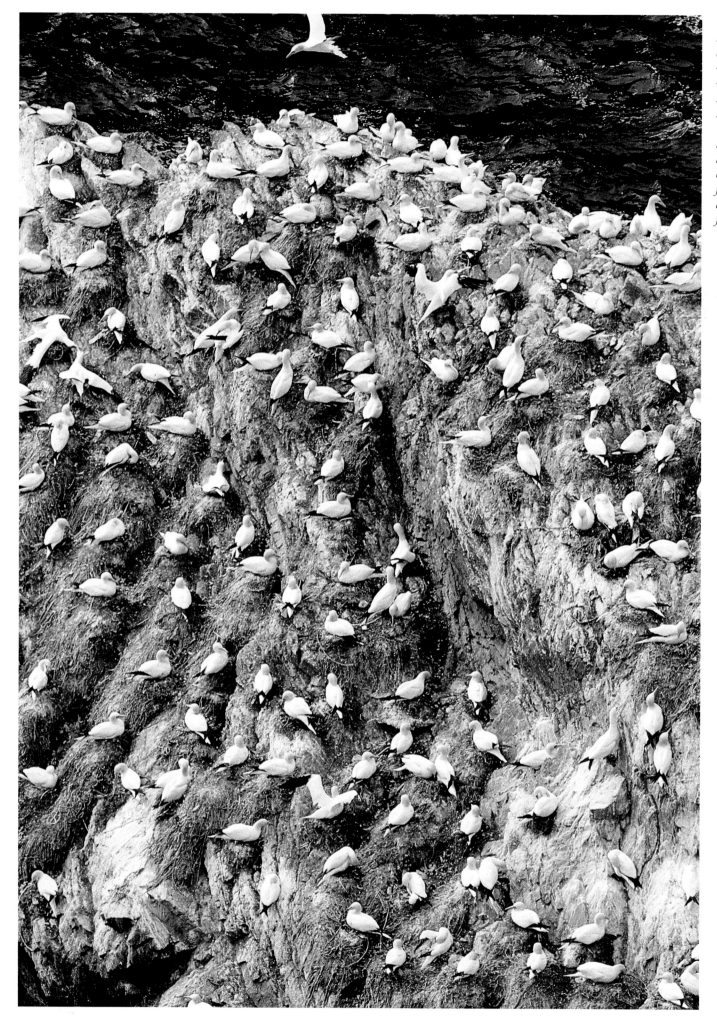

The Shetlands have several breeding colonies of gannets; with their 1.75m wing-span they are some of the largest seabirds in Europe. The great threat to these birds comes above all from overfishing of their feeding grounds by commercial fishing fleets.

Travel Guide

Roland Hill

Contents

General information

Situation and size

The northern part of the British Isles took its name from the Celtic tribe of the Scots who came from Ireland during the 5th and 6th centuries and created the Scottish nation through the conquest of and intermarriage with another Celtic tribe, the Picts. Scotland covers an area of 78,772 square kilometres and had, in 1992, a population of 5.1 million. That means that one eleventh of the population of Great Britain inhabits one third of its total surface area, making Scotland one of the most sparsely populated areas of western Europe (inhabitants per square kilometre: England 362, Germany 227, France 95, Scotland 65). It lies between 54° 38′ and 60° 51′ north and between 1° 45′ and 6° 14′ west; it is bounded in the west and north by the Atlantic Ocean, in the east by the North Sea and in the south by the range of the Cheviot Hills, which stretches along the southern border for 90 kilometres.

Geographical divisions

Scotland can be divided into three geographical zones: one, comprising almost half of Scotland, consists of the Highlands and the Western Isles, relatively sparsely populated nowadays. The second is the central belt of the Lowlands, containing roughly three-quarters of the population and the most important industrial areas as well as cultivated agricultural land.

(Since this area has hills and rolling countryside, the designation 'Lowlands' is, basically, wrong.) Thirdly there are the Southern Uplands – gentler than the wild Highlands, the highest point being the Merrick (815m) in the Galloway Hills – bordering England with magnificent scenery, some of it made famous by the novels of Sir Walter Scott. The highest mountains in Scotland are the Grampians in the Central Highlands with Ben Nevis, at 1343m Britain's highest peak. The most important cities are the capital, Edinburgh, the industrial city of Glasgow, and Aberdeen and Dundee as regional centres.

Political and administrative structure

The victory of Robert the Bruce over Edward II at the Battle of Bannockburn (1314) ensured that Scotland remained a separate kingdom until the English and Scottish crowns were united in 1603 under James VI of Scotland, the son of Mary Stuart. It is one of the ironies of history that, as James I of England, he was to succeed Elizabeth I, the Tudor 'Virgin Queen', the cousin and murderer of his mother. England and Scotland continued to be administered separately, however, apart from the short period of forced union under Oliver Cromwell in the middle of the 17th century, but in 1707 the Scottish and English parliaments decided to combine in order to achieve closer political and economic union.

Exactly 290 years later the Labour government under Tony Blair kept its election promise to hold a referendum on

Scottish devolution; 74.3 percent voted in favour, 25.7 percent against. However, the turnout of only 55.5 percent suggested that the Scots, who know a bargain when they see one, continue to rate the tax advantages of the association with Westminster above independence within the EU. The Westminster parliament retains responsibility for foreign relations, defence and security, employment, social welfare and the final decision in economic and financial matters.

The economy

Scotland, like England and Wales, has been forced to give up its traditional industries and adjust to developments in electronics and the new technologies. With foreign investment, the North Sea oilfields and the gas industry have brought about a decided technological upturn.

Mechanical engineering remains an important sector, still providing employment for a quarter of the workforce. But the trend is to light industry, especially electronics; in 1988 there were 230 firms in that sector with 44,000 employees, giving Scotland one of the highest concentrations of the electronics industry in western Europe: 60 percent of the circuits produced in Britain and more than 11 percent in the EU are made in Scotland. While traditional industries such as coal, steel and shipbuilding are in decline, the production of high-quality tweeds and other textiles remains an important contributor to the Scottish economy, and more than 100 distilleries ensure that whisky is still one of Britain's main exports.

Scotland has around one third of Britain's agricultural land. 71 percent consists of hill grazing and 11 percent is made over to arable farming, 58 percent of that producing oats. Scotland has almost half of Britain's forestry and is responsible for over

40 percent of the wood produced by Forest Enterprise. Fishing remains an important, though increasingly endangered sector of employment; more than three-quarters of Britain's catch is landed at Scottish ports.

As far as energy is concerned, Scotland is more dependent on nuclear power than the rest of Britain, 60 percent coming from that source. A particularly valuable resource in Scotland is its large supplies of clean water.

Cultural life

Scotland has a rich cultural life, of which the international festival of the arts in Edinburgh is the annual highlight. The Royal Scottish National Orchestra, Scottish Opera and Ballet – with their headquarters in Glasgow – the Scottish Chamber

Aberdeen: the headquarters of the Salvation Army (left); with its neo-Gothic façade of 1905, Marischal College (middle), founded in 1593, is the second-largest granite building in Europe after the Escorial in Spain.

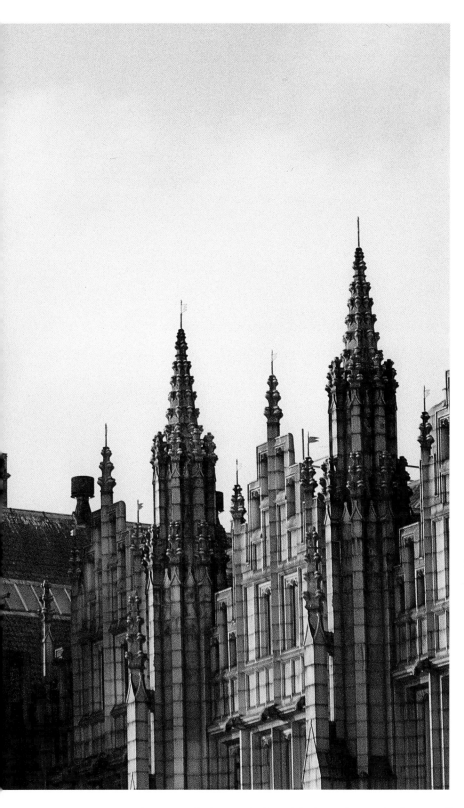

The chapel of King's College belongs to the oldest part of Aberdeen University, which was founded in 1494. King's College houses the arts, Marischal College the sciences.

Scotland and three commercial channels, while BBC Radio Scotland covers the whole of the country. Scotland now has 12 universities with a total of 120,000 students. The three oldest, St Andrews, Glasgow and Aberdeen, were founded in the 16th, Edinburgh in the 17th century, the most recent in the 1960s – Strathclyde, Heriot-Watt, Stirling and Dundee – and again in the 1990s – Robert Gordon's, Abertay, Napier, Glasgow Caledonian and Paisley; a University of the Highlands

and Islands is being set up. They are particularly famous for medicine and law, mechanical engineering and agriculture. The extraction of North Sea oil has led to the establishment of courses in that field.

Orchestra and the BBC Scottish Symphony Orchestra all enjoy a high reputation, and the art galleries in Edinburgh and Glasgow, as well as in many castles, are rich in artistic treasures.

There are some 66,000 Gaelic speakers in Scotland, mostly on the islands or in the north-west of the country. It is a language with its own literary tradition. Scots, the vernacular spoken in the rest of the country, developed from the same roots as English; indeed, until the 16th century Scottish writers called their language 'English'. In the 20th century it has increasingly been used as a vehicle for literature again. The dialect spoken in Glasgow is practically incomprehensible to outsiders.

Scotland has a vigorous press, with six national dailies and four Sundays; television programmes are broadcast by BBC

A–Z of places worth visiting

Circled numbers relate to the map on p. 155.

Abbotsford ① close to Melrose Abbey, is the house of Sir Walter Scott (1771–1832), also containing a museum with many objects connected with the famous writer, whose novels led to the popularisation and romanticisation of everything Scottish.

Aberdeen ②. Founded in 1179, the third largest city in Scotland (pop. 213,000) is called the 'Granite City', after the stone used for its fine old buildings (Old Aberdeen). The harbour goes back to the 12th century and it is only in recent years that the city, until then known as a fishing port and cattle market, has become the centre of the North Sea oil industry, with hotels, restaurants and nightlife for the workers in need of relaxation after a stint on an oil platform.

St Machar's Cathedral (14–15th century), a building with a spartan feel to it, probably stands on the spot where the Celtic

saint of the same name settled in 580. The fine oak ceiling, decorated with heraldic emblems, is from 1526. King's College Chapel (1500–5), with its attractive Renaissance tower, was part of Aberdeen's first university college, which was combined with the Protestant Marischal College (1593) to form Aberdeen University (6500 students) in 1860. Aberdeen's parks and gardens are well worth a visit, as is the Art Gallery, with its good collection of modern Scottish art.

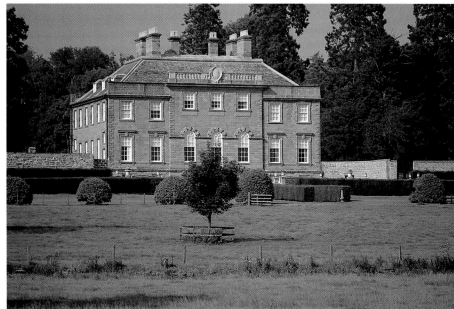

From Aberdeen an excursion to Deeside (see entry) with its many castles is recommended.

Aberdour ③ (Fife) the village (pop. 1567) on the Forth estuary, 8km from the northern end of the Forth Road Bridge, is popular for its sandy beaches, water sports and as a sailing centre. It is best known, however, for the 12th century St Fillan's Parish Church and Aberdour Castle. The latter is the seat of the Earls of Montrose, a branch of the Douglas family, which inherited the castle in 1325 from Thomas Randolph, Earl of Moray, a nephew of Robert the Bruce. James Douglas, fourth Earl of Morton, was Regent of Scotland before Mary Stuart's son, James VI, came of age. Fourteen years later Morton, who was also involved in the fall of Mary Stuart, was accused of the murder of her husband, Lord Darnley, found guilty and executed in 1581.

The ruined castle, which goes back to the 14th century and has been considerably enlarged over the centuries, still has the original tower. It has a decidedly melancholy air, perhaps because of its association with one of the oldest and finest of the Scottish ballads, 'Sir Patrick Spens'. On the recommendation of a false friend, Spens was appointed commander of a winter expedition to bring the king's bride from Norway and was

drowned with his fleet off Aberdour: 'And lang, lang may the maidens sit/ Wi' their gowd kames in their hair,/ A-waiting for their ain dear loves!/ For them they'll see nae mair./ Half-owre, half-owre to Aberdour,/ 'Tis fifty fathoms deep;/ And there lies gude Sir Patrick Spens,/ Wi' the Scots lords at his feet.'

From Hawkcraig Point in Aberdour (only recommended for calm days) one can cross to the tiny island of Inchcolm, off which Sir Patrick found his watery grave. With St Columba's Abbey, an Augustinian abbey founded by Alexander I in 1123, Inchcolm is often called the 'Iona of the East'. An Irish hermit, a Columban monk, saved the king's life when his ship was wrecked on the rocky coast and he gave thanks to God by founding the monastery. The abbey, above all the octagonal chapter house from the 13th century, the cloisters and the canons' cells from the 14th century, contains some of the best-preserved medieval buildings in Scotland.

Arbroath ④ (Angus, pop. 22,586) is an old fishing port on the Angus coast, where the celebrated 'smokies', haddock smoked by a special method, are made. The ruins of the Benedictine Abbey (1178), where Robert the Bruce signed the Scottish declaration of independence after the battle of Bannockburn, is worth a visit.

Left: a hotel in Braemar, where the best-known Highland Games are held; top right: the House of Dun (Angus); bottom right: the gravestone of Burns's father in the graveyard of Alloway church, where Tam o'Shanter saw the witches who pursued him…

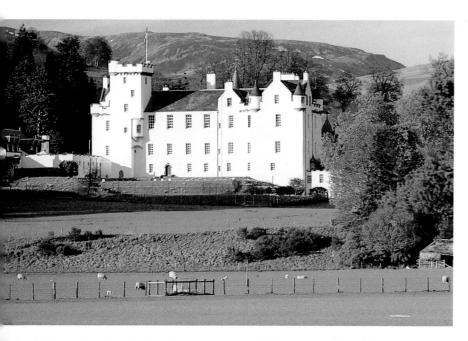

On New Abbey Road to the south of Dumfries is the delightful ruined Sweetheart Abbey, the last Cistercian foundation in Scotland. The unusual name is explained by the fact that the founder, Devorguilla de Balliol, always carried the embalmed heart of her husband, John de Balliol who died young, around with her in a casket, which was buried with her before the high altar of the abbey church. John de Balliol was the founder of the famous Oxford College that bears his name.

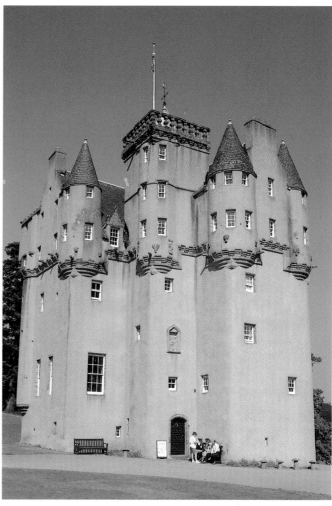

...until he crossed the Brig o'Doon (bottom left). Top left: Blair Castle was renovated in the Scottish Baronial Style in 1869. Right: Craigievar Castle, designed by John Bell and constructed between 1610 and 1626, is one of the most impressive tower houses of the Highlands.

Ayr ⑤ (pop. 47,896), in the middle of the rolling Burns country, is the ideal centre for following the traces of Scotland's bard. Starting at the medieval Auld Brig he immortalised, one can proceed via Tam o'Shanter's Inn (230 High St, now a museum), from which Tam set out on his famous ride, then drive south to Alloway, with the cottage where Burns was born, and Alloway Kirk, where his father is buried and Tam saw the witches dancing, before continuing to Kirkoswald and Souter Johnny's Cottage with its lifesize statues of the two cronies, Tam o'Shanter and Souter Johnny, sitting in the garden, ale-mugs in their hands.

Our Burns tour ends, appropriately enough, in Dumfries (pop. 29,382), known as the 'Queen of the South' (the name of its football team), where the Burns mausoleum can be seen in which the poet is buried, together with his wife, children and friends (Burns House). The Globe Tavern and the Hole in the Wa' were the poet's favourite inns where we too can raise a glass to the author of the famous 'Auld lang syne', even if we can scarcely understand his dialect poems (see also p. 43).

In a beautiful setting on a slight rise (private property) above the point where the road to Glenkiln forks off from the A75, some modern sculptures can be seen, including the early 'King and Queen' by Henry Moore and works by Epstein and Rodin.

In Dumfries and Galloway it is worth stopping at the little town of Kirkcudbright (pronounced 'Kirkoobry'). There are several ruined castles in the surrounding area, for example Threave, near Castle Douglas, with Threave Garden, run as a horticultural college.

Bannockburn see Stirling.

Birnam see Perth.

Blair Castle ⑥ (Perth and Kinross), strategically placed on the route to the Central Highlands, was built at the beginning of the 13th century. The castle belongs to the Duke of Atholl and for centuries connected his family with the Scottish aristocracy, the Montrose, Stewart and Murray families. With its beautiful silver, furniture and pictures, as well as mementos of Mary Stuart, of Elizabeth, the 'Winter Queen' of Bohemia and, of course, of Bonnie Prince Charlie – Lord George Murray was the general who won the battle of Prestonpans for him – the castle is a must among the hundreds of Scottish castles and fortresses. In the last Sunday in May the Atholl Highlanders hold their parade. They are the only private army in Britain; Queen Victoria granted an ancestor of the present duke the right to raise it.

Cawdor Castle see Inverness.

Craigievar Castle ⑦ (42km west of Aberdeen), one of the finest tower houses from the 17th century, is worth a detour on the A980 from Alford. It was built in the Renaissance style by 'Danzig Willie' (William Forbes, a merchant who had made a fortune in the Baltic trade) shortly before the country was plunged into 20 years of civil war. The castle was not damaged.

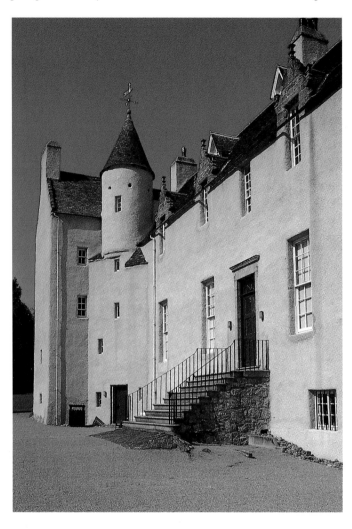

Culloden Moor see Inverness.

Culross ⑧ (pronounced 'Kewrus', Fife). In this old burgh (pop. 460), 16km to the west of the northern end of the Forth Road Bridge, the Palace, one of the jewels of the Scottish baronial style, restored by the National Trust for Scotland, is well worth a visit. Sir George Bruce, a merchant who, like his contemporary 'Danzig' Willie Forbes (see Craigievar Castle), had got rich through the Baltic trade, built it for himself between 1597 and 1611, in a position overlooking the harbour, which was once one of the biggest in Scotland and as important as Liverpool. The interior – with its pine panelling from the Memelland on the Baltic, its Dutch floor tiles, a fireproof room to keep documents and bills of exchange, half-glazed windows (the other halves were left unglazed to save on window tax), old pictures, heraldic decoration, figures and ceilings with allegorical quotations from the Bible – testifies to Sir George's taste.

A large monument with alabaster portraits of Bruce, his wife and eight children is in what is now the Parish Church, formerly the monks' choir of the Cistercian monastery, founded in 1217. Nearby (on the Dunfermline road) is the ruin of St Mungo's Chapel, where the patron saint of Glasgow, also called Kentigern, was born.

Today Drum Castle (left) is a charming museum, full of surprises, from the rich collection of paintings to the table set ready for a meal in the dining-room.

Culzean Castle ⑨ (pronounced 'Culain', South Ayrshire). The medieval tower house, set in a dramatic situation on a cliff above Culzean Bay 16km to the south of Ayr, was transformed in the late 18th century by the great Scottish architect, Robert Adam (1728–92), for the 10th Earl of Cassillis, into a showpiece of the 'age of elegance' with its fine interior including a magnificent oval staircase and the round drawing-room on the first floor, for which Adam himself designed the furnishings. Culzean Country Park, with a neo-Gothic camellia house, an orangery and a lake

Right: the special attractions of Crathes Castle on the Dee are its painted wooden ceilings and the garden laid out in geometrical design from the 18th century.

Every August the traditional Highland Games are held in Ballater in the presence of the Queen, with traditional Highland sports such as throwing the hammer and tossing the caber: the skill in the latter event lies not in throwing the long pine trunk a great distance, but high enough for it to turn over in the air.

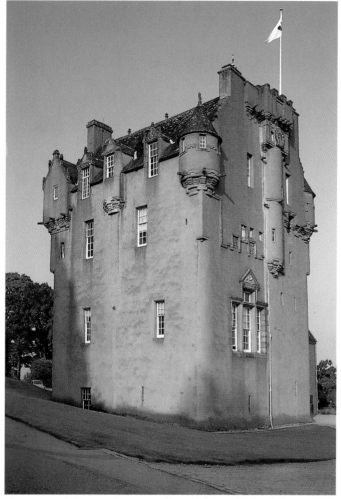

with swans, has a visitor centre; it is at its most beautiful in July and August.

Deeside ⑩ (Aberdeenshire). Salmon, the king of fish, is so plentiful in the area round the raging Dee that for that alone it would deserve the name 'Royal Deeside'. But the Dee is rich not only in salmon and trout, but also in royal associations: Balmoral Castle, bought by Queen Victoria and Prince Albert, is the summer residence of the royal family; Braemar Castle, Craigievar Castle (see entry), Crathes Castle and Drum Castle all stand on the banks of the Dee.

Doune ⑪ (5km to the west of Dunblane, Stirling) lies on one of the main routes to the Central Highlands. The town has 3977 inhabitants and in the 17th and 18th centuries was famous for its guns and pistols, the main customers for which were the Highland freebooters. Doune Castle, which can be reached from the A820, is one of the best-preserved ruined castles in Scotland. Built in the 14th century by Robert, Duke of Albany and his son Murdoch, it came into the possession of the king after the execution of Murdoch, then into that of the Stuart line of the Earls of Moray. With its own water supply, the 30m-high, free-standing gate tower was capable of withstanding a lengthy siege. An arched entrance leads into the courtyard with dungeon and store-rooms. There was a mechanism for lifting provisions into the castle during a siege. An easily defended outside staircase leads to the Duke's Hall on the first floor; a staircase beside the large double hearth leads down to the private bedrooms of the lord and his family, which have an escape route via an opening in the floor and a passage connecting them with the main tower: it is a self-enclosed unit. The rooms for soldiers and retainers were reached by a second outside staircase in the courtyard, which also led to the large kitchen area in the second tower, the upper floors of which contained living quarters for the king and other visitors. Given the good state of preservation of the

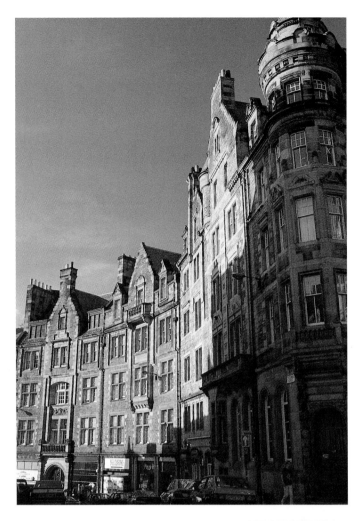

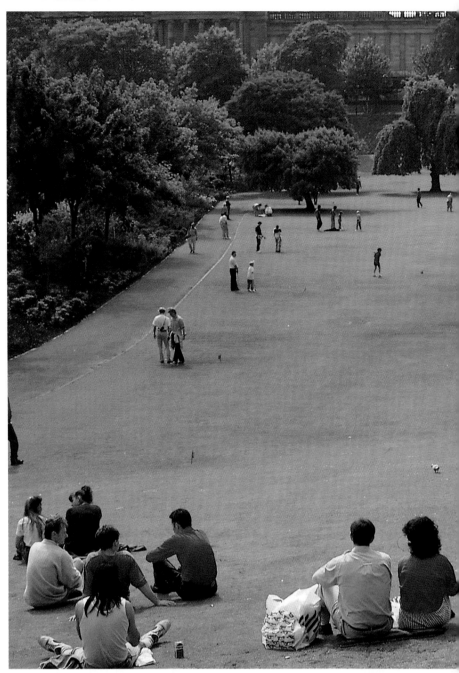

Edinburgh: with its narrow façades, gables, arcades and staircases, Cockburn St (top left), off the Royal Mile (bottom right), is typical of the houses in the old town. Even today Dean Village (bottom left), the bakers' district in the 12th century, has retained its village atmosphere. Middle: West Princes St Gardens – a patch of green, a putter and a white ball are enough to bring out the golf fanatic in any Scot. The tourist can relax here after a morning shopping, viewing the sights or in the National Gallery.

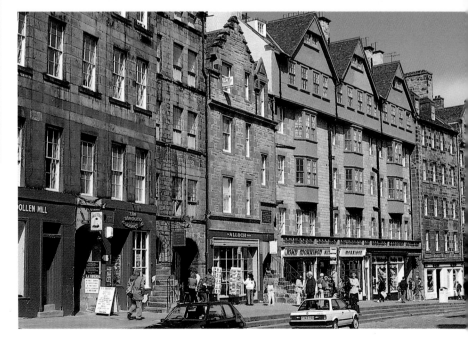

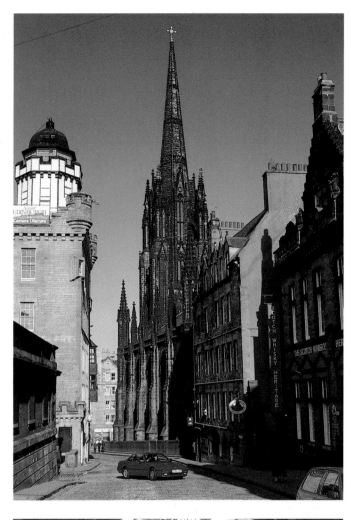

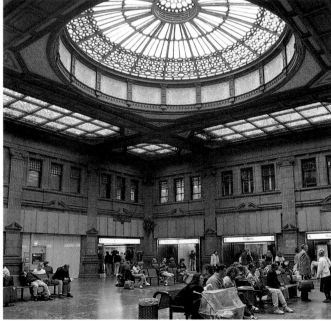

Edinburgh: Waverly Bridge over the railway, where there was originally a loch that was drained beginning in 1769 (bottom left). Top right: the Tolbooth Church and, on the left, the Camera Obscura, which offers the tourist an unusual view of Edinburgh as part of a multimedia show. Bottom right: Waverly Station, the main station in Edinburgh with the information office of the Scottish Tourist Board. The Waverly Steps that lead up from the station to Princes St are called, not without justification, the windiest spot in Britain. The photograph shows the waiting room.

113

castle, it is easy to imagine what the daily life of man and his domestic animals was like in those days.

Artefacts from more modern times can be seen only 2km away in the Doune Motor Museum, containing Lord Moray's interesting collection of vintage and veteran cars from 1905 to 1966. Its many exhibits include Hispano Suizas, Bentleys, Aston Martins and the second-oldest Rolls Royce in the world.

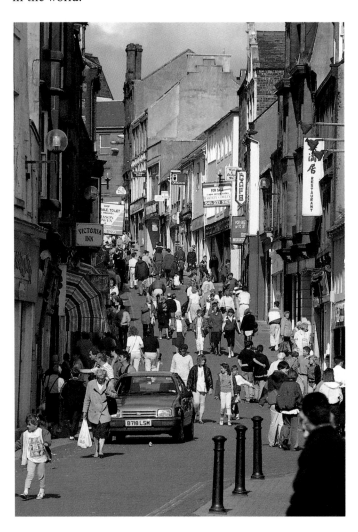

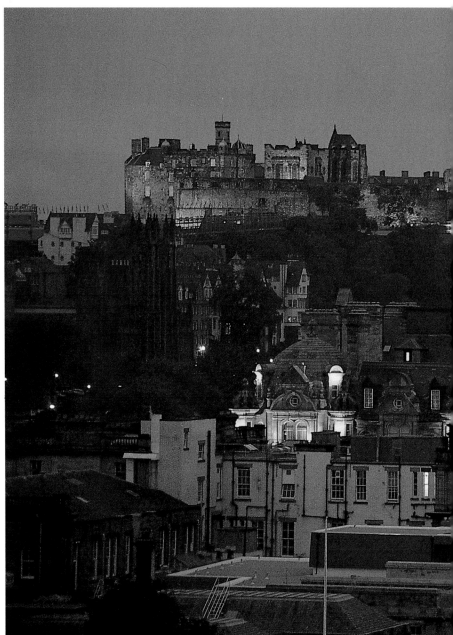

Dryburgh Abbey see Melrose Abbey.

Dumfries see Ayr.

Dundee ⑫. Scotland's fourth largest city (pop. 182,000), situated between the northern bank of the Tay and the Sidlaw Hills, is a busy seaport and the home of marmalade and the (former) British jute industry; the last jute mill was turned into a museum in 2002.

Scott of the Antartic's ship *Discovery* lies in Victoria Dock. Nearby is the Tay Road Bridge, with its 42 arches and a length of 2.2km one of the longest bridges in Europe, and the 3km-long Railway Bridge that achieved sad notoriety when, on a stormy night only 19 months after its completion, it collapsed, taking a train and all 75 passengers with it into the waters of the Tay estuary (see also p. 80).

Dunfermline ⑬ (Fife). The mining and industrial town (pop. 49,987) is an old centre of the Scottish weaving industry. Andrew Carnegie (1835–1919), later to become an American steel magnate and philanthropist, was born there the son of a handloom weaver. The house where Carnegie was born in Moodie St is worth a visit, as is the Dunfermline District Museum in Viewfield, which presents the history of the once flourishing linen industry ('Dunfermline damask'). The fine Pittencrieff Park in the heart of the town is only one of the many benefactions Andrew Carnegie made to places in the United States and Europe. He presented it to the town of his birth together with the 17th century Pittencrieff House.

The real significance of the 'auld grey town' derives from its status as a former capital of Scotland and from its connection with the abbey which the conqueror of Macbeth, Malcolm III (Malcolm Canmore, 1031–93) and his queen Margaret (1045–93) built to replace an old Celtic church. It was later occupied by Benedictines from Canterbury. With the graves of 22 Scottish kings, from Malcolm Canmore to the Stuarts, arranged, as on Iona, in long rows, Dunfermline Abbey could be called the Westminster Abbey of Scotland. The names on the gravestones are no longer legible, but in the early 19th century the grave of Robert the Bruce, who died of leprosy in 1329, was found with his skeleton encased in lead. On his deathbed he asked his nephew, Sir James Douglas, to take his heart to the Holy Land, bury it in Jerusalem and do penance in his place for the murder of Red John Comyn, his rival for the throne. He had been excommunicated by the pope for the deed. However, his nephew was killed on his way to Jerusalem in a battle against

Left: the centre of Dumfries, a picturesque town on the river Nith; centre: Edinburgh Castle with, in the right foreground, the tower of the North British Hotel.

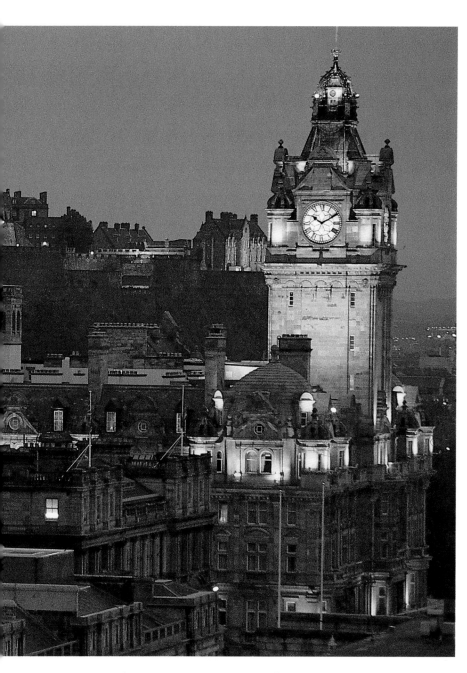

Dunstaffnage Castle see Oban.

Edinburgh ⑮ (pop. 433,500; 261km²). Situated not far from where the Firth of Forth cuts deep into the land, Scotland's capital is sometimes known as the 'Athens of the North', from the new ideas that blew through it in the 18th century; the wind that blows through it almost every day, however, is all Edinburgh's own. When it was still wreathed in the

Right: St Manus Galleries in Dundee, a city made famous above all by jute, marmalade and comics.

the Moors in Spain. Bruce's heart was saved, brought back to Scotland and buried in Melrose Abbey (see entry).

The last of the Scottish royal family to be born in the Palace, today a ruin, were Charles I (1600–49) and his sister Elizabeth (1596–1662), the 'Winter Queen' of Bohemia.

Dunkeld ⑭ (Perth and Kinross). Although today a village (pop. 273), Dunkeld, situated on the Tay 22km to the north of Perth and in the middle of 'Macbeth country' (see Perth), is the seat of a bishopric founded in the early 12th century by Alexander I. It was stormed by the Highlanders after their victory at Killiecrankie (see Pitlochry) in 1689 then recovered by their opponents, the Cameronians, for William of Orange and his wife Maria. The interior decoration of the Cathedral, which was built between the 14th and 16th centuries and houses some fine medieval gravestones, was destroyed during the conflicts of the Reformation. The 'little houses' in Cathedral St were built after the defeat of the Stuarts; in 1950 they were saved from demolition and restored by the National Trust for Scotland.

Three kilometres to the north-east of Dunkeld, on the A923, is the Loch of the Lowes, a nature reserve where one can observe nesting ospreys and other protected birds from a hide.

smoke from its coal fires the Scots also used to call it 'Auld Reekie'.

Dominating the Edinburgh skyline is the 134m-high Castle Rock, a basalt plug with the medieval Castle and the little, 11th-century Norman chapel dedicated to St Margaret. The Celtic name for this, Din Eidyn ('fort on a cliff'), was anglicised as Edinburgh ('Edwin's castle' after an Anglian king of Northumbria) following the conquest of the city by the Northumbrians in 638. In 1329 the settlement that had grown around the castle was granted a charter by Robert the Bruce. From the early 15th century it was the capital and, walled after 1450, the residence of the early Stuart kings. In 1560, when Mary Stuart was queen and John Knox preaching in the cathedral, the Reformation came to Scotland. When, after the union of the crowns under Mary's son, James I, the court was moved to London, Edinburgh's importance (especially in cultural matters) was greatly reduced. However, in 1633 the new king, Charles I, was still crowned in Holyroodhouse. During the English Civil Wars the city remained loyal to the Stuarts and was besieged by Cromwell's troops. After the Edinburgh parliament was amalgamated with that of Westminster in 1707, Edinburgh became above all a city of lawyers. The Jacobite uprising of 1745 and the short-lived

return of the Stuart court to Holyroodhouse, meant Edinburgh could once more dream of being the Stuart capital, but the mercenaries of the Hanoverian Duke of Cumberland quelled the uprising.

But in the 18th century Edinburgh became a centre of cultural and intellectual life; among its luminaries were the philosophers David Hume and Dugald Stewart, the economist Adam Smith, the geologist James Hutton, the chemist Joseph Black and the architect Robert Adam. The overcrowding in the old town forced the city to plan and build the New Town stretching to the north of the present Princes St. This early example of a new style of town planning in Europe benefited from the construction of a number of magnificent public buildings such as the Theatre Royal (1768, demolished to make way for the General Post Office in 1860), the Register House (1774–1822), the Physicians' Hall (1777) and the Assembly Rooms (1787). The geometric town plan is relieved by many aristocratic town houses, elegant streets and spacious squares.

During the period of the Enlightenment Edinburgh took a leading role in the intellectual life of Britain. The novelist Sir Walter Scott created the Romantic image of Scotland and its past, literary periodicals such as the *Edinburgh Review* and *Blackwood's Magazine* enjoyed a worldwide reputation. Edinburgh became the city of the best British publishing houses (Constable and Chambers), booksellers and second-hand bookshops. The portrait painter Sir Henry Raeburn and architects such as Robert Reid, the Playfair brothers and Gillespie Graham all contributed to the renown of the 'Athens of the North'. After the First World War there was a revival of Scottish literature with writers such as Hugh MacDiarmid, Lewis Spence, Edwin Muir and Helen Cruikshank.

The National Gallery contains an outstanding collection of international and Scottish masters, the Portrait Gallery at the eastern end of Queen St houses a collection of pictures of famous Scots: kings and queens, scientists, poets and philosophers.

Princes St forms the central axis of Edinburgh, to the north is the New Town, to the south the old town. In Princes Street Gardens stands the 61m-high memorial to Sir Walter Scott, erected by the city to its famous son, who sits in pensive mood, enthroned beneath a Gothic canopy and surrounded by 64 characters from his novels and 16 other Scottish writers.

Along the Royal Mile that runs along the spine of the old town are St Giles Cathedral (1385–1495), which contains the grave and memorial of the Reformer John Knox, and Parliament House (1632–40), no longer used for its original purpose. The Royal Mile is in reality a jumble of streets in the old town that runs from the Castle to Holyrood Palace. Holyroodhouse, a palace lacking in style built around 1500, is the official residence of the Queen when she is in Edinburgh. In this castle it is easy to imagine the ghost of Mary Queen of Scots walking. The queen was foolish enough to fall in love with the libertine Lord Darnley, who then out of jealousy had her secretary, David Rizzio, murdered in one of the small chambers of the palace while she looked on (see also p. 13).

To the north-east of the city is Leith, the old port of Edinburgh. Long neglected, it is becoming fashionable again, with wine bars and restaurants along the waterfront. It was here that, on her return from France in 1562, Mary Stuart first set foot again in a country already starting to be torn apart by the birth pangs of the Reformation and the conflicts among the powerful nobles. Another landing in Leith that is not forgotten is that of the Hanoverian king, George IV in 1822, on a visit organised by Sir Walter Scott. In order to appear before his subjects suitably attired, the king is said to have worn a specially designed kilt over flesh-coloured tights – a dire warning to all non-natives to exercise caution when imitating any Scottish customs.

Falkland ⑯ (Fife), on the edge of the Lomond Hills, is one of the most delightful historic towns of Scotland. In the course of the bloody feuds of the early 15th century the old castle, which belonged to the Macduffs, Earls of Fife, came into the possession of the Stuarts. James IV (1473–1513) and James V (1512–42) built the palace that still stands in the Renaissance style. Following his defeat in the battle of Solway Moss, James V died there only a few days after he had received the news of the birth of his daughter, Mary Stuart, and prophesied she would be the last queen of Scotland. Within the Palace Gardens is the royal tennis court, built in 1539, where Mary Stuart may well have played; what is known for certain is that she played golf. Fine views out over the Howe of Fife.

Fort William ⑰ (Highland) is situated on Loch Linnhe in the Western Highlands, in the shadow of Ben Nevis, Britain's rather ungainly-looking highest peak (1343m, can be climbed, but care must be taken). The little town (pop. 4214) is a good centre for shopping and excursions in the surrounding area, for example (in the summer months) a trip by steam train to Mallaig (fish market and ferry to Skye). Events of interest are the Great Glen Sheepdog Trials, which take place every year at the end of July/beginning of August, the Highland Games and the Lochaber Agricultural Show in August.

Glamis Castle ⑱ (Angus), 18km to the north of Dundee, is an impressive building in reddish-grey stone with a large tower and several turrets. Originally built in 1372 but substantially extended in the 17th century, it was once the hunting lodge of the Lyon family, Earls of Strathmore. Duncan's Hall is the scene of Shakespeare's *Macbeth*. Glamis Castle belonged to the Queen Mother; Princess Margaret was born there. it is surrounded by a beautiful Italian garden.

Ten kilometres to the west of Glamis is Meigle, the legendary burial place of Queen Guinevere, the beautiful but faithless wife of King Arthur. Meigle Museum has a splendid collection of Pictish carved stones from both the pre-Christian and early Christian eras.

Glasgow ⑲ (pop. 703,200, 198km²). Scotland's most densely populated city, its most important industrial centre and major port, is the fourth largest in Britain and has started, since its year as Cultural Capital of Europe, to challenge Edinburgh with, for example, Scottish Opera and the new Gallery of Modern Art. Outstanding, too, are the Burrell Collection, the Hunterian Art Gallery, belonging to the University of Glasgow, with paintings from the 19th and 20th centuries and the Mackintosh wing with the faithful reconstruction of an interior by Charles Rennie Mackintosh (1888–1928), the Glasgow architect who inspired the European style of art nouveau. Mackintosh's memorial is the Glasgow School of Art, which he designed at the age of 28; it contains a collection of his furniture, designs and paintings. Old masters are on view in the Kelvingrove Art Gallery. There is also a fascinating Transport Museum with old cars and bicycles and models of ships built in Scotland.

The old centre of Glasgow is dominated by the Cathedral standing on the spot where St Kentigern (also called Mungo, d 612), the apostle of Strathclyde, built his first wooden church. In Cathedral Square is a new Museum of Religion

116

continued on page 125

The striking town hall clock tower in Union St, the main street of Aberdeen. Its pale grey granite gives the university town an atmosphere of sober clarity.

The wealth of Scotland lies in its natural resources, including fish: the fish market in Aberdeen, Scotland's largest fishing port.

Scenes from the life of a national drink that is known and loved all over the world. Top left: the name being stencilled onto whisky barrels; top right: the pot stills for making single malt whisky.

Last but not least, storage, if possible in oak casks and for a minimum of three years, is crucial for the quality of a whisky. Photographs from the Glenfarclas Distillery by Ballindalloch (Moray).

Overleaf: Dunottar to the south of Stonehaven, one of the most beautifully situated ruined castles in Scotland. The oldest surviving parts of this former excise post go back to the 14th century.

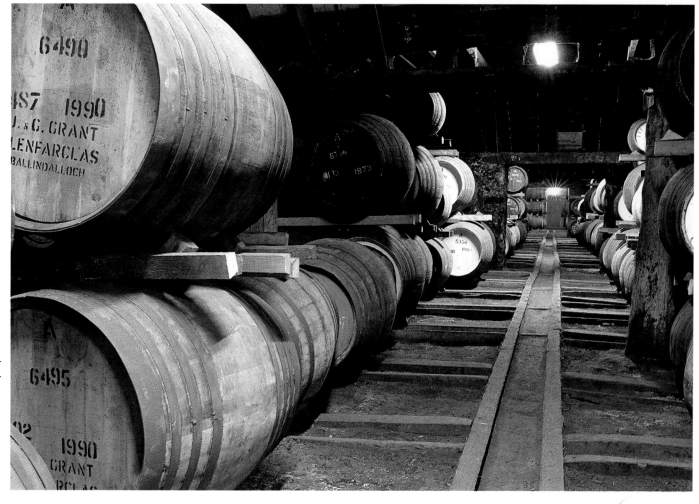

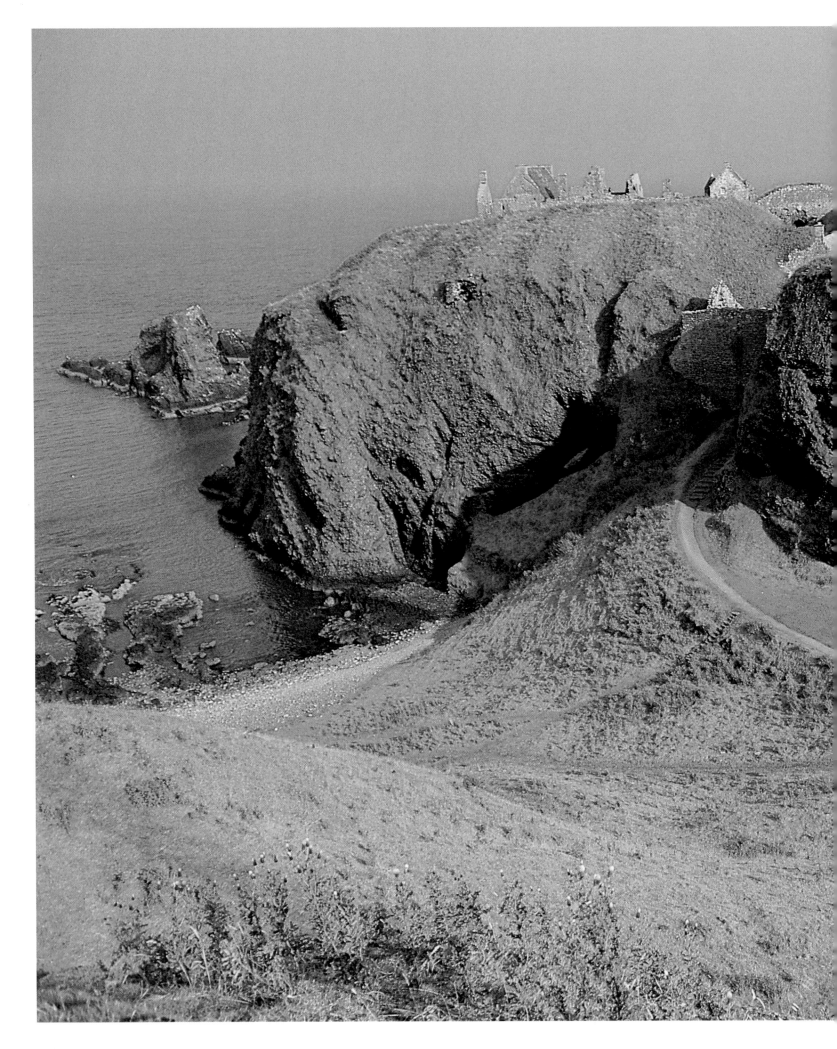

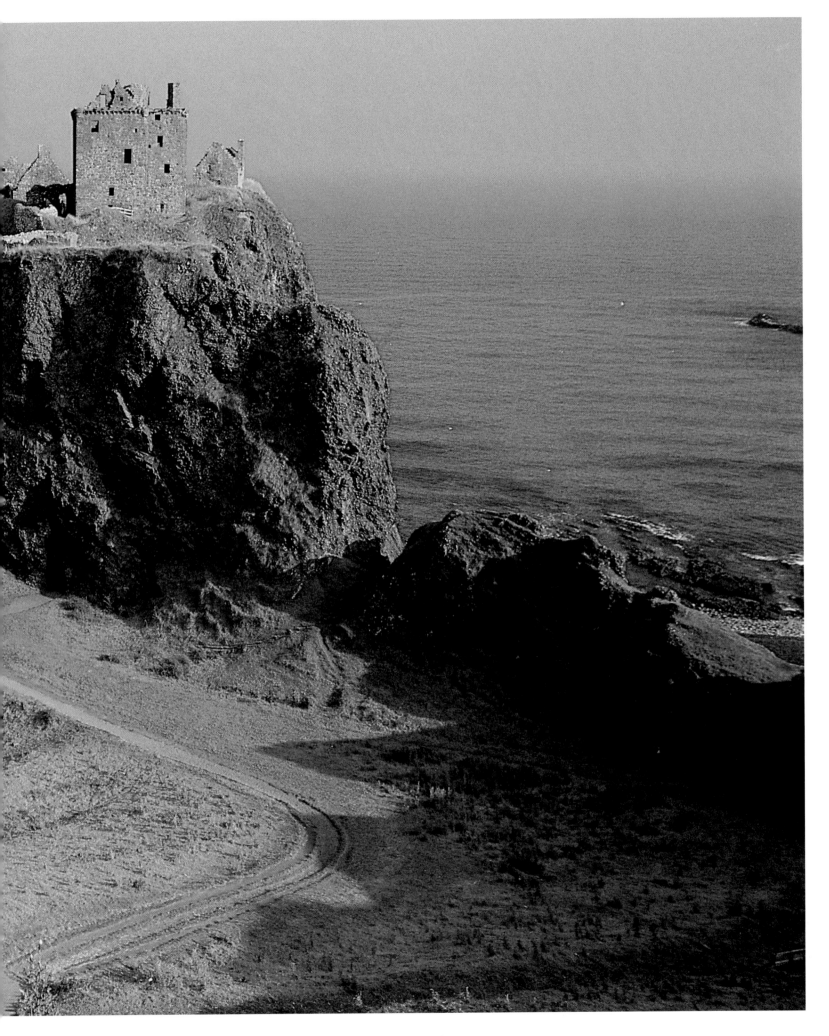

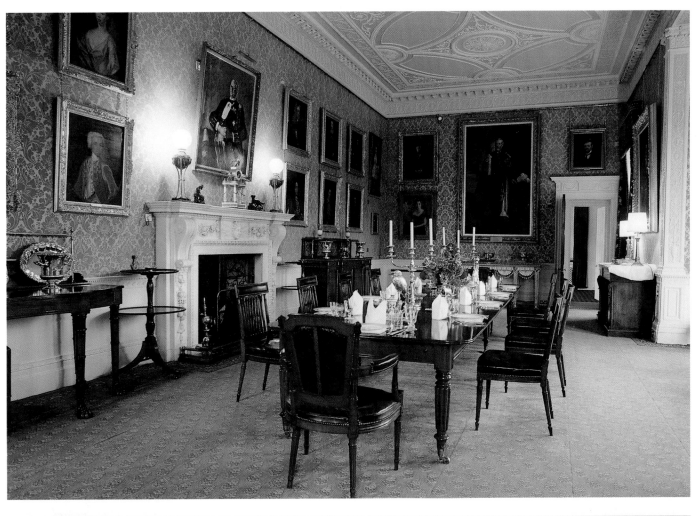

In the 18th century the fortified tower houses were gradually replaced by stately homes in the classical style: here the elegant dining-room of Haddo House, built by the famous architect, William Adam (1731–35).

The kitchen of Drum Castle contains a collection of old cooking utensils. The low arch and thick walls are evidence of its origin in the 13th century as a fortified tower from which the estates were watched and defended.

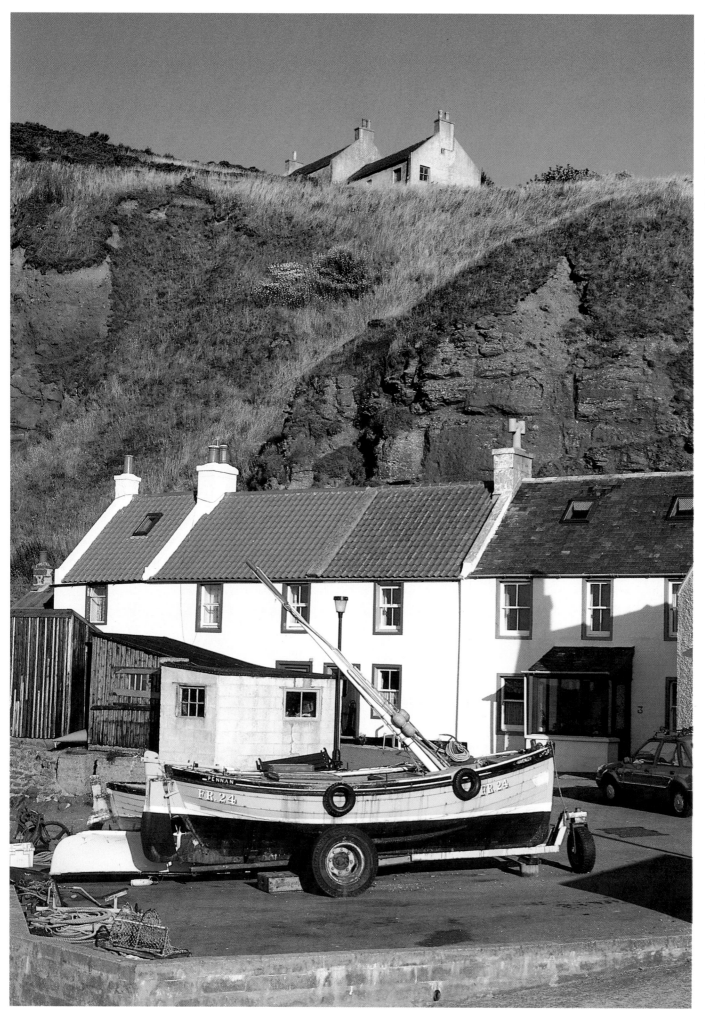

The village of Pennan in Aberdeenshire, where parts of the film Local Hero *were shot; its plot revolves round the way the attempts of an American oil company to build a refinery in the bay are thwarted by the gentle but unwavering resistance of the locals.*

housed in a building designed to blend in with its mediaeval surroundings. That this formerly Catholic church is best viewed from the 18th century Necropolis and contains a column dedicated to the Calvinist reformer, John Knox, is one of the paradoxes of Scottish religious history: the Scots have a deep admiration for both Mary Stuart and John Knox, something no other country would be capable of, one imagines.

Glasgow, with the River Clyde running through the middle, is a city of work, not of elegance like Edinburgh; the relationship is not unlike that of New York to Washington. Formerly Glasgow was the centre of British economic power based on coal, mineral ore and heavy industry, and produced two thirds of its ships. A number of proud Victorian buildings still bear witness to this past, whilst its shame, the Gorbals, the worst slums in Europe, have now been largely razed to the ground or renovated. Unfortunately this does not apply to the ugly tower-blocks the 20th century has wished on the city and its suburbs.

Tenement House (145 Buccleuch St, north of Sauciehall St, open daily May to October, otherwise at weekends), dating from 1892, is a typical Victorian block, showing the life of a Glasgow working-class family. The two-room apartments with kitchen and bathroom have been restored to their original state, even if they are a little too clean and tidy, so that one has to use one's imagination to visualise the careworn, over-worked mother, surrounded by a horde of children, waiting on a Friday night for her drunken husband to come home with his pay packet. East Glasgow is a particularly neglected area of the old town which, partly as a result of the introduction of the 'right to buy', has made remarkably good progress.

Paradoxically, the ugliness of Glasgow's working-class districts has had a positive influence on the pulsating life of the city. Its confident motto, 'Let Glasgow flourish', appears in its original form on a scroll on the bell of St George's Church, 'Let Glasgow flourish by the preaching of the word and the praise of thy name'.

A great moment in the history of the city was the defeat William Wallace inflicted on the English in 1300 at the place where High St now runs. Glasgow was also the scene of Mary Stuart's last attempt, after her flight from Leven Castle in 1568, to hold onto power in Scotland, but her troops were defeated at the battle of Langside, even though she rode into the fray to encourage them.

Glasgow University is the second oldest in Scotland, founded by Bishop Turnbull in 1451, forty years after St Andrews. Cromwell discovered that Scottish divines were no respecters of persons when he was forced to listen to a two-hour sermon in the cathedral from the minister of the Barony, Zachary Boyd, in which he was denounced as a 'sectarian and blasphemer'. He got his revenge by inviting Boyd to a dinner at which the minister had to submit to three hours of prayers before eating.

Separated from America by the Atlantic Ocean alone, Glasgow merchants grew rich after the Union through the import of sugar and tobacco, later through 'King Cotton' and the export of textiles. The Clydeside shipyards built the biggest ships for customers all over the world. Now they are still. In their place Glasgow today is trying to adapt to the demands of a changed world in which Britain has to face competition from the continent, as Scotland's financial centre and through several hundred manufacturing firms equipped with the latest in modern technology.

Recommended excursions from Glasgow are the Trossachs (see entry), the Queen Elizabeth Forest Park and Loch Lomond (see entry).

Gretna Green (20) (Dumfries and Galloway). It is now well over fifty years since eloping lovers used to head for this village, 12km to the north of Carlisle and just across the Scottish border, but with its romantic history it remains a magnet for tourists, despite its somewhat scruffy appearance. Runaway couples used to get themselves married by the smith there, in his function as registrar, because under Scots law sixteen-year-olds could marry without their parents' consent. One smith by the name of Rennison is said to have performed more than 5000 marriages. This lucrative trade brought competition from the smith in the neighbouring village of Springfield, but it was eliminated when the construction of the bridge over the Sark left only Gretna Green on the main road. The smith employed agents in Carlisle who advertised his services to absconding couples.

Haddington (21) (East Lothian) is a pretty market town on the banks of the River Tyne, 16km north of Dalkeith. The 14th-century St Mary's Church, which lost its roof during the Reformation, was restored in 1973 with the help of famous musicians such as Yehudi Menuhin and Louis Kentner, and made into an ecumenical centre. It was the church John Knox attended as a child and young man. Jane Welsh is buried here, the wife of Thomas Carlyle who wrote a moving epitaph for her gravestone. The church also houses the family vault of the Maitlands, the Earls of Lauderdale. In recent years, after miracle cures associated with the statue of St Mary were recorded, it has become the site of an Anglican pilgrimage in June every year.

Nearby is Lennoxlove, a seat of the Maitlands, now the residence of the Duke of Hamilton, whom Hitler's deputy, Rudolf Hess, named as his contact after his sensational mystery solo-flight to England in 1941. Treasures in the collection of the dukes of Hamilton include the famous death-mask of Mary Stuart and the silver casket, a wedding present from her first husband, Francis II of France, in which the notorious (probably forged) letters were found, which proved her complicity in the murder of her second husband, Darnley.

Inveraray (22) (Argyll and Bute). This little village (pop. 399) with some pretty houses in the classical style dominated by the Gothic Revival Castle built at the end of the 18th century, bears the stamp of the Duke of Argyll, one of the largest landowners in Britain and chief of Clan Campbell. This castellated mansion, with its four projecting round towers with high conical roofs rising above the woods of spruce and birch, enjoys a beautiful situation on Loch Fyne, a sea loch stretching 70km inland. The castle (84 rooms) is worth visiting for its 18th-century tapestries from Beauvais, its Waterford crystal chandelier, its outstanding collection of Worcester, Crown Derby, Meissen and Japanese porcelain, as well as portraits of members of the Argyll family by Gainsborough and Allan Ramsay.

The bell tower was built by the father of the current 11th duke in memory of the Campbells from all over the world who died in the two World Wars. When staying in Britain, a visit to Inveraray, in the course of which they take a malt whisky with the clan chief, is a must for any of the Campbells living throughout the world.

In the town is the Court House and the notorious Inveraray Jail (1825), from which many were sent to the penal colony of Australia. Up to thirty men, women, children or defectives were crammed into each of the eight cells; even empty they have an eerie feel to them.

Nearby is that status symbol of every British stately home, a wildlife park, which is thronged with visitors in the summer. Amongst other species, it contains wallabies, wildcats, badgers,

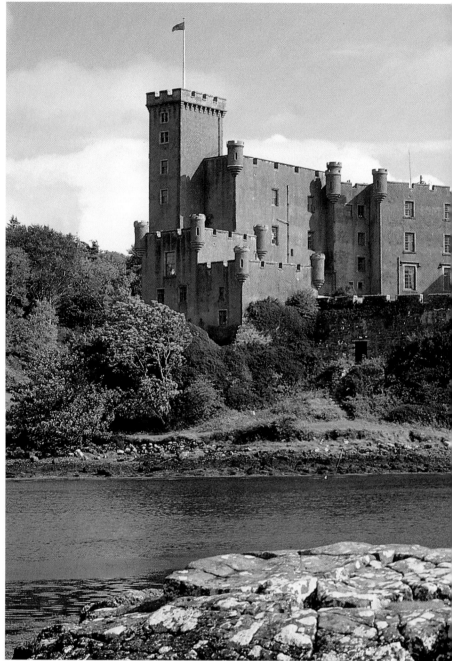

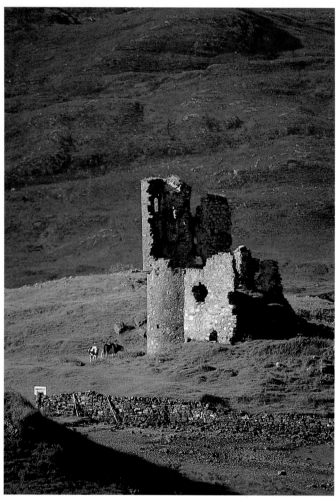

Top left: Lauriston Castle in Cramond in the north-west of Edinburgh; bottom left: the ruins of Ardvreck Castle on Loch Assynt in the Highlands, built around 1490 by the Macleods; top middle: Dunvegan Castle on Skye, the ancestral home of Clan Macleod, inhabited since the 13th century. The tower is from the 14th century, the other parts were added around 1600. Many of the unusual contents document the centuries-old feud between the Macleods and the Macdonalds. Bottom right: Drumlanrig Castle, to the north of Thornhill in the Southern Uplands, contains many interesting art objects.

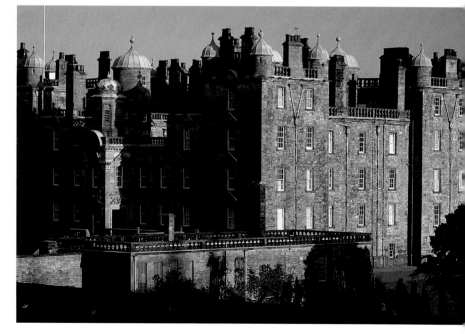

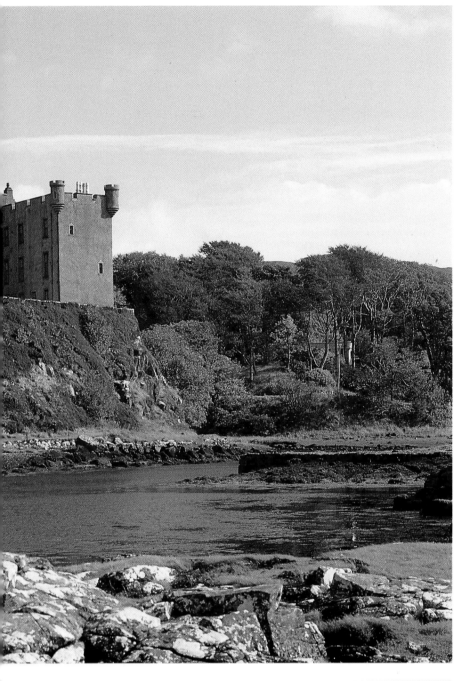

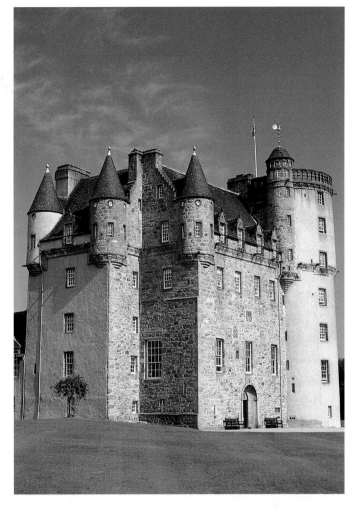

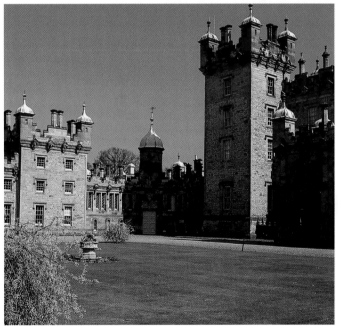

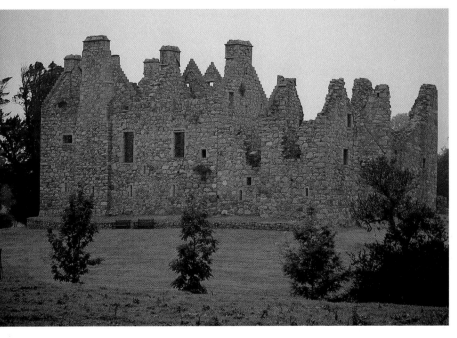

Bottom left: Tolquhon Castle near Pitmedden to the north of Aberdeen, was built in 1420. The ruin of the massive square building is all that is left today. Top right: Castle Fraser lies 25km to the west of Aberdeen. It was built by the Bell family of stonemasons in the late 16th century and is set in a magnificent park. Bottom right: Floors Castle in Kelso (Borders), the country seat of the Duke of Roxburghe, houses a rich collection of furniture and tapestries. Two famous Scottish architects were involved in its construction: it was designed by William Adam in 1721 and extended in the Victorian style by William Henry Playfair in 1837.

127

Highland foxes and wild goats. Also worth seeing during spring and autumn is Crarae Woodland Garden, 15km to the south, with azaleas, rhododendrons and other interesting plants. The woodland walks give beautiful views out over Loch Fyne and the mountains. (See also Oban.)

Inverewe Gardens ㉓ (close to Poolewe, Highland) is the unique creation of the Scottish estate owner, Osgood Mackenzie

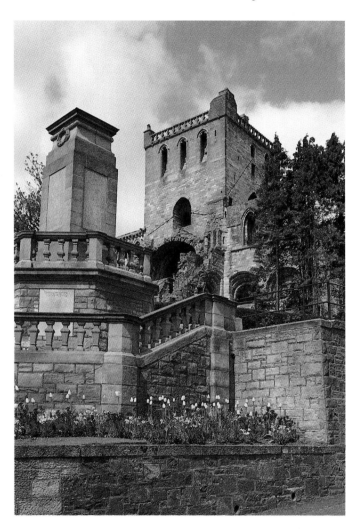

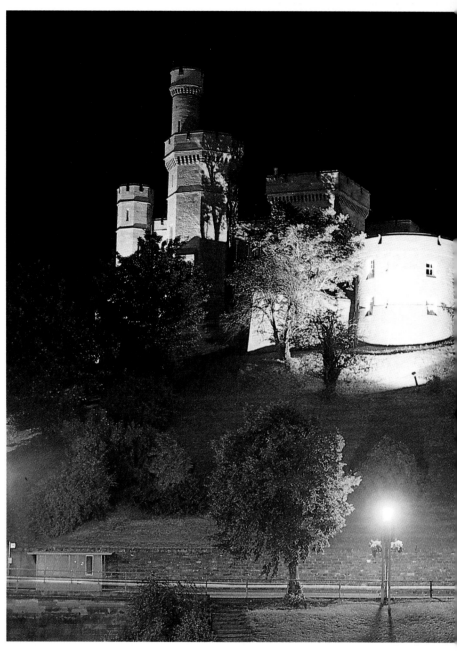

(1843–1922), now cared for by the National Trust for Scotland. On a windy, barren, 25-acre peninsula, on which only heather, brambles and dwarf willows used to grow, the garden-lover will find a subtropical paradise with beautiful flowers from all over the world. Today Scots and Corsican pines provide shelter from the winds; wire netting keeps out rabbits and deer. Inverewe Gardens lies on almost the same latitude as Cape Farewell in Greenland, but the influence of the Gulf Stream allows palms and alpines to flourish. Plants from Japan, South America and the Pacific region grow beside pretty little lakes, from May to early autumn a delight for anyone who takes a walk along the winding but well-marked paths. Every interesting species has an identification marker.

Inverness ㉔ (pop. 39,500) is the centre of the Highlands. Even if not particularly beautiful itself (except for the parts of the town along the River Ness), it is an excellent starting point for excursions into the Highlands.

It was here that St Columba (521–97), the Irish apostle of Christianity in Scotland, converted the Pictish chief Brude, in his fortress that possibly stood on the little hill of Craig Phadraig, possibly on Auld Castle Hill to the east of the present Castle Hill, where Macbeth's castle stands. The murder of

Duncan in 1039 probably did not happen there, but in a house in Elgin. Inverness Castle was later destroyed in revenge for the murder of the king. During the Scottish wars of independence in the 12th century it was occupied by the English, then Bruce won it back. Later on it was used by the English in their attempts to tame the wild Highland tribes. Mary Queen of Scots had a rebellious governor, who had refused her entry, hanged on the walls, and the Jacobites blew it up in the course of the '45 in case it fell into government hands. Today Inverness Castle houses the Sheriff Court and the District Court.

Excursions in the surrounding area: Culloden Moor (9km to the east, reached by the A9 and the B9006), the famous battlefield where the Jacobites were defeated by 'Butcher' Cumberland on 16 April 1746. There is an audiovisual re-creation of the historic event in the Visitor Centre, and a faithful reconstruction in Old Leanach Cottage. Nearby are the impressive Clara Cairns, burial sites from the Stone and Bronze Ages.

Each year Cawdor Castle, 15km north-east of Culloden, draws some 50,000 tourists who have read Shakespeare's Macbeth or seen it at the theatre. Even today there is a Thane of Cawdor, the title that the three witches prophesied King Duncan would grant Macbeth, upon which Macbeth murdered

Left: Jedburgh Abbey in the Borders; middle: Inverness Castle on the Ness; destroyed several times in the course of its history, it was rebuilt in the Victorian style between 1834 and 1846.

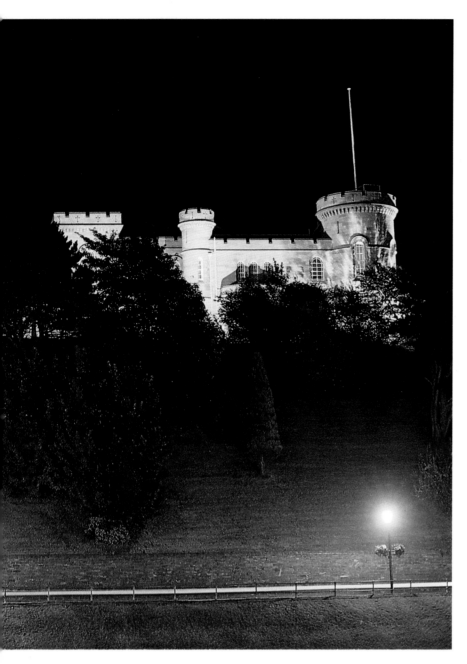

Isle of Gigha ㉖ (pronounced 'Geeya') is a small island 5km off the west coast of Kintyre (Argyll and Bute); the name comes from the nordic god Gigha. Nine kilometres long and nowhere more than 3km wide, its climate enjoys the benefits of the Gulf Stream, so that frost is as good as unknown there.

Top right: the Museum of Island Life, an open-air museum in Osmigarry on Skye, shows the traditional life of the island. Bottom right: Gretna Green smithy. In the past the place to go for an express wedding, today a tourist attraction. Until the 1930s people could still be married there secretly and without formalities.

him in order to become king, as they had also prophesied. As far as Cawdor Castle, the setting of his play, is concerned however, Shakespeare was out by over 300 years. The historical King Duncan died in 1040 in Elgin, but the castle has only been the seat of the Cawdors since 1372, so that Shakespeare's addition to their family history does not correspond to the historical facts, but is doubtless as welcome as it is profitable.

Isle of Arran ㉕. With its 420km² and 3576 inhabitants this is the largest of the islands in the Clyde estuary (between the Firth of Clyde and Kilbrannan Sound). It is sometimes called 'Scotland in miniature' as it has features of both the Highlands and the Lowlands, mountains and valleys. The island is much loved for its mild climate and also for its beautiful beaches and lonely areas for hill-walking, pony trekking and rock-climbing. Brodick Castle, dating back to the 13th century, is worth a visit. Today this former Viking fortress is the seat of the dukes of Hamilton. Set in a lovely rhododendron park, the best time to see it is April and May.

Access to the island is by the car ferries from Ardrossan to Brodick (one hour), or from Claonaig to Lochranza (30 minutes; April–October).

Gigha is a paradise for nature lovers and very popular with honeymooners. Achamore House Gardens are well worth a visit, especially when the azaleas are in bloom.

Access to the island is by the ferry from Tayinloan on the west coast of Kintyre (six times a day on weekdays, four on Sundays).

Isle of Inchcolm see Aberdour.

Isle of Iona ㉗. The monastery on this tiny and desolate Hebridean island (8km², pop. 128) close to the western tip of Mull was founded in 563 by St Columba (521–97). It was from here that the Irish missionaries Christianised Scotland (up to 664), turning the island into a place of pilgrimage. In 1203 it was taken over by the Benedictines. During the Reformation most of the ecclesiastical buildings were destroyed and in 1617 the church was annexed to the Protestant Bishopric of the Isles. The old abbey church was restored in 1902–10 and is now in the hands of the ecumenical Iona Community. Worth seeing are: the Nunnery of St Mary, Reilig Odhrain (the graveyard of Oran), the burial place of Scottish kings up to the 11th century, St Oran's Chapel built in 1074, the oldest building on the island, and the Abbey,

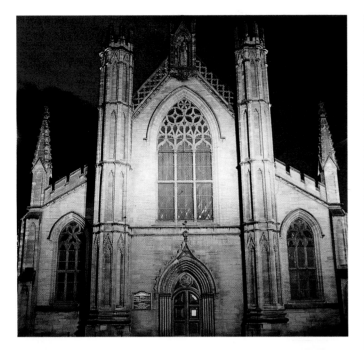

Glasgow is not only the town of industry and workers' tenements. Top left: St Andrews Roman Catholic Cathedral (1816), James Gillespie Graham's fine example of neo-Perpendicular architecture, was the first Gothic revival building in Glasgow. Bottom left: The Argyll Arcade, designed in 1827 by John Baird, was one of the first shopping arcades in Europe. Today it contains Glasgow's elegant jewellers' shops. Right: the imposing Victorian Winter Gardens, part of the People's Palace, stand in Glasgow Green, the oldest park in the city, in the east end, across the river from the Gorbals, the once notorious slums, which have now been largely redeveloped.

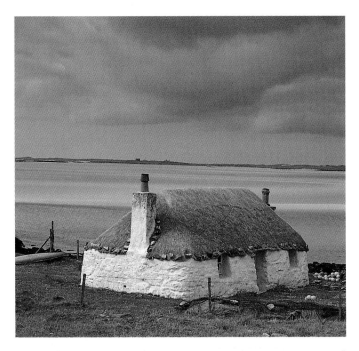

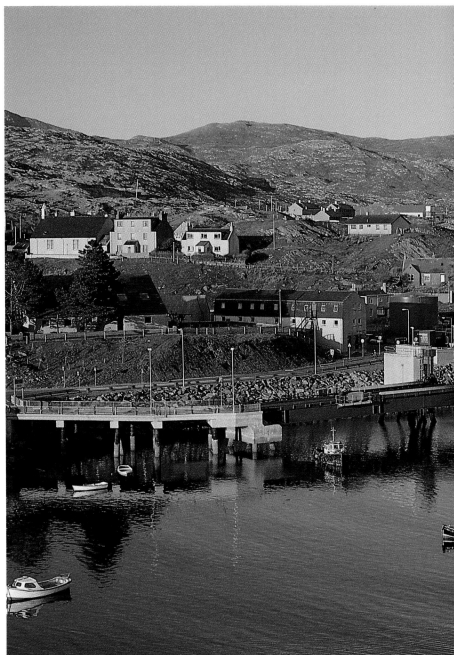

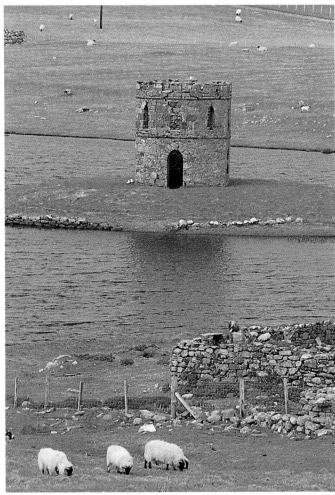

The Hebridean islands of North Uist, Benbecula and South Uist are now joined by causeways. It is above all the countless lochs and bays that give their landscape its characteristic stamp. Top left: a traditional fisherman's cottage on North Uist; bottom left: one of the numerous small fortresses that can be found all over Scotland; top middle: the Hebridean ferry connects the towns of Uig on Skye with Tarbert on Harris and Lochmaddy on North Uist. The photograph shows the natural harbour of Tarbert on the east coast of Harris. Bottom right: Houses with brightly painted doors and window-frames (here in Uig) are typical of Skye.

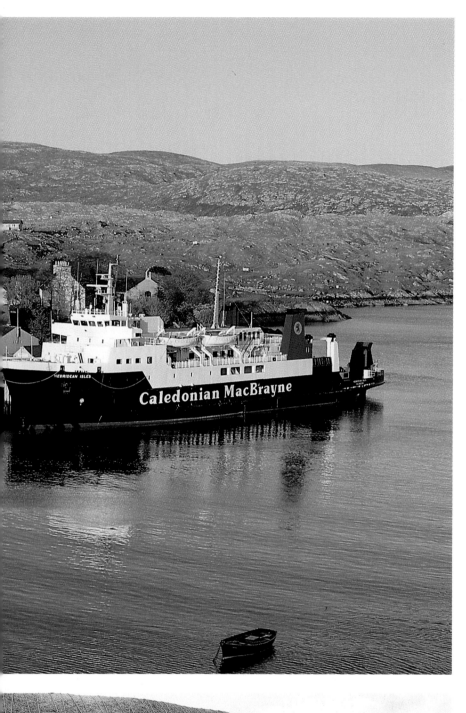

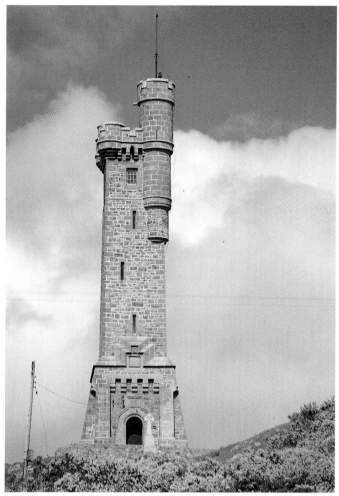

Impressions of Lewis. Bottom left: the 'black house', a typical old Highland cottage, in Arnol. The walls are between 1.5m and 1.8m high and thick; built without mortar, they have an insulating layer of soil and peat, which provides good protection against rain and wind. Top right: a monument in Stornoway, the capital of Lewis. In the 19th century it was one of the biggest fishing ports in Europe, but since then oil extraction has replaced fishing as the most important source of employment. Bottom right: a cairn near the broch of Carloway, a Pictish round tower.

much of which dates from the 13th–15th centuries. Cars are not permitted on the island. The crossing from Fionnphort on Mull takes five minutes; it can also be visited as part of a cruise from Oban.

Isle of Islay ㉘ (pronounced 'Eye-la'; Argyll and Bute) is the southernmost of the Inner Hebrides (600km², pop. about 4000). About 20km from the west coast of Kintyre, it is reached by ferry from Kennacraig (to Port Ellen or Port Askaig, both two hours) or directly by plane from Glasgow or Campbeltown on Kintyre to Glenegedale airport (30 minutes). Buses run on the island.

Islay is of interest to archaeologists because it was already inhabited during the New Stone Age; the rich birdlife attracts ornithologists, and painters and photographers are inspired by the landscape. The Duich and Sorn rivers offer excellent salmon fishing; sea fishing is also available. There are beautiful beaches with good surfing and an 18-hole golf course in Machrie.

In the early 17th century Islay was conquered by the Campbells, who in the 18th century were renowned as enlightened but absolute rulers. In 1767 one of them built a Round Church (to leave the devil with nowhere to hide) in the Italian style. Bowmore Distillery has been producing whisky since 1774 and claims to be the oldest legal distillery on Islay (there were numerous illegal ones). Although distinctive, the single malt whiskies from the eight Islay distilleries – Ardbeg, Bowmore, Bruichladdich, Bunnahabhainn, Caol Ila, Lagavulin, Laphroaig and Port Ellen – are well known for their strong peaty bouquet. The Museum of Islay Life in Port Charlotte on the west shore of Loch Indaal is worth a visit, as is the RSPB Reserve at the south end of Loch Gruinart. Finlaggan Castle on Loch Finlaggan, now ruined, was once a stronghold of the Macdonalds, the former Lords of the Isles.

Close to Islay, but wilder and with fewer visitors, is the quartzite island of Jura (400km², pop. 500), with good hunting for red deer. It has a hotel and a whisky distillery in Craighouse and two mountains (The Paps of Jura, 785m, 734m) with splendid views.

Isle of Mull ㉙. Mull (910km², pop. 1529) in the Inner Hebrides is less well known than the larger neighbouring island of Skye, but is at least its equal for variety of attractive scenery and remote tranquillity. Awaiting the visitor are an unspoilt white sandy beach (Calgary Bay), a ruined castle from the 12th century (Duart Castle home of the head of the Maclean clan), Ben More (966m), pretty crofting townships and fantastic views of the sea. There are pleasant excursions for the motorist, but you must make sure to keep your tank topped up because there are very few filling stations on the island. Every year there is a Drama Festival in March, a Music Festival in April and Highland Games in July; Gaelic music can be heard at the many improvised ceilidhs in the pubs and hotels. The Mull Little Theatre in the park of Druimard House is well-known for its two-man plays; it only has room for an audience of thirty-seven.

Tobermory ('Mary's well', pop. 641) is the 'capital' of Mull. The ferry from Oban (one hour) lands at Craignure. Excursions can be made to Iona (see entry) and Staffa with its 30m-high basalt columns; there are huge colonies of seabirds to be seen – if the sea is calm enough to permit landing. Fingal's Cave on Staffa, which inspired Mendelssohn to compose his Hebrides overture after a visit in 1829, is a natural work of art created by the power of the sea; it resembles nothing so much as a Gothic cathedral.

Isle of Skye ㉚. Rich in legend and song and famous for its natural beauty, Skye, the largest of the Inner Hebrides (70km long, between 5 and 40km wide, is Scotland's magnet for tourists. It has to be said, however, that the attractions of Skye are very dependent on the weather; its all-enveloping mist can lead to disappointment. The Gaelic character of the island has suffered from the tourist trade, but there are still many old castles to be seen such as Dunvegan Castle, the ancestral seat of the MacLeods, or the grave of Flora MacDonald in Kilmuir graveyard, the woman who smuggled Bonnie Prince Charlie, dressed as her maid, to Skye, for which she spent a year in prison. The 30km road along the coast of the Trotternish peninsula, north of the 'capital' Portree, is lined with bizarre rock formations. It also offers magnificent views out to sea and of the 50m-high basalt rock called The Old Man of Storr.

Access since 1995 is by the Skye Road Bridge (the tolls are still the subject of protest by the locals); car ferries run from Glenelg to Kylerhea and from Mallaig to Armadale. The Kyle line, from Inverness to Kyle of Lochalsh and the West Highland Line from Glasgow to Fort William are two of the most beautiful railway journeys in Britain; there is a rail link from Fort William to Mallaig. There is also an airstrip on the island.

Jedburgh ㉛. (Borders; pop. 4168) lies on the Jed Water, just to the south of Teviotdale, on Dere Street, an old Roman road, now the A68. It is a royal burgh, founded 800 years ago by King David I. Augustinian monks from Beauvais were settled there by the king and in 1152 the priory, combining Romanesque and Gothic features and one of the most beautiful of its kind, was raised to the status of Abbey. Scottish kings were crowned and married there. The Borders suffered much from the depredations of its robber barons and cattle thieves, and the abbey was finally destroyed and its possessions 'nationalised' by order of Henry VIII in 1544, though services continued to be held in the ruins. Jedburgh Castle was pulled down by the owners themselves, to stop it falling into the hands of the English; it was rebuilt in the 19th century and used as a prison which was considered one of the most progressive of its day.

The traveller entering Scotland by this route will find one of the many places in Scotland dedicated to Mary Stuart there. The Mary Queen of Scots House Visitor Centre is a pretty, L-shaped 16th-century house in well-maintained gardens that once belonged to the Kers of Ferniehurst and had a defensive tower and thick walls. Mary stayed there in 1566, when she was still married to Darnley, to perform her function of royal judge. The house was the only one in the district with its own sewage system. The small but interesting exhibition contains the famous, if disputed death mask, the Breadalbane and Antwerp portraits of the queen and other mementos.

Kirkcudbright see Ayr.

Lennoxlove see Haddington.

Linlithgow ㉜, away from the heavy traffic of the M9, is a quiet little town (West Lothian; pop. 9544) dominated by the ruined palace (15th to 17th centuries) on the shore of the loch of the same name. It was once the favourite residence of James V, whose second wife, Mary of Guise, gave birth to Mary Stuart on 28 December 1542; one week later the infant was proclaimed Queen of Scots on the death of her father. Cromwell's troops occupied the palace for nine years. The

134

continued on page 143

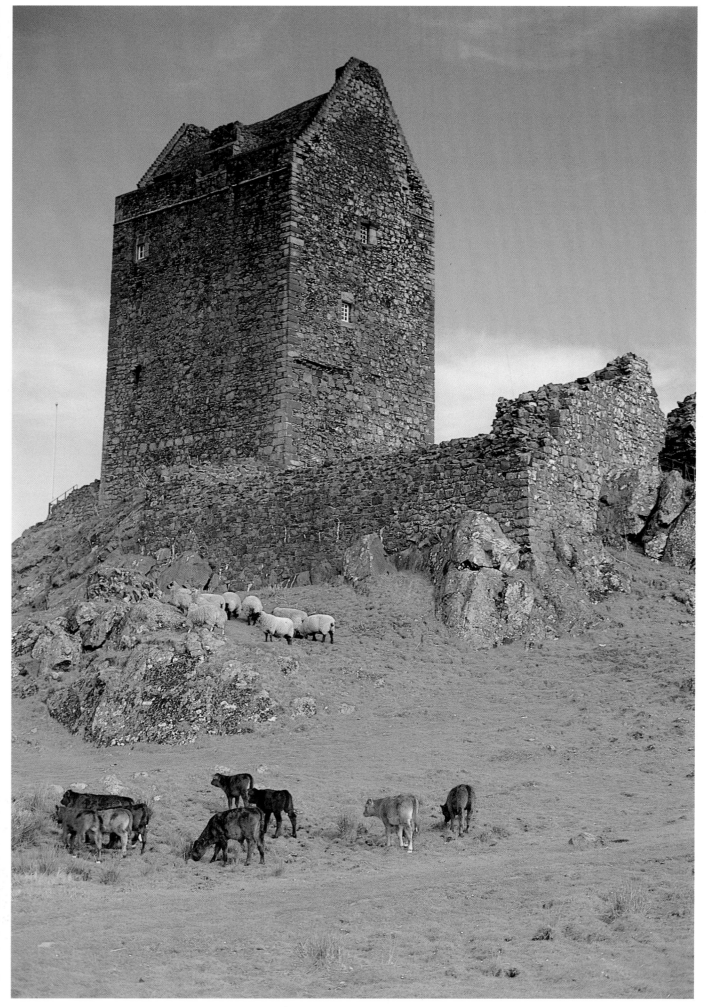

Smailholm Tower, a fortified tower house in the Border country, which was fought over for centuries.

Overleaf: romanesque and Gothic arches hint at the former splendour of Jedburgh Abbey, one of four important abbeys in the Borders. Like the others, it too suffered frequent plundering and destruction in the course of the countless wars between England and Scotland.

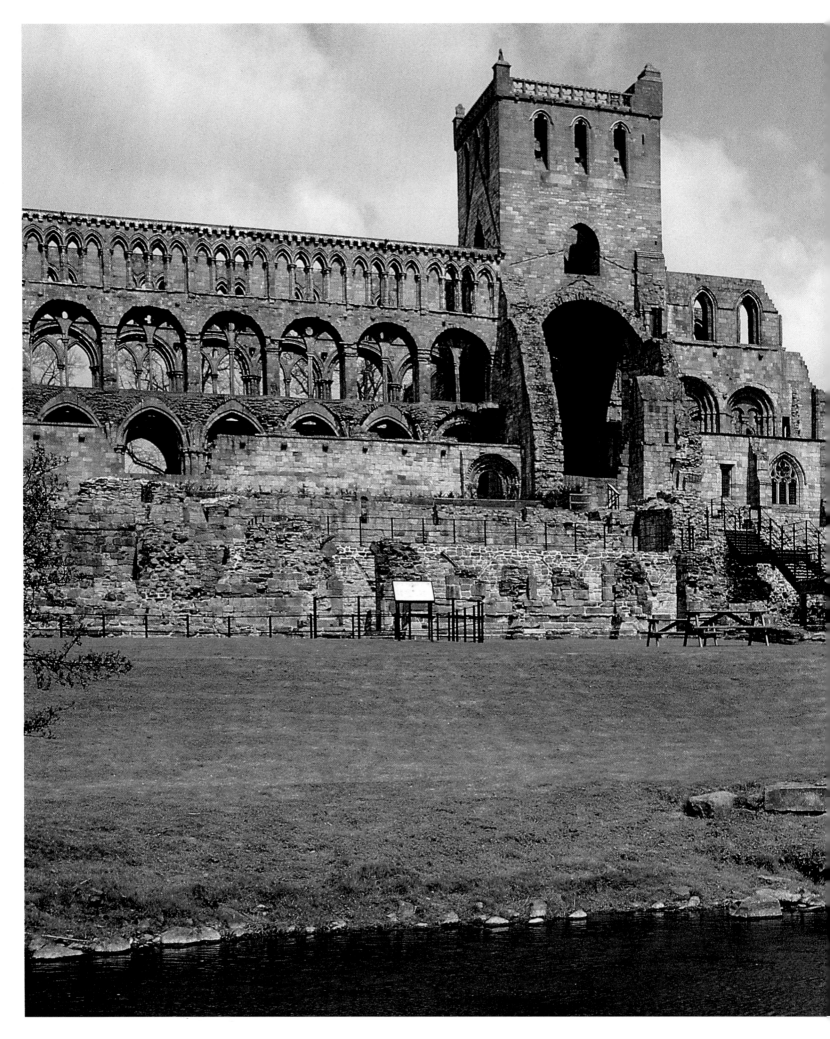

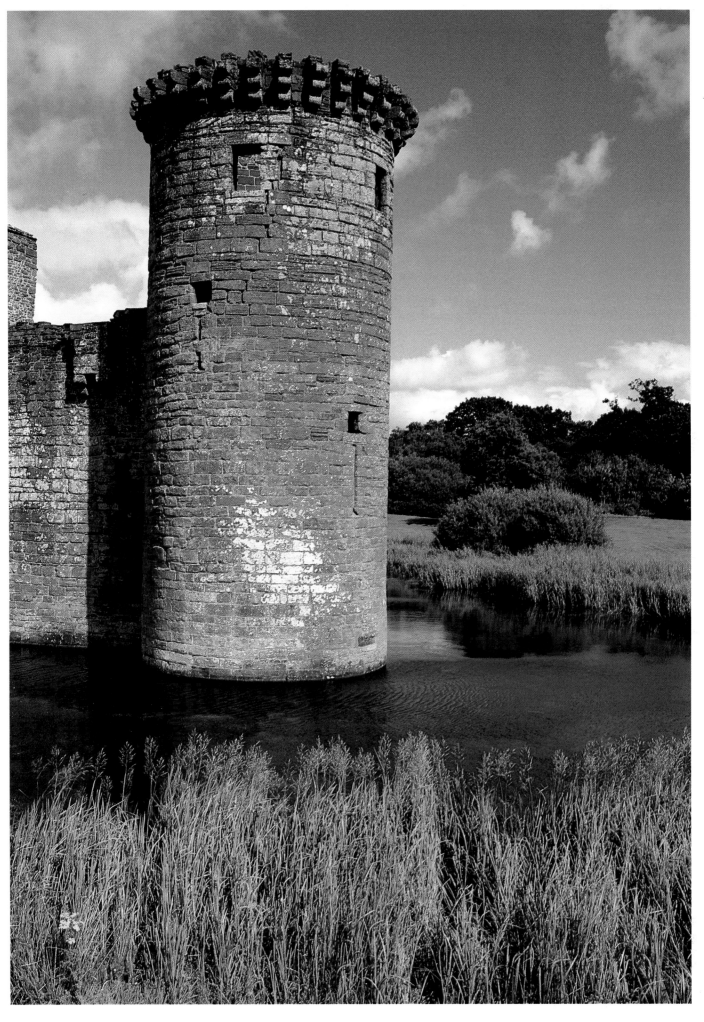

South of Dumfries is Caerlaverock Castle, a 13th-century moated fortress. Its triangular ground plan makes it an unusual example of mediaeval architecture; most impressive of all are its massive round towers.

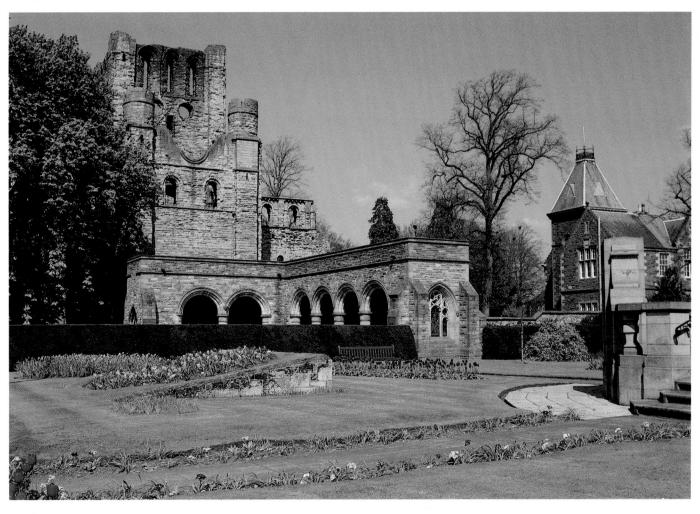

A description from 1517, found in the Vatican archives, shows that Kelso Abbey (1126) must have been the oldest, largest and wealthiest in the Borders.

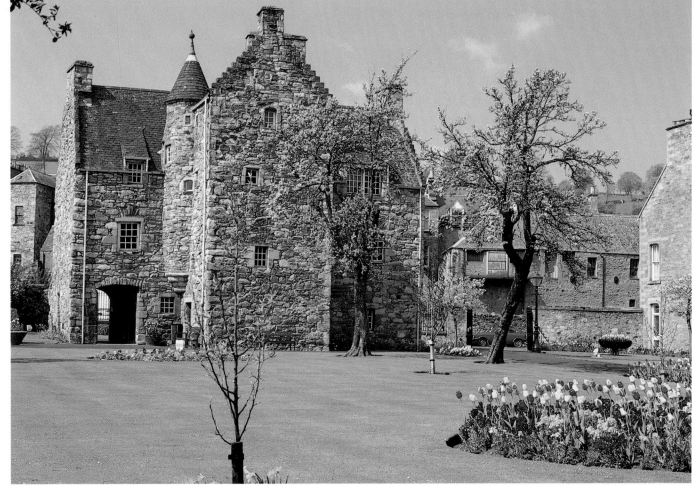

Legendary mementos of Mary Stuart are kept in the Mary Queen of Scots House in Jedburgh where, in 1566, she dispensed justice before setting out on her notorious 30km ride to her wounded lover Bothwell, after which she was laid low by fever for a month.

Overleaf: Sir Walter Scott considered Kelso the most beautiful, if not most romantic village in Scotland. Among the sights are the ruined abbey, a bridge over the Tweed in the classical style and the market place.

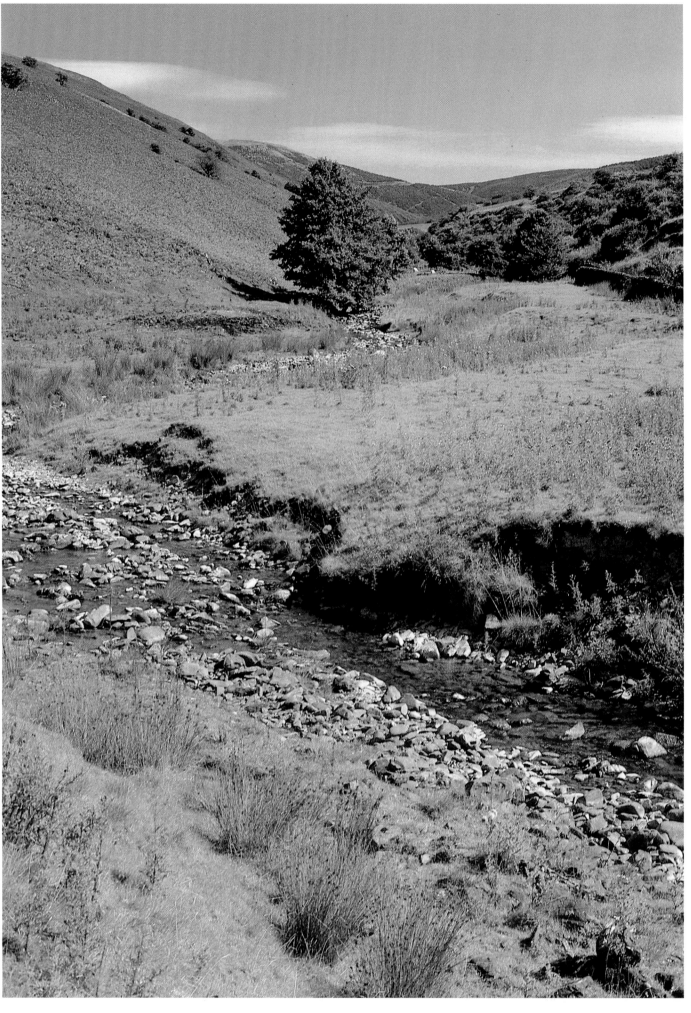

With their hilly pasture, the Borders, seen here near Hawick, are well suited to sheep-rearing, which has been important since the Middle Ages.

best view of the palace is from the M9, at night when, bathed in floodlight, it appears as a ghostly shape against the sky.

St Michael's Church next to the palace is a 19th-century reconstruction of the original Gothic church in the Scottish Decorated Style.

Lochgilphead ㉝ (Argyll and Bute) is 30km to the south-west of Inveraray on Loch Gilp, a small inlet off Loch Fyne. It is a good shopping centre (Argyll Show in August). Recommended for a fine Sunday is a boat trip along the 15km Crinan Canal that cuts across the top of the Kintyre peninsula. The Crinan Hotel in the hamlet of Crinan, one of the most beautiful (and most expensive) in Scotland, is worth a visit. (See also 'Scottish Cuisine').

Loch Lomond ㉞ (30km long, 8km wide, 200m at its deepest point; 30km from the centre of Glasgow) with its incredibly deep blue is undoubtedly the 'Queen of the Scottish Lochs', though perhaps praised in song a little too often. The famous song was composed by the Jacobite Donald Macdonald of Keppock, who was executed in Carlisle. It expressed the longing he felt in prison to reach his Scottish home more quickly by the 'low road' (of death) than the 'high road' taken by his living friends.

Cruises on Loch Lomond take the visitor to Inch Cailleach (Old woman's isle), the old burial ground of the wild MacGregor clan, and to the ruin of Lennox Castle on Inch Murrin, the scene of the bloody vengeance the heir to the Scottish throne, James I, took on the usurping Duke of Albany after his return from 18 years of captivity in England.

Loch Ness ㉟ and 'Nessie', the mysterious monster to which the Scottish tourist industry owes such a debt of gratitude for keeping its identity secret, can best be seen during a drive along the A82.

The loch owes its existence to the 'Great Glen', the result of a geological split that tore the Highlands apart 400 million years ago. In the 19th century the engineer, Thomas Telford, joined the lakes that were left when the Ice Age ended 10 million years ago, to form the Caledonian Canal. The 90km-long waterway with its 29 locks uses the lochs created by the geological fault; only one third is a canal in the literal sense. Loch Ness (36km long, 1.6km wide and 230m deep in places) is the first lake on the canal, coming from the north, and one of the most beautiful; it is worth taking a cruise on it. The Loch Ness Exhibition in Drumnadrochit provides a good introduction to 'Nessie', who proved to be a friendly creature after St Columba (as reported by his biographer Adamnus) gave her a good talking to when she threatened one of his monks.

Loch of the Lowes see Dunkeld.

Meigle see Glamis.

Mellerstain House ㊱ (open daily apart from Saturdays at Easter and from 1 May to 30 September) is in the Borders, 11km north-west of the ruins of Kelso Abbey (1128; destroyed 1523) which, with its museum, is also worth a visit. Mellerstain is the residence of Lord Haddington and one of the most beautiful Scottish stately homes in the Georgian style of the 18th century. It was begun by William Adam in 1725 and completed in 1778 by his son Robert. A 2km avenue lined with huge beeches, oaks and pines leads to the house and the beautiful Italianate terraced garden.

The house still has the library ceiling with plaster decorations by Robert Adam, carved figures around the fireplace and a

classical frieze with marble busts by Roubilliac in the niches, including Lady Grizell Baillie and her daughter. The room is decorated in pale green, ivory, pink and pewter grey. There are Delft tiles around the fireplaces in the entrance hall and drawing-room, which has a Gothic ceiling. On the walls are portraits of the family and others by Gainsborough and Allan Ramsay as well as paintings by Constable and Veronese. The rooms have furniture by Chippendale, Sheraton and Hepplewhite.

Melrose Abbey ㊲ (Borders), set among picturesque hills in the valley of the Tweed, is the most beautiful of the four Cistercian monasteries founded along the border by King David I in the 12th century. Destroyed several times by the English in revenge for the cross-border raids carried out by Scottish cattle thieves, it was repeatedly rebuilt by the monks. The most beautiful survivals in the Gothic ruin are the windows and arches decorated with carvings, including flowers and leaves; among the latter is the Scottish kale the monks grew. There is also a pig playing the bagpipes, the significance of which no one has yet been able to decipher. It is in Melrose Abbey that the heart of the Scottish hero, Robert the Bruce, is buried.

Seven kilometres to the south-east of Melrose, in a sheltered situation on a bend of the Tweed, is Dryburgh Abbey, the oldest Premonstratensian monastery in Scotland (12th century). During the 14th to 16th centuries Dryburgh too was several times set on fire or destroyed in the course of the constant warfare in the border country. The monks' living quarters in the middle and lower stories of the cloisters are remarkably well preserved.

Oban ㊳ (Argyll and Bute). This fishing town, full of life in the summer, is a good centre for excursions on land (see Inveraray) and sea, for example to Mull (see entry) and others of the Inner and Outer Hebrides. There is plenty for the tourist to do: cafes, discos and the opportunity of attending a *ceilidh*. Highland Games are held here in August (the Argyll-shire Gathering) and in September Oban Gala Day with a market. There are many small hotels and bed-and-breakfasts, also in the hilly district surrounding the town. It is ideal for sailing and for skin-diving, especially given the large number of wrecks in the Sound of Mull.

The Mull of Kintyre (the tip of the peninsula, only 20km from the Irish coast), with its dramatic cliffs, lonely lighthouse and raging seas, was made famous all over the world when the Beatle, Paul McCartney, bought a house in the area and wrote the song 'Mull of Kintyre' for the Campbelltown Brass Band.

The Sea Life Centre, off the A828, 15km to the north of Oban, houses many interesting marine plants and sea creatures.

With St Columba's Cathedral, Oban is the seat of the Catholic bishops of Argyll and the Western Isles. There are still many Catholic enclaves in the region, dating back to pre-Reformation days.

Starting from Oban there is an interesting 150km circular route with ruins such as Dunstaffnage Castle, home of Clan MacDougall. Flora MacDonald (1722–90), who aided Bonnie Prince Charlie on his flight through Scotland to France in 1746, was imprisoned there. Dunstaffnage Castle is also important because it was there that the Stone of Destiny was originally kept. This stone, according to one legend Jacob's pillow, on which Scottish kings were crowned, was later taken to Scone. It was removed to England by Edward I, 'Hammer of the Scots' in 1296. In 1950 it returned briefly to Scotland when some nationalists took it from Westminster Abbey. It was finally returned to Scotland in 1996; it is now in Edinburgh Castle.

Overleaf: Contrary to their own statutes, in Melrose the Cistercians built a magnificent abbey rich in decoration and ornament.

143

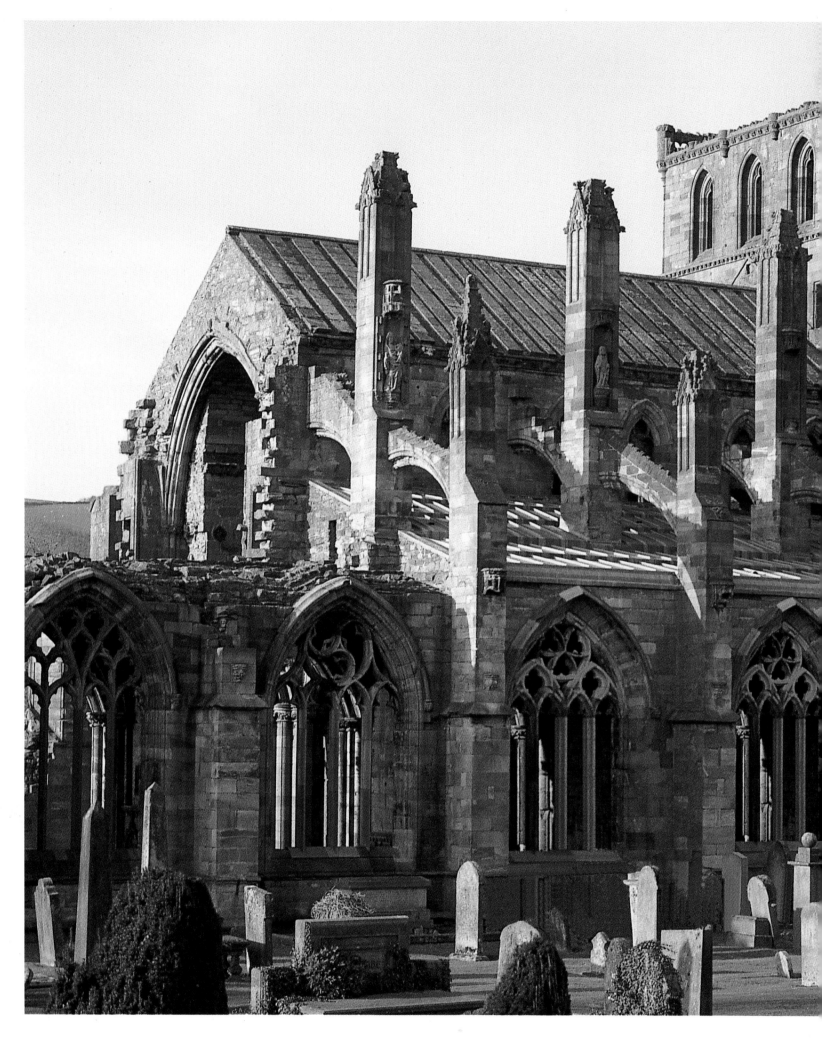

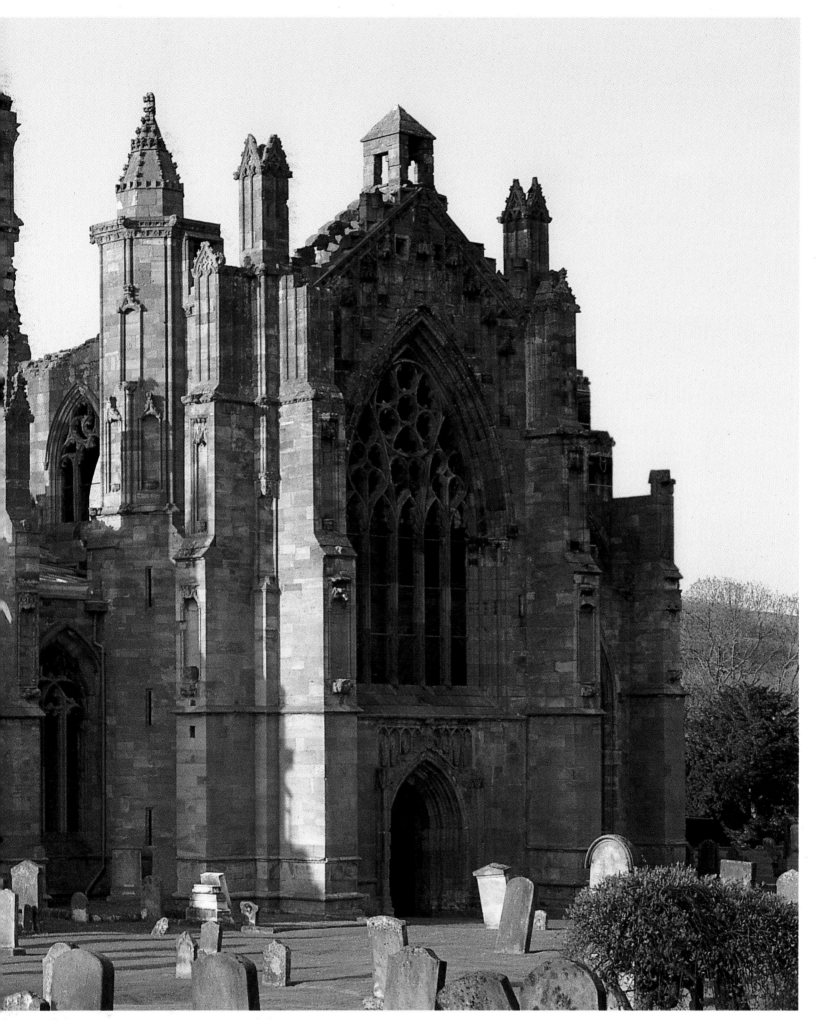

Interesting from a technological point of view is a pump storage scheme at the Cruachan Power Station Visitor Centre at the foot of Ben Cruachan (1120m) on the Pass of Brander, which runs along the beautiful northern shore of Loch Awe, at 40km one of the longest of the Scottish inland lochs.

Nearby is Bonawe Furnace, a former charcoal furnace. In the 18th century its presence led to the cutting down of the thick woods, with the result that the troops of the Hanoverian

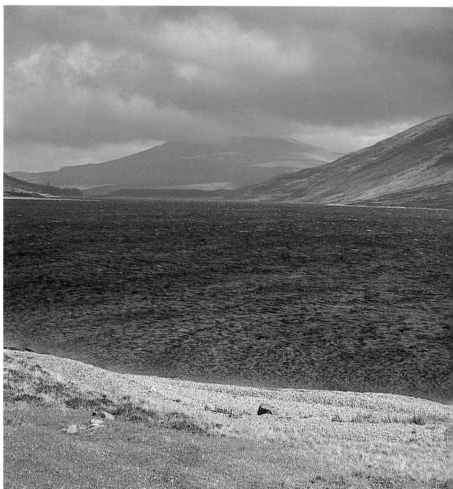

kings found it easier to flush the Jacobite Scots out of their hiding places.

To the south of Oban Kilmartin, with its graveyard and 14th–16th century carved gravestones, museum and many prehistoric monuments, is well worth a stop.

Orkney Islands ㉞. The archipelago comprises 67 islands, of which more than half are inhabited. For the Romans *orcus* was hell; the inhabitants of the islands are called Orcadians. They are closer to Oslo than to London; this is true in a historical sense as well. Although already inhabited in the Stone Age, their 'golden age' was under Scandinavian rule from the 8th to the 12th century, with legendary figures such as Thorfinn the Mighty, St Magnus and the crusader Rognvald. With their Norse tradition, the islands are also linguistically distinct from the Gaelic culture of the Highlands.

In May and June the sunsets are fantastic; on the longest day of the year the sun is in the sky for 18 hours and one can read out of doors late into the night. The largest of the islands, with the 'capital' Kirkwall, is called Mainland; for Orcadians the Scottish mainland is simply 'Scotland' or 'the south'. The imposing St Magnus Cathedral was begun in the 12th century by Earl Rognvald over the grave of his uncle, St

Magnus the Martyr, but was only completed in the 17th century. The ruins of the 17th-century Bishop's Palace can still be seen.

Maes Howe, 15km from Kirkwall, is one of the largest and most remarkable Stone Age burial chambers in Britain (9m high, 34m in diameter). It was excavated in 1861, and because of the Viking inscriptions was initially thought by archaeologists to be an old Norse structure. It turned out, however, that the Vikings were just grave robbers and Maes Howe was the burial place of a ruling family from the time around 2700 BC (Stonehenge 2800–1560 BC).

Left: A monster is good for business, as here on a cafe in Drumnadrochit. The Caledonian Canal, seen here near Fort Augustus (bottom right), links Inverness and Fort William.

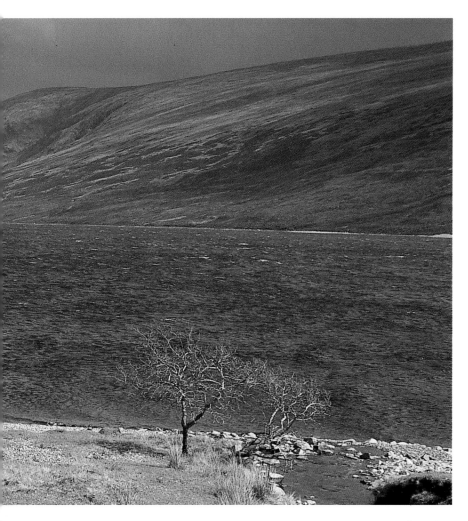

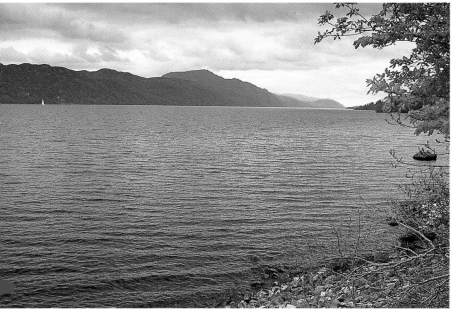

The famous 120m rock pinnacle, The Old Man of Hoy, is on Hoy, the second largest of the islands, to the south of Stromness.

There is a car ferry service from Scrabster, 30km from John o' Groats (nine hours) and daily flights from Glasgow, Inverness and Aberdeen.

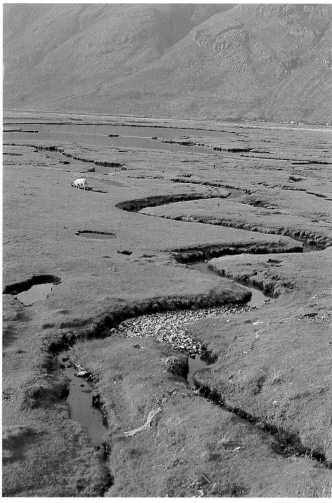

The lonely landscapes of the north-west cast a powerful spell: Loch a Chroisg (top middle), Loch Ness (bottom left) and Upper Loch Torridon (right).

An equally fascinating prehistoric site is the Ring of Brodgar (1560–1200 BC), 6km to the north-west of Maes Howe; 27 of its original 60 giant stones are still standing. Skara Brae is also worth a visit. It is a Stone Age settlement that was buried beneath the sand and only discovered 4000 years later. Stone tools and 'furniture' have been preserved there; a small museum explains the finds.

Excursions are also recommended to Stromness, the second largest, indeed the only other town on the islands, and to Scapa Flow, an important naval base in the two World Wars.

Perth ⑩ grew up at a point where the dangerous River Tay could be bridged. It was formerly a royal city, the capital of Scotland until the 15th century and the preferred residence of the Stuart kings – James I was murdered there and the last of the Stuarts, James VI, only just managed to escape an attempt on his life. It was in St John's Church that John Knox delivered his first tirade against the lax habits of the monks, which incited the people to storm and destroy all four monasteries in the town. Sir Walter Scott made the little market town (present pop. 43,000) famous all over the world with his novel *St Valentine's Day or The Fair Maid of Perth*; the grateful citizens immortalised him in bronze. In Balhousie Castle is the Museum of the Black Watch, the famous Scottish regiment that was raised in 1739 to put down the rebellious Highlanders.

It is worth while making an excursion to Scone Palace, only 3km away on the A9, a building at the heart of Scottish history and the Macbeth legend. The present Gothic Revival castle, built in the 19th century and owned by the Earls of Mansfield, replaced the old palace in which the kings of Scotland were enthroned until 1651 (Charles II). Originally they sat on a stone, dating from the days of the Picts and symbolising the pillow on which Jacob rested his head when he dreamed of the ladder up to heaven, but it was taken to

Westminster Abbey by Edward I in 1296 and placed under the throne of Edward the Confessor. It was stolen by Scottish nationalists in 1950 and kept in Arbroath for three months before being taken back to London. Legend had it that the stone that went back to London was not the real one, which would reappear when Scotland gained its independence. The stone was returned to Scotland in 1996 and is now kept in Edinburgh Castle.

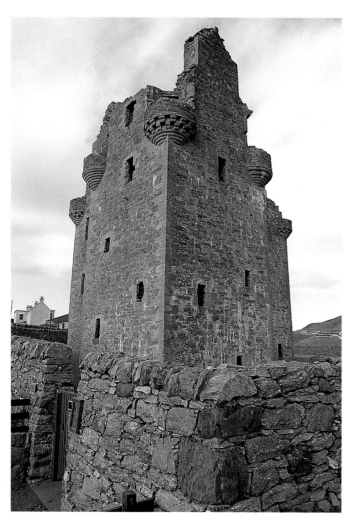

The connection with Shakespeare's *Macbeth* suggests a visit to the village of Birnam. According to prophecy, Macbeth would never be vanquished 'until Great Birnam Wood to high Dunsinane hill shall come.' Macbeth believed 'that will never be,' but Malcolm ordered his soldiers to camouflage themselves with branches from the trees in Birnam Wood before they stormed the castle.

Pitlochry (pop. 2599) Since 1951 this little town beside the Tummel, on the A9 north of Dunkeld ⑭ has had a summer Festival of Music and Drama. An 18m-high and 150m-long dam on the edge of the town forms the artificial Loch Faskally, rich in trout and salmon. The latter can be observed through windows as they ascend the 'salmon ladder' to the loch when they return upriver to their spawning grounds between April and October.

To the north of Pitlochry the A9 passes along a dangerous-looking gorge to the steep cliffs of Killiecrankie, the site of the famous battle of Killiecrankie (27 July 1689), in which Highlanders loyal to the Stuarts under 'Bonny Dundee' defeated the troops of William of Orange. However, Dundee was fatally wounded in the battle and his leaderless army suffered a decisive defeat at Dunkeld.

Pitmedden Garden ㊶, 20km to the north of Aberdeen, is the reconstruction of a nobleman's park from the 17th century (at its best in July and August). The plans which Sir Alexander Seton (1639–1719) drew up for the original garden were lost when Pitmedden Castle was burnt down in 1818. The reconstruction carried out by the National Trust for Scotland is based on the garden of Charles II at Holyroodhouse in Edinburgh. The park is on two levels: above are lawns, hedges and herb gardens, below, the rigidly formal garden with geometric patterns formed by trimmed box hedges, a symphony of colour from the 30,000–40,000 flowers which change throughout the year, coloured gravel walks and green grassy paths, with many additional features such as arbours, fountains and no less than 27 sundials.

Scone Palace see Perth.

Shetland Islands ㊷. This most northerly Scottish archi-pelago (90km north of the Orkneys) contains 100 islands, of which fewer than 20 are inhabited. The principal town is Lerwick (pop. 6127). The 17,300 inhabitants earn their living through fishing, knitwear, farming and, since the 1970s, North Sea oil. The links between past and present are perhaps best

Left: Scalloway Castle on Shetland, built by Patrick Stewart around 1600; middle: Lerwick harbour.

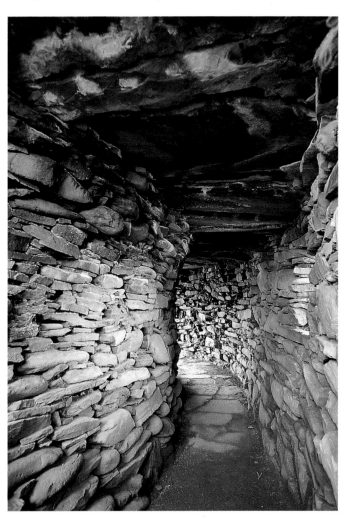

St Andrews ㊸. Scholarship and golf are the twin hallmarks of this port in Fife, situated on a peninsula between the Firth of Forth and the Firth of Tay. St Andrew lived up to his name (it means 'manly'), or rather, he died up to it, being martyred by being nailed, at his own request, to a cross that was tilted to one side, so as not to be higher than Christ. According to legend, the bones of Scotland's patron saint were brought to the town, at the time the ecclesiastical capital of Scotland, and transferred to the cathedral in the 12th century.

Today St Andrews is a charming little university town with an active cultural life. The University, founded in 1410 and the oldest in Scotland, has 3600 students. Since the 19th century St Andrews has become the Mecca of golf, where the R & A (The Royal and Ancient Golf Club), which decides on the rules, has its seat and where many a famous championship has been fought out on the Old Course. It is not surprising to find Mary Queen of Scots and John Knox in opposition here, as elsewhere in Scotland: the queen was the first of the Stuarts to play golf, while Knox berated it, together with football, as the greatest temptation the devil had visited upon Scotland.

Stirling ㊹ (pop. 29,776), controls access to the northern bank of the Forth with its fortress on a hill dominating the town in the same way as the Castle dominates the old town of Edinburgh. Since the 12th century Stirling Castle has played an important role for the kings of Scotland and in the wars of independence at the end of the 13th century, as for example in William Wallace's victory in the battle

Right: After landing at busy Sumburgh Airport in the Shetlands, a visit to the prehistoric excavations at nearby Jarlshof offers a striking contrast.

symbolised by the proximity of the prehistoric settlement of Jarlshof, from the 2nd to 3rd millennium BC, to the modern airport of Sumburgh. In contrast to the largely flat Orkney islands, the influence of the sea is everywhere to be seen on the Shetlands, creating areas of outstanding natural beauty and rich in birdlife. Shetland is the old Thule, as Tacitus called it; the Romans were afraid of the 'edge of the world' and, like Ireland, it remained unoccupied by them.

Shetland (the name comes from the Norwegian *hjaeltland*, or high land) is known for its wool, which is so finely spun that a genuine Shetland shawl can be pulled through a ring. Shetland ponies are as tough as the hilly landscape where they graze; their tail-hair is much in demand for fishing lines. The Viking festival of *Up-Helly-Aa*, held on the last Tuesday in January, in which a ship is burnt as sacrifice, expresses the islanders' understandable yearning during the long winter nights for the midnight sun.

Particularly rewarding is a visit to the broch on the uninhabited island of Mousa, 15km from Lerwick. Brochs are fortress-like roundhouses (especially to be found in the Highlands) going back to the 5th century BC. Mousa is a paradise for seals and wild ponies.

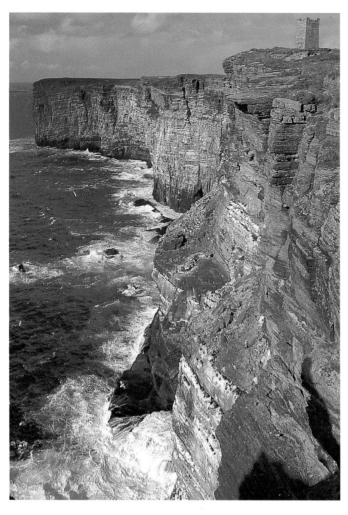

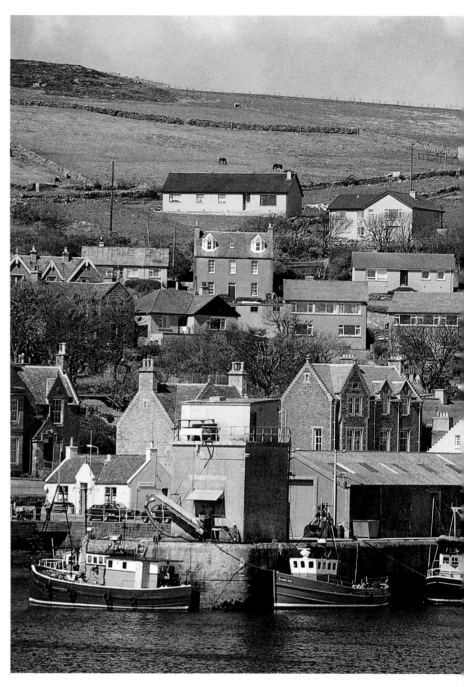

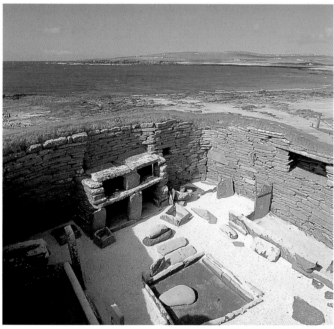

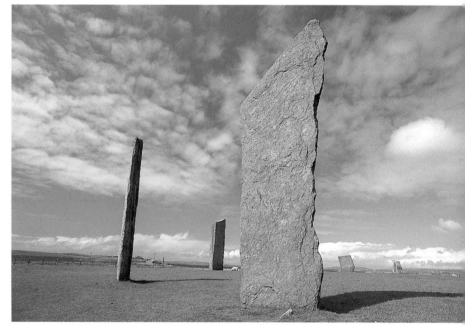

Top left: the monument on Marwick Head (Orkney) is a memorial to Lord Kitchener who drowned in a shipwreck within sight of the coast in 1916. Bottom left: excavations at Skara Brae on Orkney have uncovered a complete Stone Age village. Middle: Stromness, a former whaling port on Orkney. Bottom right: the four remaining Standing Stones of Stenness (Orkney) have been defying wind and rain since 3000 BC. They stand stark in the landscape and one can only guess at their original purpose.

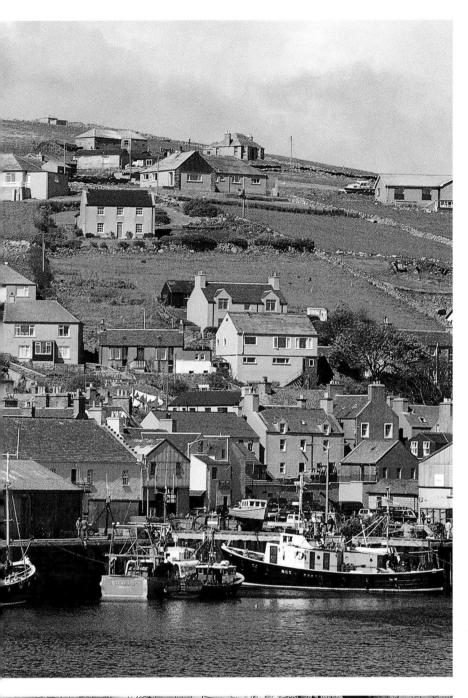

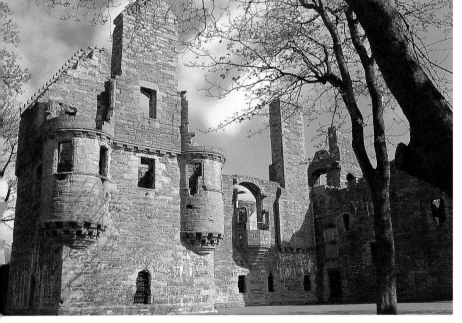

Bottom left: From 1600 to 1607 the hated Earl Patrick ('Black Pate') had his palace in Kirkwall built by forced labour from his subjects. All that is left today are the ruins. Top right: St Magnus Cathedral in Kirkwall which Earl Rognvald built over the grave of his uncle, St Magnus the Martyr. Bottom right: Italian prisoners-of-war working on the construction of a causeway to keep German warships out of Scapa Flow during the Second World War turned a toolshed into the 'Italian Chapel'. All kinds of materials were used, including skilfully worked scrap.

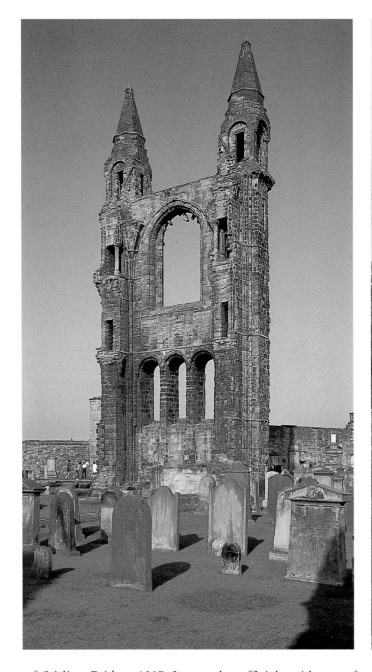

of Stirling Bridge, 1297. It was the official residence of the Stuart kings and it was James IV (a contemporary of Henry VIII) and James V (1488–1542) who gave the palace its Renaissance character. Mary Stuart, orphaned early, was crowned in the chapel, and her son James, the later James VI, was christened there. Elizabeth I was his godmother; she did not come personally, just sent a costly present. Later James VI had the chapel rebuilt for the baptism of his own son. With its stupendous setting and bloody history, Stirling Castle makes a deep impression on any visitor who is sensitive to the mute witnesses to history. There, for example, is the Ladies Rock, from which the ladies of the court used to watch knights jousting, Gowan Hill with its beheading stone, or the Douglas Room, where William Douglas, accused of disloyalty by James II, was murdered. The visitor is told exactly how and where the king threw the corpse out of the window, the same king who, as an eight-year-old boy twelve years previously, had been forced to witness the murder of a previous Earl of Douglas in Edinburgh Castle. Scotland's ancient history can send shudders down your spine.

From the battlements one can see the sites of no less than fourteen battlefields which were important in the history of Scotland. The best known is Bannockburn where, on 24 June 1314, Robert the Bruce (1274–1329) put the English army under Edward II to flight, securing Scotland's independence, enshrined in the Declaration of Arbroath (see entry). The visitor centre, 3km to the south of Stirling, has an audiovisual presentation of the battle.

Traquair House ㊺(Borders), on the A72 between Walkerburn and Peebles, 45km from Edinburgh, is claimed to have been inhabited longer by the same family than any other castle in Scotland. The Earls of Traquair ('tra' meaning house, 'quair' meaning winding stream) have lived there since 1491. The main gates of the castle, between huge pillars surmounted by bears, are known as the 'Steekit Yetts' as they have not been opened for over 200 years. The popular (though incorrect) legend is that they were closed when Bonnie Prince Charlie left after a visit to Traquair during the '45, the Jacobite earl declaring they would not be opened again until a Stuart once more sat on the throne of Scotland. Parts of the house are 1000 years old. It was once a hunting lodge of the Scottish kings and its turrets give it the air of a French château. The interior has a pleasantly 'lived-in' atmosphere and does not feel like a museum, as so many historic houses do.

Left: With a length of 102m, St Andrews Cathedral was once the biggest church in Scotland. Built in 1160 and consecrated in 1318, it was destroyed by fanatical supporters of John Knox in 1559. Middle: Stirling Castle, the main residence of the Stuarts, rises high above the town.

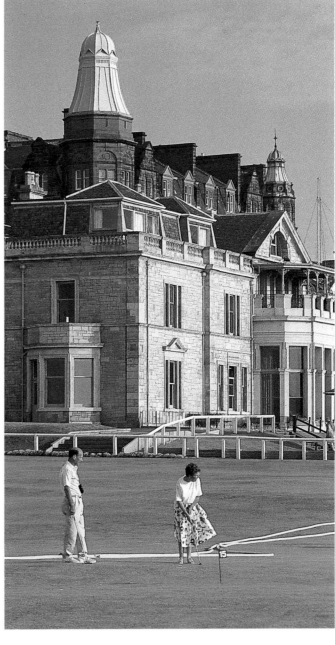

Right: the Old Course of the Royal and Ancient Golf Club in St Andrews. Golfers from all over the world have the ambition to play on its 'holy ground'. It was here that the rules of the game were first set out in 1754.

Twenty-seven monarchs stayed at Traquair, including Mary Stuart with Darnley and their son, the future James VI who became James I of England. His cradle, Mary's rosary, crucifix and purse are family heirlooms. In the entrance hall the 18th-century bells can still be seen which told the servants in which of the fifty rooms their presence was required.

There is fine, early 19th-century furniture in the Chippendale style. An embroidered quilt on the yellow, four-poster bed of state is said to have been used by Mary Queen of Scots. The 3000-volume library is more a showpiece than intended for everyday use. The earls of Traquair are Catholics; in front of the early 19th-century chapel there is a secret Priest's Room where mass was celebrated. Until the 18th century it was forbidden and heavy fines were imposed on nobles who were found guilty of allowing it.

Since the 18th century Traquair House has been brewing its own beer (current output 50,000 bottles per year). On the large estate are old farm-workers' cottages, which the current countess has made available to artists and craft workers with the idea, following her own artistic inclinations, of turning Traquair into a cultural centre.

Leading southwards from Traquair House is a beautiful and not too strenuous walk (12km) to St Mary's Loch, surrounded by gentle hills. On its south-eastern bank is Tibby Shiel's Inn named after the landlady who ran the inn in the first half of the 19th century when it was visited by many famous names of the Scottish literary world such as Sir Walter Scott, Thomas Carlyle and, especially, James Hogg, William Aytoun, Christopher North and Robert Chambers.

The Trossachs ㊻ (possibly 'cross-hills'; the older, now disputed derivation was 'bristly hills') is the name of possibly the most beautiful scene in Scotland with a narrow defile between the massive bulk of Ben Venue and Ben An along a small river to Loch Katrine. It can easily be reached by the A821 from Callander, and there are steamer trips along the loch, the scene of the romantic encounter between Ellen Douglas and the king in Sir Walter Scott's poem 'The Lady of the Lake'. The tour continues along the A821 (the hilltop viewpoint over Loch Achray offers the photographer magnificent views) through Achray Forest (picnic sites) to the village of Aberfoyle, that makes the most of its connection with Rob Roy MacGregor, a kind of Highland Robin Hood. The B829 then leads to Stronachlachar, at the farther, western end of Loch Katrine (it can also be reached by steamer). The road ends at Inversnaid on Loch Lomond,

with fine views of the 'Arrochar Alps' (The Cobbler, Ben Narnain, Ben Vorlich, Ben Vane and Ben Ime) rising above the farther shore.

Wester Ross is the Atlantic coastal region of the northern Highlands, a wild and dramatic mountain landscape which can be explored in two day trips. The first part (150km) goes from Kyle of Lochalsh via Plockton (a harbour for sailing boats), round Loch Carron (a sea loch), over the 626m-high Bealach nam Bo ('pass of the cattle'), round the Applecross peninsula, up Glen Torridon and along the magnificent Loch Maree with Slioch (980m) towering in the background, past the waterfalls named after Queen Victoria to the lively fishing port of Gairloch. After spending the night there the route continues north-east along the A832 through breathtaking mountain scenery past Poolewe (view up Loch Maree) to the famous Inverewe Gardens (see entry), Loch Ewe, the Falls of Measach and Ullapool (pop. 807), a historic fishing port on the shore of Loch Broom, a meeting point for fishing boats from western and eastern Europe (84km).

Music

Long before the European Romantics discovered Scotland in the late 18th and early 19th centuries, and were inspired to express the beauty of its scenery in music (in Mendelssohn's Hebrides overture, for example), Scottish folk songs were famous for their moving, expressive power. Highland songs are similar to those of Ireland, the Lowland melodies to those of the north of England. In the 20th century the old love songs and hymns of the Hebrides, often with a connection to history and legend, were collected and published. The oldest go back to the 15th century, the earliest surviving manuscript to the 1620s. The absence of early instrumental music remains a mystery, although it is known that music was part of life at the medieval Scottish court. The explanation probably lies in the rigorous eradication of anything recalling the Catholic past.

The Gaelic tradition of the wandering minstrel is kept up by the annual Highland Mod, an event similar to the Welsh Eisteddfod. Very popular with the modern tourist are the *ceilidhs*, informal gatherings round the fire where the whisky and beer flow, folk songs are sung and old instruments played, for example the Jews' harp, a kind of primitive mouth organ, known throughout Europe in the 16th century.

Edinburgh, the old capital of Scotland has been the musical centre of the country since the 18th century. The Musical society, founded in 1728, organised concerts in St Cecilia's Hall and well-known musicians from abroad visited the city; Hans von Bülow, for example, often came to Edinburgh to conduct the concerts with a large choir which were so popular in the 19th century. The main focus of the Edinburgh Festival, which started in 1947, is music, because music is an international language, but there are also art exhibitions, drama and dance. Lasting three weeks, the festival attracts some 175,000 visitors. The Military Tattoo with a cosmopolitan programme in the picturesque setting of the castle is always a high point, together with concerts by world-famous orchestras and soloists in the Usher Hall and guest performances from great international theatre companies. Great art and great entertainment is the motto. The occasional shocks to conservative taste are part of Edinburgh, that even in earlier centuries was the scene of extreme contrasts as for example between the sophisticated court of the Stuarts and the Calvinist preaching of John Knox, who condemned it as the devil's brood.

Symptomatic of this tradition is, for example, the refusal of Edinburgh's city fathers, known for their combination of staidness and parsimony, to build a new opera house (which is genuinely needed); when they did eventually agree to the conversion of an old bingo hall for this purpose, they refused to approve its use for anything apart from military parades. It took decades of international success to reconcile the city fathers, of whatever political party, to an event which, though expensive, is very profitable for the city. Alongside the official festival there is the Fringe Festival (for the 'people', that is, for all those who prefer jeans to jacket and tie) where a wide variety of often primitive venues host performances of immense youthful enthusiasm and, occasionally, real artistic talent.

Scottish cuisine

Taste of Scotland is the title of the brochure published every year by the Scottish Tourist Board with a list of 200 hotels and restaurants approved for the Scottishness and quality of their food. The *Good Food Guides* are a further important source of information in Britain. The best test is, of course, one's own. Scotland is good as far as the raw materials are concerned: wild salmon, both fresh and smoked, tastes much better than the fatter farmed salmon so widespread today; also to be recommended are shellfish, venison, game birds, beef and lamb.

Haggis, the national dish, is worth a try; the traditional recipe uses the heart, lights and liver of a sheep mixed with oatmeal, beef suet and spices, tied up in a sheep's stomach. Haggis, doused in whisky and eaten with 'tatties and neeps' (mashed potatoes and turnips) tastes much better than the description would suggest. Arbroath smokies are smoked haddock; they taste excellent eaten cold with a little lemon juice and brown bread and butter for 'high tea' (roughly between 4.30 and 6.30), an alternative to a hot evening meal. 'High tea' also gives the visitor the chance to sample the great variety of oatcakes with butter and honey and Scottish cheeses, for example crowdie, a kind of coarse cream cheese, dunlop, similar to cheddar, or caboc, covered in oatmeal on the outside.

The Scottish breakfast is substantial and will set you up for the day, especially if you have it with porridge, which true Scots eat salted and, supposedly, standing up; foreigners are allowed to enjoy it sitting down with plenty of sugar and cream.

The land of whisky

The word 'whisky' applies to American bourbon and Irish whiskey as well as to 'Scotch'. In its Scottish homeland the 'water of life' (Gaelic: uisge beatha) has achieved mythical status. A genuine Scot will never order a 'Scotch', assuming what he will get under that name will be some kind of foreign imitation.

Blended whisky consists of a mixture of spirits distilled from malted barley and from other grains. The blend, the precise ratio of the different types of spirit, is a closely guarded secret. In modern times blended whisky has proved more popular and is exported in large quantities all over the world. Scotland's whisky exports bring in some £900,000,000 per annum. In Scotland itself malt whisky is only drunk on special occasions. It is usually drunk neat, without ice; people say any addition spoils the taste. Other kinds of whisky are drunk with soda, water or ice. What gives Scottish whisky its characteristic flavour is the local combination of melted snow and peaty spring water as well as the various carefully mixed types of barley. Originally whisky was the

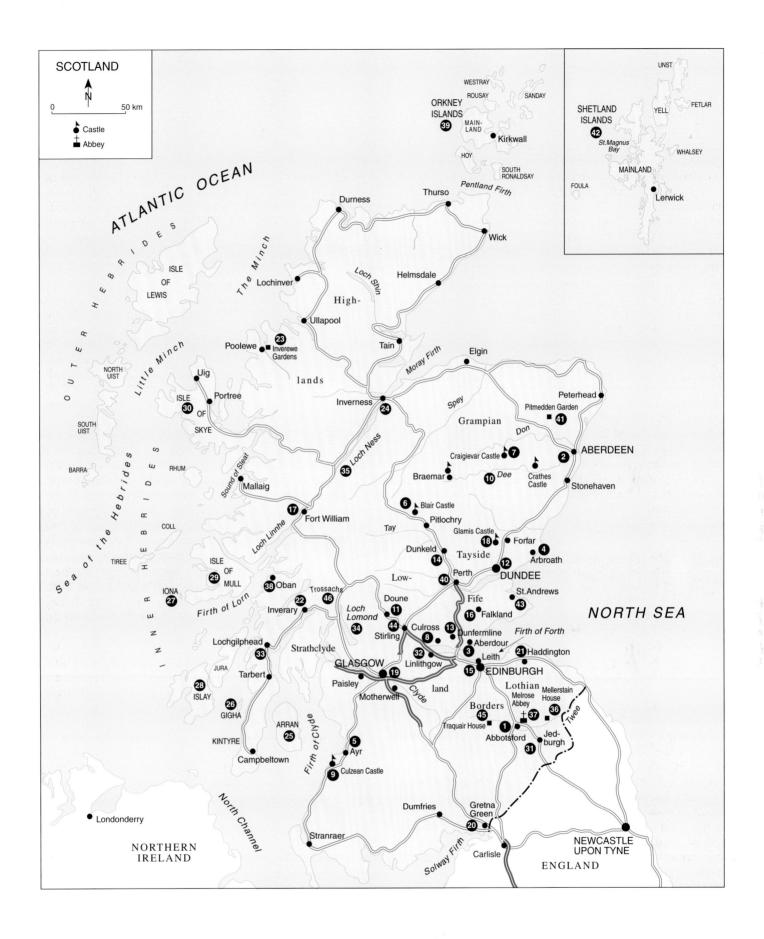

product of a single distillation and nowadays this, known as malt whisky, is once more in demand among connoisseurs, because of its smoky bouquet. A hundred and sixteen different malt whiskies are produced in Scotland, divided into Highland, Lowland and island (mostly Islay) malts; they are more expensive than blended whiskies. Drambuie is a well-known whisky liqueur.

Since Highland water is such an important factor in whisky production, the majority of whisky distilleries are on Speyside (Highland and Moray), and on Islay and Jura. A Speyside tour known as the Malt Whisky Trail is recommended (ask at tourist information offices). Many whisky distilleries have guided tours lasting about one hour and ending with a dram.

Index

Numbers in Italics refer to illustrations

Acknowledgements

Text

James Boswell, *Dr. Samuel Johnson: Leben und Meinungen*, German translation by Fritz Güttinger, Zurich, Diogenes, 1981.

Robert Burns quoted from David Daiches, *Scotch Whisky*, Luzern/Frankfurt Main, C.J. Bucher Verlag, 1971.

G.F. Dutton, in *ibid.*, *Camp One*, Edinburgh, Macdonald, 1978. © G.F. Dutton

Theodor Fontane, *Jenseits des Tweed: Bilder und Brief aus Schottland*, Berlin, Rütten & Loening (p. 74ff).

Theodor Fontane, in *Europäische Balladen*, Stuttgart, Philipp Reclam Junior, 1967 (pp. 80–1).

James Macpherson, *Ossians Werk*, German translation by Franz Spuda, Leipzig, Wolkenwanderer Verlag, 1924.

Johanna Schopenhauer, *Reise durch England und Schottland*, Library of classical travel writing, Stuttgart, Steingrüben Verlag, 1965.

Sir Walter Scott, in Theodor Fontane, *Wanderungen durch England und Schottland*, German translation by Theodor Fontane, Bd. 2 Berlin, Verlag der Nationen, 1980.

Robert Louis Stevenson, *Entführt*, German translation by Michael Walter, Frankfurt Main, Insel, 1978. © Insel Verlag, Frankfurt Main, 1973.

Thanks to all copyright holders and translators for kindly allowing reproduction. In spite of intensive effort it has not been possible to find all copyright holders. We would like to ask these copyright holders to contact the publisher.

Pictures

Aberdeen University Library, Aberdeen: pp. 56 bottom right, 56–7 top middle, 76 top.

Archiv für kunst und Geschichte, Berlin: p. 14 left, pp. 39, 74, 75, 79.

Bildarchiv Foto Marburg, Marburg: pp. 54, 77 bottom, 78 bottom.

Bildarchiv Preußischer Kulturbeseitz, Berlin: pp. 14 bottom right, 38 middle left, top right and bottom right, 82.

Bilderdienst Süddeutscher Verlag, Munich: pp. 40–1 top middle, 41 top right.

British Museum, London: p. 35.

Historia-Photo, Hamburg: pp. 15 (2), 37 top left, 38 top left and bottom left, 55, 80.

The Hulton-Deutsch Collection, London: p. 56 top left and bottom left.

Interfoto-Pressebild-Agentur, Munich: pp. 37 middle left, bottom left, top right and bottom right, 40 top left, 58 left, 59 right.

Ullstein Bilderdienst, Berlin: pp. 14 top right, 34, 40 bottom left and bottom right, 41 bottom left and bottom right, 57 bottom, 58–9, 76 bottom, 77 top left and top right, 78 top left and top right, 83.

All other illustrations come from Kai Ulrich Müller, Berlin

The map on p. 155 was drawn by Astrid Fischer-Leitl, Munich.

Kai Ulrich Müller would like to give special thanks to the following people and organisations for their support: the organisers of the Braemar Highland Games, especially the Press Secretary Bob Smith and his wife, Aberdeen; the organisers of the Edinburgh Tattoo, Edinburgh; the National Trust for Scotland, especially Jane Rowson and Peter Reekie, Edinburgh; Mr G.S. Welsh FRCS, consultant orthapaedic surgeon, his team and the nursing staff at the Raigmore Hospital, Inverness, for their excellent treatment after his accident in the Highlands; last but not least his girlfriend Claudia Ille, Berlin, for her unselfish and energetic support.

Production

Picture concept: Axel Schenck
Editorial: Bettina Eschenhagen, Susanne Kronester
Captions: Harald Henzler
Anthology: Peter Torberg
Picture documentation: Maria Guntermann
Graphcs: Werner Poll
Print production: Angelika Kerscher

Technical production: Fotosatz Ressemann, Hochstadt; Repro Ludwig, A-Zell am See; Printing and binding: Editoriale Lloyd S.r.l., I-Trieste.

Published in 2002
by Tauris Parke an imprint of
I.B. Tauris & Co Ltd
6 Salem Road,
London W2 4BU
175 Fifth Avenue,
New York NY 10010
www.ibtauris.com

© 1992, 1993 (I, II), 1994, 1995, 1997, 1999, 2000 by C.J. Bucher Verlag GmbH & Co. KG, Munich
All rights reserved
Printed and bound in Italy
ISBN 1 86064 826 6